MW00984205

The House of Barnes

The House of Barnes

The Man, The Collection, The Controversy

Neil L. Rudenstine

American Philosophical Society
Philadelphia • 2012

Memoirs

of the

American Philosophical Society

Held at Philadelphia

for Promoting Useful Knowledge

Volume 266

Published by the American Philosophical Society

ISBN: 978-0-87169-266-5

Library of Congress Cataloging-in-Publication Data

Rudenstine, Neil L.
 The house of Barnes : the man, the collection, and controversy / Neil Rudenstine.
 pages cm. — (Memoirs of the American Philosophical Society held at
Philadelphia for promoting useful knowledge, ISSN 0065-9738 ; volume 266)
 Includes bibliographical references and index.
 ISBN 978-0-87169-266-5 (alk. paper)
 1. Barnes, Albert C. (Albert Coombs), 1872-1951. 2. Barnes, Albert C.
(Albert Coombs), 1872–1951 — Will. 3. Barnes Foundation — Management. I. Title.

 N5220.B28R83 2012
 709.2—dc23

 2012035474

Winner of the 2012 JOHN FREDERICK LEWIS AWARD
Presented by the American Philosophical Society

for Angelica

Contents

Acknowledgments

Anyone who writes on Albert C. Barnes is inevitably indebted to Mary Ann Meyers, whose volume *Art, Education & African-American Culture: Albert Barnes and the Science of Philanthropy* is extraordinarily detailed and invaluable. Howard Greenfeld's volume *The Devil and Dr. Barnes* offers an informative, stimulating view of Barnes and his many activities.

In my research for this book, I have benefitted from the assistance of many individuals. The professional staff at the Barnes Foundation have been unfailingly generous with their time and expertise. Derek Gillman (Executive Director and President), supportive of the project from the beginning, read an early draft and offered important suggestions. Dr. Bernard Watson was crucial in his willingness to carefully review key parts of the manuscript's final chapters. Judith Dolkart (Deputy Director and Chief Curator) responded with speed to questions of provenance, dating, and other cataloguing details about individual works in the collection, and much else. Martha Lucy (formerly Associate Curator and co-author with the late John House of the magisterial, recently published *Renoir in the Barnes Foundation*), shared her insights about the Renoir holdings. From the rich Foundation archives (thoroughly catalogued and located in Merion), the knowledgeable archivists Katy Rawdon (Director of Archives, Libraries & Special Collections), Barbara Beaucar, and Amanda McKnight, provided me with critical documents and information about Barnes and the collection. Peg Zminda (Executive Vice President) helped to locate essential materials about the financial history of the institution. Photographs and permissions to reproduce them, could not have been obtained without the admirable persistence of Deborah Lenert, Visual Resources Manager.

Outside the institution, Eva Gossman, formerly of Princeton University, read a very early draft of the manuscript, and offered challenging and invaluable comments. Jayne Warman, co-author of the forthcoming on-line catalogue raisonné of *The Paintings of Paul Cézanne*, graciously shared her research on the provenance and dating of several works by the artist. My many conversations with Joseph J. Rishel (Senior Curator of European

Paintings and Sculpture before 1900 at the Philadelphia Museum of Art, who skillfully chaired the Barnes Foundation Collection Assessment Advisory Committee starting in 2000) were illuminating and helpful in countless ways. Yve-Alain Bois (Professor of Art History at the Institute for Advanced Study) read the entire manuscript with broad understanding of the period and meticulous attention to detail, sharing much important new information. Under his leadership and editorship, the exhaustive scholarly study of Matisse in the Barnes collection by Claudine Grammont, Karen K. Butler, and Barbara Buckley, is forthcoming.

Mary McDonald (Editor, Director of Publications at the American Philosophical Society), has been more than generous with her time, assistance, and patience at every turn. Gail Goldfarb, my assistant, was essential in innumerable generous ways to the preparation of the manuscript and many other vital matters. More than anyone else, Angelica Zander Rudenstine did her editorial utmost to ensure that my ideas, facts, and prose were in good order. For everything that remains in conspicuous disorder, I am myself entirely responsible.

Neil L. Rudenstine

1

Latch's Lane

The Barnes Foundation was originally located in Merion, Pennsylvania, not far from a main highway and the moderately busy streets of a nearby village. Its actual site, however, was on Latch's Lane, a quiet drive that is part of the "Main Line," which stretches for miles from Philadelphia through several of the city's wealthy suburbs. In fact, the Barnes was doubly sheltered: by the quietude of its immediate neighborhood and by its own wooded acres of land, including a well-cultivated and beautiful arboretum.

Latch's Lane has a handful of large houses with ample surrounding space to provide privacy. There is very little traffic, and because the Foundation was placed well behind a high wrought-iron fence with a security guard at its entrance, it was altogether inconspicuous from the road. For the innocent and uncertain visitor, the actual process of finding Latch's Lane, passing through the guard-post and then coming suddenly upon the Foundation's two discreet neoclassical buildings, seemed in itself a minor triumph. Something quite hidden was gradually revealed, and because there were usually no visible automobiles and few if any people in sight, one felt unexpectedly in full possession of the serenity of the setting, the understated elegance of the architecture, and the riches of the art collection. One was entering a secular sanctuary or hidden country Great House: or rather, one had the feeling of silently invading a harbored private place, not merely visiting it.

I first saw the Barnes in the early 1960s, and it would never have occurred to me that the collection might one day move, leaving behind its buildings and arboretum, while bringing its art and education programs to center-city Philadelphia. But that is exactly what has happened. The pages that follow are the result of an interest in the entire Barnes saga, not simply the events of the last few years. Because Albert C. Barnes and his dominant personality lie at the heart of the saga, there is inevitably a major focus on him and his many conflicting impulses and ideas. Yet, this book is in no sense a biography: it also deals with the Foundation's educational programs, its most contentious legal cases, and its longstanding — finally desperate — financial problems.

Albert Barnes is often viewed as an isolated figure: a unique and brilliant autodidact who created an astonishing art collection and developed a set of educational theories very much on his own. That he admired the ideas of William James and was a close friend of the philosopher and educator John Dewey are well-known facts. But perhaps because of the force of his personality, Barnes is frequently portrayed as a lone anti-establishment figure who collected "modern" art that was regarded as shocking or mad, while also developing an original approach to the works in his collection.

While not denying either the forcefulness or the originality of Barnes, in the following pages I try to place him within the context of his own historical era; to shed light on the ideas and movements (especially concerning art collecting, education, and aesthetics) that influenced him and shaped so much of his thinking; and to carefully consider the validity of his ideas.

The last chapters of the book deal with the events surrounding the Foundation's move to Philadelphia, including the reasons that have been put forward in opposition — as well as in support. There is an analysis of the Foundation's financial plight, a review of the major court cases involving the Barnes, and a description of the fervent reactions following the court's decision to allow the move to take place.

I was invited to become a member of the Barnes Foundation's board of trustees in 2005, following the court's decision. But before joining, I read through the relevant financial, legal, and other materials in order to decide whether I believed the move to be justified. After this review, the arguments in favor seemed to me to be completely persuasive, and nothing since then has caused me to change my mind. It was, however, the entire saga of Albert Barnes and his Foundation — not the move itself — that prompted me to write this volume, simply because the tale and its shifting cast of characters continue to arouse intense interest, strong emotions, and controversy a full century after Barnes acquired the first paintings that eventually led to the creation of his extraordinary collection, the establishment of his Foundation, and the transformation of the entire institution.

2

Mr. Barnes

I came into the world maladjusted — and I'm still that. I saw my trouble when I was about twelve years old, and at about fourteen I began the study of psychology from a deep interest which probably had its origins in an unconscious need. Even at that age, I was an inveterate experimenter and nothing I ever came in contact with did I accept as standard or right or ultimate. I wanted to change the status of everything in my boyhood world. . . . I don't regret it because it taught me to fight and it was always for an ideal — of course, a disbalanced, youthful, stupid ideal in many cases.

— Letter to Alice Chipman Dewey, September 20, 1920

Albert Barnes was a controversial figure during his lifetime and has remained so more than half a century after his death in 1951. By the 1930s, he had assembled the greatest personal collection of post-impressionist art in the world. But his "Indenture of Trust"[1] was so extensive that it seemed intended to control the use of the collection and the operations of his Foundation almost as firmly after his death as he himself had done during his lifetime. Rarely has such a document been drafted in such detail — including the precise salaries of several employees — and rarely has such a document been in need of frequent change. One result was that the Barnes Foundation was in litigation nearly thirty of its eighty-six years of existence (until 2011), and the litigation has almost always been

[1]Barnes' Indenture of Trust was a completely different document from his will, with which it is often confused. Barnes' will was not broken by any court rulings. The Indenture of Trust outlined the purposes and the organization of the Foundation, including many specific details related to the Foundation's operations. These included such matters as staff salaries, investment policies, and admissions policy. Over the course of more than half a century, the Indenture has been modified a considerable number of times.

contentious as well as costly. Even today, sixty years after Barnes' death, the controversy remains heated and divisive. How and why this happened remains one of the more interesting stories in the history of art collecting and art education.

Albert Barnes was born into a family whose means were well below those of Philadelphia's solid middle class. His father was a butcher who (after losing an arm in the Civil War) later became a postman. For most of his youth, the family lived in rough-and-tumble parts of the city, but in spite of this, Barnes demonstrated his intellectual precociousness early in life. He studied hard and was only one of two students from his local school to win entrance to Central High School — Philadelphia's leading public secondary school designed exclusively for unusually talented students. Admission was a *coup,* and Barnes was on his way.

He entered Central in the autumn of 1885, when he was thirteen. The curriculum was more than challenging. In fact, it was so rigorous that barely one-fifth of all entering students eventually graduated. Barnes did well — so well that in 1889, he was awarded a BA (a degree conferred by special dispensation on all Central High graduates). Barnes then skipped college and decided to enroll directly in the University of Pennsylvania's Medical School. He began with a study of general chemistry and may have won an assistant-ship in Penn's Chemical Laboratory, as well as a board of education scholarship for his second year (1890–1891). By the next spring, he graduated with an MD. He was just twenty years old.

If we look beyond Barnes' academic achievements, it is clear that several of his strongest personal qualities and characteristics were already visible during his school and university years. His neighborhoods were anything but congenial and — by his own account — he was often the victim of local bullies who overpowered him in frequent fights. But with hard-earned pocket money, he and his brother bought boxing gloves and began to spar and practice until Albert was skillful enough to emerge as the victor in several of the local brawls. Barnes once recalled a particular incident in which he "knocked" a rival "cold" (using a bottle!): "so you see," he wrote, "that early habits crop up later in life."[2]

These habits — competitiveness, combativeness, determination to win, and the great pleasure in victory — were deeply ingrained in Barnes from childhood onward. They showed themselves in any number of ways, some of which were entirely benign. For instance, he was a good athlete and apparently played baseball on a local team. He entered high school "politics" and was elected vice president of his senior class. He claimed to have tried his hand at painting and drawing (although he soon withdrew in the face of

[2]Barnes to Horace Stern, April 11, 1949. Barnes Foundation Archives (hereafter BF Archives).

criticism by a fellow student and lifelong friend, the artist William Glackens). In short, he "experimented" with life, as he himself liked to say, and his successes showed promise.

Some measure of self-awareness and self-insight led to his early interest in psychiatry. We know (thanks to his friend Henry Hart) that he volunteered at the Pennsylvania Hospital for the Insane after graduating from medical school. Following months of observation, he concluded — with unconscious irony — that individuals who were mentally ill could in many cases be cured if they were willing to adopt "valid ideas" and discard "wrong beliefs," putting them in a position to "acquire new attitudes and habits."[3] Barnes did not elaborate on the nature of "valid ideas" and "wrong beliefs," but he gave every indication of appearing to know what they were.

This early anecdote reveals Barnes' interest in applying observation and experimentation or "science" to human behavior. We can also detect his emerging tendency to dogmatism. On one hand, he seemed convinced that people are able to change, to explore new realms, to alter habits, and to lead increasingly rewarding lives. On the other, he insisted that they embrace only ideas that were said — somewhat inexplicably — to be valid or true, while relinquishing convictions that were judged to be false.

Despite this latent dogmatism, Barnes' inquiry into the nature of insanity was another example of his genuine intellectual curiosity and desire to pursue knowledge. In this case, the curiosity was related closely to his interest in the varieties of human experience and the ways in which such an interest might increase one's understanding of the self. Moreover, he explored this subject with considerable energy. He read Bernard Hart's *The Psychology of Insanity*; Freud; William James' *Principles of Psychology* and much else by James; and he became immersed in John Dewey. In time, he engaged deeply with many other writers who were interested in the zone where psychology, aesthetics, and education intersect.

This effort to understand how the mind (including instincts, feelings, and emotions) actually works; how experience can be defined and then how it can be directed in such a way as to enrich life and foster "growth;" how art (as an analogue to everyday experience) can affect viewers in fresh, stimulating, and even transformative ways: this effort eventually became the central concern of Barnes' life and philosophy. It provided the basis for his theories about the nature of art and certainly of education. It was, in essence, a lifelong quest to search, discover, theorize, and experiment as a scientist might.

At the same time, Barnes' quest came increasingly to represent another example of his desire to achieve mastery and to emerge victorious. Although he was an autodidact in the field of art, his intellectual powers

[3]Henry Hart, *Dr. Barnes of Merion: An Appreciation*, Farrar, Straus, New York, 1963, p. 34.

enabled him to achieve far more — in his collecting and in his writing — than most of his peers. He was also, however, an intellectual pugilist who rarely missed an opportunity to do battle in order to advance his own ideas and to dismiss those of others who entered what he considered to be his own terrain. The fight to sustain the validity of his theories eventually led Barnes, not to the potential fruitfulness of many give-and-take exchanges, but to the exclusion of most ideas that might challenge his own assumptions. At that point, Barnes' mind began to close — not entirely, but increasingly so.

Despite the fact that Barnes created a substantial Foundation including a major art gallery of international significance, a formal education program in art appreciation, and an arboretum with regularly scheduled classes of instruction, he was in no sense an institutional person. His instincts were essentially autocratic: they were those of a self-made businessman whose small company proved very quickly to be immensely profitable and was easily managed. Barnes' natural entrepreneurship, his individuality, and his talent for self-advertisement (including the marketing and sales of his products) were given free rein. By virtue of his fortune (which gave him total independence), his famed art collection (mainly developed over the course of about three decades), and his combination of intellect and forcefulness, he was ultimately accountable to no one but himself. In effect, he created his own landed kingdom in Merion, Pennsylvania — with its own cadre of devoted citizens, its own impressive habitat, and its own laws and bylaws. And, the entire province was, as suggested, enclosed by a high surrounding fence to control entrance. Considering the fact that Barnes' Foundation was chartered as a tax-exempt public institution, it was by any standards idiosyncratic — and ingeniously conceived.

How Barnes made his fortune — and how his institution came to be founded and shaped — were largely the result of his particular combination of talent and drive. But there was also a crucial element of good luck involved. The fact that he became a capable chemist whose temperament was essentially practical, with an obvious inclination to act quickly and decisively, led him to exploit his capabilities to the full. What he could not have controlled (or necessarily predicted) was that the historical moment (from the late nineteenth century into the opening decades of the twentieth) was unusually ripe for discoveries and inventions in applied sciences, including medical sciences. Recent advances in physics, chemistry, and aspects of biology (especially but not only evolutionary biology) were producing a revolution in both scientific theory and experimentation. This was the moment when Roentgen developed the x-ray process, when the Curies identified radium and its properties, when the Pasteur Institute was founded, when Thomas Huxley was popularizing (with considerable sophistication) the ideas of Darwin — and when Einstein propounded his theory of relativity.

Although England and France obviously played an important role in these developments, it was Germany that had been for decades the unquestioned pioneering center for research and discovery in the sciences. At least as early as the mid-nineteenth century, most of the brightest American college graduates who wanted to undertake advanced studies habitually chose Germany as the place to continue their work, simply because the United States was substantially behind in the move to create doctoral programs and excellent laboratory facilities. For instance, William James (one of Barnes' intellectual guides) went to Germany after Harvard, and although his experience was less than altogether cheerful, he returned with a new sense of what might be achieved in his own field of experimental psychology, as well as in other fields. In fact, when it came time, years later, for Harvard to appoint another experimental psychologist, the search led to Germany and the choice was Hugo Münsterberg, a young protégé of James who was lured away from Freiburg.

It was not surprising, therefore, that after completing medical school in 1892, Barnes decided to continue his studies in Germany. Having apparently first visited hospitals in Paris and London during the summer of 1893 (on a very constrained budget), he moved to Berlin in 1896 for eighteen months of serious study and research in chemistry (and even some philosophy). He perfected his skill in the German language, and came back to the United States as a valuable "commodity:" he was a German-trained chemist at a time when the entire field of chemistry was starting to blossom in America.

Barnes joined the firm of H.K. Mulford, a small but excellent pharmaceutical company that was already achieving some success in the invention of medications to treat a number of diseases. He stayed with Mulford long enough to recognize what might be achieved in a business of this kind and then, in 1900, traveled again to Germany, this time to the University of Heidelberg, where he stayed for four months. He focused again on pharmacology, and in his final research paper, he published the results of his experiments on the varying effects of morphine on frogs and rabbits. He then returned to Mulford, bringing with him an exceptional young German scientist, Hermann Hille, who had a doctoral degree from Heidelberg and had previously studied with Roentgen. The addition of Hille to the company proved to be a brilliant move. He and Barnes rapidly created an informal (later formalized) partnership: they would work together "after hours," with the goal of making products of their own, in an effort to capitalize on the burgeoning market for effective new medications.

To understand this demand, one has to remember that the United States — recognizing the fact that it had lagged badly behind Europe — was in the process of trying to catch up in science and medicine. The new University of Chicago had recently been founded (1892) and Johns Hopkins even earlier (1876); both institutions were primarily focused on graduate studies and research, rather than (as was traditional in America) undergraduate

collegiate education. Hopkins created a new medical school (which Henry James described in *The American Scene*). Meanwhile, a large donation in 1901 from J.P. Morgan helped to found the Harvard Medical School. Medical education began to move from the old "apprentice" model to a formal scientific-based model requiring concentrated study.

Finally, and very significantly, the Rockefeller Institute for Medical Research — later Rockefeller University — was created in 1901. It had no students and was entirely dedicated to research by the most talented scientists available. The goal was to undertake both basic and applied study in order to discover cures, primarily for infectious diseases. Interestingly, the newly born Institute was ridiculed by many professionals, because it seemed to represent the essence of what Benjamin Jowett (of Oxford) once vilified as "research, research!"

John D. Rockefeller, however, decided to take the long view: it was far more effective to discover the causes of diseases in order to cure them, rather than to try — rather haphazardly — to find a way of alleviating symptoms. Simon Flexner was persuaded to become the president of Rockefeller Institute for Medical Research (RIMR), and the dean of Johns Hopkins Medical School was enlisted as its director. The entire venture was funded by Rockefeller, and the Institute was soon (in 1904–1905) given a chance to prove its worth: an outbreak of cerebrospinal meningitis occurred in the New York area, resulting in about 3,000 deaths. By 1908, scientists at RIMR had developed a drug to cure the disease, and the reputation of the Institute soared. Other advances, relating to hookworm and syphilis, followed. Medical science was producing important results in the field of public health, and the power of pharmacological medications was finally making a mark in the United States.

It was into this milieu that Albert Barnes ventured in 1900. He soon suggested that he and Hille should work to create a silver compound that would be superior in several ways to silver nitrate, currently used as an antiseptic to cure a number of different infections. The difficulty with silver nitrate was that it caused serious irritation, and it often failed to penetrate tissue deeply enough to be fully effective. Hille experimented with a compound that could neutralize these defects, and after a number of months, he succeeded. Several experts provided testimony to the virtues of the new medication, which was given the name Argyrol. The effectiveness of the drug was reported (in May 1902) to the American Therapeutic Society (and was published in the Medical Record less than two weeks later).

Success was almost instantaneous. Hille and Barnes formed a legal partnership and (leaving Mulford) went into business for themselves. Hille's role was to manufacture Argyrol (a relatively simple process), and Barnes was in charge of publicity and sales. The partners had very little capital, but the entire operation was small, inexpensive, and comparatively uncomplicated. The business flourished quickly, not only because Argyrol proved to be gen-

uinely effective, but because of Barnes' genius for marketing. Armed with excellent professional testimonials he decided that he would advertise directly to physicians (often bypassing pharmacies) and would then use the additional testimonials of medical doctors to accelerate distribution. He also decided to tap the international market and soon traveled to Germany, England, Scotland, and Ireland in order to expand sales exponentially. He mailed countless circulars to physicians, dispensed samples, and, with his apparently inexhaustible energy, took advantage of every opportunity to promote the new drug. The results were stunning. Sales climbed from a total of about $100,000 in 1904 to a quarter of a million dollars within three years. Barnes was well on the way to becoming the formidable Dr. Albert C. Barnes, master of his own dominion. And it was clear that, within a few years, he and Hille could expect to be millionaires.

Before long, however, Barnes found (as he did repeatedly in his life) that formal partnerships or alliances were ultimately intolerable. He and Hille began to quarrel, and while it is impossible to sort out all of the reasons, it soon became clear that the two men were doomed to separate. Hille controlled the well-guarded secret of the precise way to manufacture Argyrol, while Barnes controlled not simply the marketing but also the financial books of the company. Under these conditions, it is perhaps not surprising that suspicions, quarrels, and (apparently) even threatened physical assaults began to characterize the relationship.

Efforts to forge an agreement to share information eventually failed. Barnes began a civil action against Hille in 1907, charging that he had acted irresponsibly with respect to the secret process for manufacturing Argyrol, and had withheld records of the firm's research activities. He asked that an injunction be issued, demanding (among other things) that the firm's assets should be disposed of through a sale. The injunction was granted, Barnes won the "bidding war" and bought Hille out. In the process, he gained access to the formula of Argyrol and all of its future profits. Since the product proved extremely successful as well as durable, Barnes emerged as very wealthy indeed.

Albert Barnes and Laura Leighton Leggett could hardly have been more different. Laura's family had considerable wealth and could trace its lineage on her father's side to seventeenth-century American settlers who had emigrated from England, while her mother's family also had early American roots. The Leggetts lived in an ample house in Brooklyn, staffed with a cadre of servants. Laura was charming and interested in music, although she was also strong-willed and thoroughly capable of managing household and family affairs. She is said to have been called "the boss" in her family, and it was perhaps this quality that enabled her to be an equal match for Albert Barnes.

In the summer of 1900, Laura and her sister Edith were staying with their mother at a hotel in Milford, Pennsylvania, a summer resort town. Barnes happened to be visiting a cousin in Milford and met Laura purely by chance. He was instantly attracted to her. She was twenty-five, he was twenty-eight, and — by the end of the summer — it was agreed that he would visit her in Brooklyn. Matters moved fast: by October, they had agreed to marry, and the wedding took place in June of the following year. The marriage lasted until Barnes died suddenly in 1951, at the age of almost eighty.

After a honeymoon in Europe, the couple moved into a rented house in Overbrook, Pennsylvania, an upper middle-class neighborhood just inside the border of Philadelphia. But soon afterward, Barnes' business success enabled him in 1905 to buy nearly three acres of land on the Philadelphia Main Line, in Merion, Pennsylvania. That was to be their permanent place of residence, and the couple set out to build a good-sized house on the property. Next door, there was a fifteen-acre plot of land with an arboretum that had been created by the owner, "Captain" Joseph Lapsley Wilson. The Rose Tree Hunt Club was close enough for Barnes to become a member. He appeared to be adopting the style of a conventional Main Liner: a large house, fox hunting, social events, and a leisurely marital existence with Laura. Given his temperament, however, this way of life was destined to pall very quickly. Barnes was often socially ill at ease — not at all suited to the local scene. His business was thriving, and it was clear that he needed new interests and activities to occupy his time.

One of these was an experiment that he was already trying in his small factory. He would set aside two hours every day devoted to the education of his workers, an education that was partly practical (intended to make their work environment as rewarding as possible) and partly intellectual (to introduce them to a series of major writers). An employee of Barnes, Mary Mullen (whose sister, Nelle Mullen, was also on Barnes' staff), was placed in charge of these "seminars," and the readings were more than challenging: a good deal of William James (including *The Principles of Psychology*), some John Dewey, Nietzsche, Bertrand Russell, Santayana, Tolstoy, and Roger Fry among others. The seminars met with mixed results. From Barnes' point of view, however, the experiment was absorbing and stimulating, and he began to consider ways in which he could expand upon it. When he started to collect, he placed a selection of paintings in his factory and used them as material for weekly discussion. The idea to create a different work environment became an important part of Barnes' education effort. His seminars were innovative, although they may well have had precedents that he encountered abroad. In England, some labor groups arranged for lectures or sermons to be given by itinerant speakers, and a very few others seem to have actually organized regular on-site sessions. For a variety of reasons, shoemakers had (since at least the eighteenth century) been more literate, more politically active, and more radical than

most other labor groups. In the November 1980 issue of *Past and Present,* Eric Hobsbawm and Joan Scott elaborated on this entire subject:

> Shoemakers working together in larger workshops were among those crafts (tailors and cigar makers are others), which developed the institution of the "reader" — one of the men taking turns to read newspapers or books aloud, or an old soldier being hired to read.[4]

Most of the readings seem to have consisted of newspapers, political tracts, and other books. In America, a tradition of "readers" in cigar factories emerged. It was centered in Florida and has been described in Araceli Tinajero's *El Lector: A History of the Cigar Factory Reader.* There may also have been analogous examples in the German workers' unions, which Barnes might have heard about during his time in either Berlin or Heidelberg. Whether he was in fact acquainted with any of these experiments is simply not known, but it is possible that (especially during the days of the labor union movement) practices of the kind were not uncommon in the general effort to bring education to ordinary workers.

Other educational experiments were of course taking place in America and England, although many of the American initiatives were aimed at strengthening the vocational skills of workers and a good number of the English undertakings were intended to enrich the "aesthetic" aspects of the lives of working-class people. In other words, Barnes' effort was part of a much broader development to inspire and "elevate" those who had few educational opportunities. Ultimately, the English approach (which had a great deal of influence in America) was the one that, at least in principle, coincided with Barnes' views. Art — and especially painting — was to be a primary means through which ordinary people might be educated, not only in "aesthetics," but in life itself. The initial ideas were democratic in nature, and the fundamental conviction was that all people — not simply a select few — were capable of understanding and responding to art.

John Dewey's influential book, *Democracy and Education,* was published in 1916, and its central ideas served to reinforce Barnes' own "experimental" views about education and life. The book's impact was so strong that in 1917 Barnes (at the age of forty-five) applied to attend Dewey's Columbia seminar and then actually did so. He was immediately drawn to the patient, kindly man himself, who soon became (and remained) an indulgent but also discerning and sometimes critical father figure for him. Dewey's philosophy mattered to Barnes, but he was also impressed by the older man's extra-

[4]Eric Hobsbawm and Joan Scott, "Political Shoemakers," *Past and Present* 89, no. 1, 1980, p. 71.

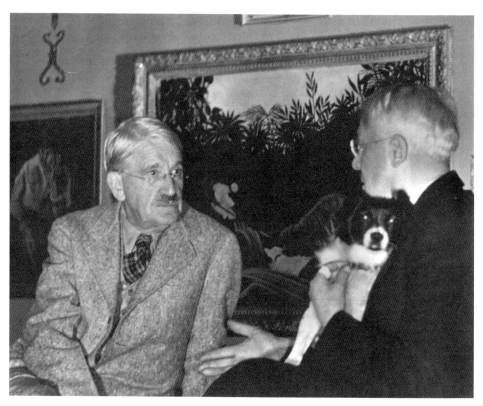

John Dewey and Albert C. Barnes (with *Scouts Attacked by a Tiger; Eclaireurs attaqués par un tigre* by Henri Rousseau), 1941
Photograph by Pinto Studios, Barnes Foundation Archives

ordinary national and international stature, combined with his solicitousness and open-handed friendship.

It was not long before Barnes invited the Deweys to visit Merion, and shortly afterward, Dewey (who was going with his wife to China and Japan on a lecture-tour) invited Albert and Laura to join them (which they were unable to do). Thus began a relationship that was to last for decades, despite the sharp differences in temperament between the two men. Dewey was clearly impressed by Barnes' intellect, energy, and deep commitment to learning as well as his knowledge of art. He also admired Barnes' genuine concern for democracy and "equal rights" for all people, including specifically African-Americans. Meanwhile, Barnes instinctively knew that he needed Dewey's approval (and guidance) to validate him, both as a person and as an aspiring educator. Symbiosis was the basis of the relationship between the two men, binding them together in an odd (certainly unpredictable) friendship in which each felt he had something important to give — and to learn — from the other.

When Barnes suggested to Dewey (in 1919) that he teach a course in aesthetics at Columbia, Dewey's counter was a challenge to Barnes to

undertake a similar venture himself. Barnes replied that he simply did not have the capacity to do so, but this must have stimulated him to undertake the study of aesthetics (and related fields) even more systematically, in order to develop his own ideas on the subject. As matters turned out, *The Art in Painting*, Barnes' first (and very substantial) book, appeared just a few years later, in 1925.

Meanwhile, Barnes' art collecting moved forward at such a pace that he no longer had room to accommodate his paintings in his house. In 1922, he persuaded his neighbor, Captain Wilson, to sell his fifteen acres of adjoining property, and Wilson's only condition was that the existing arboretum be well maintained. Laura, who had a strong interest in horticulture, readily agreed to do so. Now with a good deal of land to spare, Barnes quickly engaged the services of the architect, Paul Cret, to create an art gallery for his collection. Cret proposed two linked buildings — a gallery and a residence. The work was soon underway, resulting in the

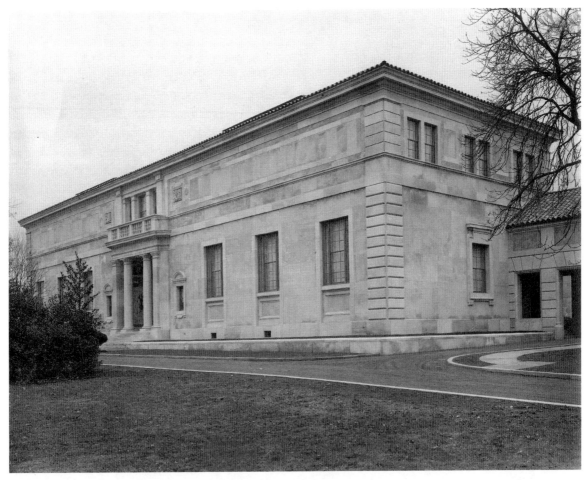

Gallery of the Barnes Foundation, 1925, Paul Cret architect
Photograph by Walter H. Evans, Barnes Foundation Archives

handsomely designed structures on Latch's Lane, surrounded by lawns and the arboretum.

It was at this time that Barnes, encouraged by Dewey, decided to create not simply a private art gallery or a museum, but an educational foundation dedicated to the study and appreciation of art — in the service of democracy — with the collection serving as "material" for lectures, classes, and courses. Barnes always insisted that, without Dewey's prompting, the Foundation would never have been created. By the end of 1922, the legal work had been completed, and the new institution, with total assets valued at $6 million, had become an impressive reality. During the same year, friends of Barnes at the Pennsylvania Academy of the Fine Arts asked whether they could present a show of his recent acquisitions at the Academy. Unexpectedly, Barnes agreed. A well-received exhibition of these same works (including some additional African sculptures) had been held at Paul Guillaume's gallery in Paris. Perhaps Philadelphia would also see the value of the art he was collecting? To pave the way, he wrote an "introduction" to the exhibition catalogue, explaining some of the artists' ideas and emphasizing the need to take them on their own terms.

Perhaps no exhibition from Barnes' "modern" collection would have been well received in Philadelphia in 1923, but there might have been a better chance had he focused only on Renoir and other more "established," relatively accessible modernists. Instead, the recent acquisitions (75 works) that went on display included nineteen Soutines (whose "wild" paintings were essentially unknown); five difficult Derains; and seven works each by Lipchitz and Modigliani (essentially unknown). Even a reasonably knowledgeable and open-minded audience would have been significantly challenged by the art displayed.

As it was, a storm of adverse criticism was virtually guaranteed. The paintings were "insane," morbid, unintelligible, and degenerate — and Barnes was labeled "a perverter of public morals." Indeed, the press was unsurprisingly unrestrained. In the Philadelphia *Record*, Francis Ziegler commented that the paintings were "debased art in which the attempt for a new form of expression results in the degradation of the old formulas;" the works were described as "trash." Soutine was particularly singled out for contempt by — among others — Edith Powell (in the *Public Ledger*): "Are we willing to look at the world with his eyes? Are we willing to give careful attention to what . . . seems to us diseased and degenerate? Is it a good thing to visit morgues, insane asylums, and jails?"[5]

Predictably, Barnes replied with blasts of his own. Wounded by the response, he took up arms against the philistines and wrote furious letters to the critics, though to no avail. As a tonic, he soon left for Paris in order to buy

[5]"Peale Portraits–Ultra-Modern French Art," *Public Ledger*, April 15, 1923, p. 11.

more art. But the exhibition was a watershed event for him. It strengthened his already strong view that Philadelphia's cultural institutions and many members of the Philadelphia public were ignorant, unserious, and snobbish. It encouraged him in his feelings that ordinary "museum-goers" were superficial. This response was predictable, but fatefully misguided, precisely because Barnes (together with Dewey) was in the midst of creating an educational foundation dedicated to democratic principles and values. It was not at all clear how his repudiation of much of "the public" and his simultaneous democratic impulse to embrace "the people" could ultimately be reconciled. Meanwhile, however, he was able to step back from the battlements at home and go abroad where he could find both a stimulus and a refuge. The new season was underway, and Barnes was very much in the mood to add to his fast-growing collection.

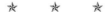

In pursuing his "vocation" as a student and collector of art, Barnes was relentless. He was ferociously competitive and decisive. He was both intellectually engaged and avaricious. He would use every lawful tactic available to acquire the art that he wanted, but he was also shrewd enough to wait when the price for an object was too high or when it was otherwise temporarily out of his grasp. He was in addition so determined to install the art in his gallery according to his own personal system that he would at times pass up masterpieces because they would not fit properly with the rest of his collection and its "hang."

Although Barnes could often be generous, neither friendship nor the spirit of good sportsmanship ever prevented him from acquiring whatever art he set out to obtain — almost always at the lowest possible price and often regardless of the implications for others (such as the artist Soutine, or his most faithful dealers, or other collectors). Nor would he lend any of his works of art, except on the rarest occasions, no matter how important or worthy the cause. In this and other respects, his faults were glaring, and his treatment of others often unforgiveable.

It would be a serious mistake, however, to overlook the extraordinary nature of what he accomplished, and a portrait of him would be altogether incomplete if it failed to note how admirable and impressive he was precisely because of his passion for art and education. This drive was so absolute that it had the effect of atoning for a great deal of what was abrasive and intolerant in him. In his autobiography, Sir Kenneth Clark (director of the London National Gallery from 1933 to 1946) captured, laconically, Barnes' main contradictions: "not at all an attractive character . . . [b]ut his passionate love of painting made him supportable."

That passion (described by Barnes himself as "almost an obsession") was consuming in its nature, and it compensated for a very great deal. Art not

only moved Barnes profoundly; it stimulated him and occupied him utterly from day to day and year to year, with scarcely any respite. To see art, to experience it, to purchase and possess it, to contemplate and commune with it, to study and teach and write about it — most of all to find ways to understand, describe, and assess it — were Barnes' unquenchable desires, and he was driven by them for the better part of four decades.

Barnes once criticized Picasso for his lack of "assiduousness," "single-mindedness and resoluteness," and inability to work toward "a single chosen end." The passage tells us much about Barnes and little about Picasso. For Barnes was often single-minded to the point of self-destructiveness and resolute in spite of virtually all consequences. Yet, there was something heroic about this: the tale of a man too inclined to battle the world without compromise on behalf of the art and ideas in which he believed.

Giorgio de Chirico, *Dr. Albert C. Barnes*, 1926. Oil on canvas, 36½ × 29 in. (92.7 × 73.7 cm). BF805

Several of these qualities emerge in photographs of him and in de Chirico's portrait (now hanging in the new Barnes building in Philadelphia). Indeed, Barnes looks unfailingly resolute and determined in virtually every surviving image of him. There are no informal, smiling moments. There is a steady gaze, with the jaw often rather taut and firmly set.

Barnes himself testified to the reasons for his complete dedication to collecting in a revealing passage published in his early essay "How to Judge a Painting:"

> Good paintings are more satisfying companions than the best of books and infinitely more so than most very nice people. I can talk, without speaking, to Cézanne, Prendergast, Daumier, Renoir, and they talk to me in kind. I can criticize them and take, without offense, the refutation which comes silently but powerfully when I learn, months later, what they mean and not what I thought they meant. That is one of the joys of a collection, the elasticity with which paintings stretch to the beholder's personal vision which they progressively develop. And that is universal, for a painting is justly proportionate to what a man thinks he sees in it.
>
> As a substitute for other pursuits, collecting, living with, and studying good paintings — the enthusiast believes — offers greater interest, variety, and satisfaction than any other pleasure or work a man could select. . . .
>
> A man with a house full of good paintings needs no subterfuge of excessive heat or cold to drive him north or south to get away from his own wearying self. Golf, dances, theaters, dinners, traveling, get a set-back as worthy diversions when the rabies or pursuit of quality in painting, and its enjoyment, gets into a man's system. And when he has surrounded himself with that quality, bought with his blood, he is a King.[6]

The passage is revealing on several counts. There is, above all, Barnes' declared aversion to "very nice people" as well as social events of many kinds — something that makes itself clear in the "Indenture" he wrote when creating his Foundation. There is also the sense of escape from one's own "wearying" — often embattled, pugnacious, and vituperative — self. Finally, there is the particular kind of power that the possession of great paintings can yield: bought in earnest "with blood" and supreme effort, one can be "a King." Indeed, "power" emerges as a word that Barnes often uses in relation to much of the art he collected and admired — whether in old masters, or in Cézanne, with whom he felt a particular kinship.

[6]*Arts and Decoration*, April 1915, pp. 248–249. BF Archives.

In discussing Barnes, vignettes are often as illuminating as analysis. There is his statement that, once having retired from his business, he would spend from two o'clock in the afternoon until well into the evening, every day, alone in the gallery with his paintings. There is his description of how his research was undertaken: he would travel abroad with a small entourage each summer and spend nearly every day standing in front of individual paintings and taking detailed notes that he would then revise and re-revise, in the vain quest to describe each part of every work objectively and scientifically. And his visits were legendary in other ways. His Parisian dealer Paul Guillaume gave his own (perhaps unduly warm) account (in *Les Arts à Paris*) of Barnes' 1923 excursion to France:

> Dr. Barnes has just left Paris. He has spent three weeks here, each hour not devoted to social calls, soirées, official receptions, but as one expects this extraordinary, democratic, ardent, inexhaustible, unbeatable, charming, impulsive, generous, unique man must. He has visited everything, seen everything shown by dealers, artists, patrons of art; he has bought, refused to buy, admired, criticized; he has pleased, displeased, made friends, made enemies.[7]

Guillaume himself was soon exhausted, but Barnes kept up the pace.

Guillaume's gallery was not only a sanctuary and place of respite, but an energizing milieu. Apart from many other comments that he made, Barnes once recalled a

> memorable argument with Waldemar George [that] lasted an entire afternoon. Before it was finished I had learned something about one phase of modern painting that I had never been able to understand from volumes of writing. On another occasion Jacques Lipschitz [sic] and I became so completely engrossed that I did not know until Paul Guillaume informed me later, that for a part of the time we sat on the floor of the gallery.[8]

In 1926, Guillaume visited the Barnes Foundation, and listened to Barnes lecture on African-American art:

> He has no notes; he stands, unpretentious, his glance envelops the audience, he speaks at once. — He goes directly to his subject. . . . His dialectic is insinuating, adroit, compact, direct; . . . His speech is, by turns, tender, angry, musical, harsh. . . . Dr. Barnes has spoken in this way for thirty or forty minutes; . . .[9]

[7]"Le Docteur Barnes," *Les Arts à Paris*, Jan. 1923, p. 1. BF Archives.

[8]"The Temple," *Opportunity*, May 1924, p. 140. BF Archives.

[9]"Ma Visite à la Foundation Barnes," *Les Arts à Paris*, May 1926, p. 8. BF Archives.

Albert C. Barnes lecturing to a class in the Main Gallery, 1942
Photograph by Pinto Studios, Barnes Foundation Archives

Barnes' circle of friends — as contrasted to acquaintances — was not large. Most of his close companions were associated with his world of art: Violette de Mazia, William Glackens, Paul Guillaume, John Dewey, and (intermittently) Leo Stein. Other people — such as Horace Mann Bond (president of the historically black Lincoln University) were clearly much more distant. But Bond never failed to credit Barnes' strong commitment to equal rights and equal educational opportunity for African-Americans, and his championship of the African-American cause (including his involvement in aspects of the Harlem Renaissance). Dewey applauded this commitment in his dedicatory speech at the inauguration of the Foundation, and shortly afterward, Charles Johnson — writing in *Opportunity* — added:

> Those who know Dr. Albert C. Barnes treat him as a valuable secret. . . . He was the first and is distinctly the last word in Primitive African Art and his pieces, the rarest of their kind — exquisite, exotic, distinctive—once casually valued at fifty thousand dollars, are becoming invaluable. . . .
>
> It was a prophetic vision, uncanny in its sureness, that prompted this connoisseur to encourage . . . modern painters by buying their pictures long before they felt the glimmer of a promise

of prominence and recognition. . . . The whole modern art move-
ment thus owes an immense debt to him, . . . Behind each convic-
tion [of Dr. Barnes] is a long, tireless, searching interest.[10]

The "long, tireless, searching interest" is part of what gives magnitude
to Barnes and his quest. Nothing less could have created his extraordinary
collection, or his five volumes on aesthetics and art criticism, or the Foun-
dation and its approach to art: in their totality, a unique and extraordinary
set of achievements of a man who entered the field of art late and found his
way through its many complexities by sheer force of energy, determination,
and acumen. Toward the beginning of this journey, in July 1914, he wrote:

> I have been reading and thinking . . . about art during the past
> three years [so] that it has become almost an obsession. . . . I have
> lived with my own two hundred paintings as constant companions
> and objects of study. . . . I find I am constantly changing: paintings
> which interested me and which I fairly loved a year or even six
> months ago now leave me cold. I have in the store-room of my
> house probably twenty paintings, many of which cost me consid-
> erable money and which were discarded because I think the per-
> sonal message of the painter was either insincere or his presenta-
> tion so bungling that it is not to be considered a work of art.[11]

Barnes' achievement was hard won. Much of his love of art often isolated
him and seems at times to have been a source of frustration and even pain,
while also keeping boredom and defeat at bay. In his correspondence with
Leo Stein, there is a relatively early letter in which Stein confessed how
lonely his life in Fiesole had become. Barnes replied:

> I read with interest your account of your lonely life, but you have
> very little on me in that respect. I have a business which takes but
> a couple of hours of my time a day, and when I finish with that, I
> go home to [my paintings]. I have absolutely no social life, and
> except for a few friends like Glackens and some of the other artists
> . . . , I am as lonely as you are. . . .[12]

Similar sentiments were later echoed in a letter to Alice Dewey:

> [I]t's a damned lonesome life, my most satisfactory adjustments are
> with artists and thinkers but as I don't live with such people, the

[10]"Dr. Barnes," *Opportunity*, May 1924, p. 133. BF Archives.
[11]Barnes to Leo Stein, July 17, 1914. BF Archives.
[12]Ibid.

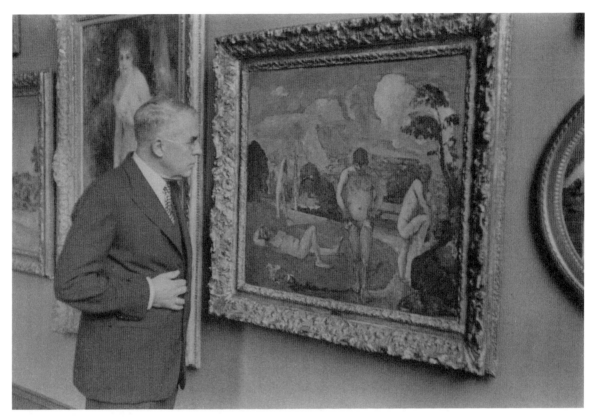

Albert C. Barnes (with *Bathers at Rest*; *Baigneurs au repos* by Paul Cézanne), 1932
Photograph by Pierre Matisse, Barnes Foundation Archives

life that touches me most deeply is the vicarious one with books, paintings, and music.[13]

Barnes' theories have long passed into virtual oblivion, and it is a rare day when anyone consults his publications. Yet the books he wrote still remain — oddly — impressive achievements. The installation of the art in his gallery may seem willfully eccentric, but it was obviously the result of an effort to embody an elusive form of harmony and coherence: a desire to lead students and visitors to an understanding of new constellations of order and meaning. If he and his life often resembled a battleground, art revealed a side that was poignant, touching, and indomitable:

When an artist has shown us a vision of things which profoundly stirs our emotions, he calls all our interests into harmonious play, which strips from material things all the accidents, irrelevancies,

[13]Barnes to Alice C. Dewey, September 20, 1920. BF Archives.

discrepancies with which they are usually encumbered, he has rebuilt the world according to his heart's desire, and the sense of mystical union ceases to be illusory, and becomes a realization of substantial fact.

* * *

3

Collectors and Collecting

Impressionist and Post-Impressionist Painting

Although countless books and articles have been written on the subject, it is still surprising to remember the extraordinary violence of public reaction to the modern art that emerged during the latter part of the nineteenth century and the early decades of the twentieth. Established conventions in Western art had of course been challenged and modified since the very early Renaissance, but those conventions had a good deal of resilience, and each new challenge was — relatively soon — accepted as part of an evolving recognizable tradition.

The late-nineteenth century challenge was different in significant ways. It struck at the very heart of received tradition, and the conflict was dramatized — in England at least — in the infamous 1878 trial in which James McNeill Whistler sued John Ruskin for defamation of his reputation as an artist. Whistler's *Nocturne* paintings — with their dark tonalities and barely visible objects — were ridiculed by Ruskin, and Whistler struck back. Ruskin's lawyer attempted to prove that Whistler's paintings were not "art," and in the course of his defense, he argued that legitimate art should contain recognizable images and details, carefully structured compositions, "realistic" paint colors, a high degree of "finish," and subject matter that could be accommodated within the long-established categories of portraiture, landscape, genre scenes, or history painting.

Whistler's *Nocturnes* possessed none of these characteristics, and they had affinities with the kinds of contemporary "impressionistic" paintings that were if anything even more controversial. The new painting appeared to repudiate, not simply established aesthetic conventions, but other fundamental values and traditions (particularly social and political) associated with the very order of society insofar as these were implicitly (or explicitly) embodied in art. To those who responded with so much outrage to "modern" painting, it was not simply a question of artistic styles that was at stake, but the apparent jettisoning of many societal assumptions and convictions.

Contemporary painters (including Monet, Cézanne, the Fauves and Picasso) introduced new modes of composition; the use of bold colors that were often unblended and vigorously applied to the canvas; and new ways of representing space. Moreover, traditional uses of light and shade were often ignored. In effect, the new painters gave art itself a new sense of autonomy by releasing it from the obligation to represent the real world in an immediately recognizable or "photographic" manner. Equally important, subject matter that had previously seemed intrinsically trivial, ugly, socially unacceptable, or simply inexplicable was suddenly admissible into the very precincts of sanctified aesthetic domains.

In the early years of the twentieth century, only a few commentators or critics were receptive to — and perceptive about — the enormous changes taking place, and they focused their attention on French impressionist and post-impressionist painting. The English critic Roger Fry, writing in 1910, was a leading voice among them, championing — above all — Cézanne and other post-impressionists:

> Anyone who has had the opportunity of observing modern French art cannot fail to be struck by the new tendencies. . . . A new ambition, a new conception of the purpose and methods of painting are gradually emerging: a new hope, too, and a new courage to attempt in painting that direct expression of imagined state of consciousness which has long been relegated to music and poetry. This new concept of art, in which the decorative elements preponderate at the expense of the representative . . . has in it . . . the promise of a larger and fuller life.[1]

Fry stresses the expressive and formal qualities of the new painting, in which the "decorative" (or "design") aspects are conceived as dominant. By moving to subordinate or even suppress the traditional role of representation, Fry was indicating how wide a gulf existed between contemporary artists and those who preceded them.

Willard Huntington Wright, one of the great proponents of modern art in America, suggested (in his 1915 book, *Modern Painting*) how the methodology of traditional painters differed from that of the moderns: with earlier painters, drawing came first, chiaroscuro second and color third. By contrast, he described a Cézanne as the locus for intense interaction among lines, colors, and other plastic elements, where all were conceived simultaneously as a single whole:

> Cézanne . . . understood how one slanting line modifies its direction when coming in contact with another line moving from a

[1]"Cézanne," *Burlington Magazine*, January–February 1910, p. 207.

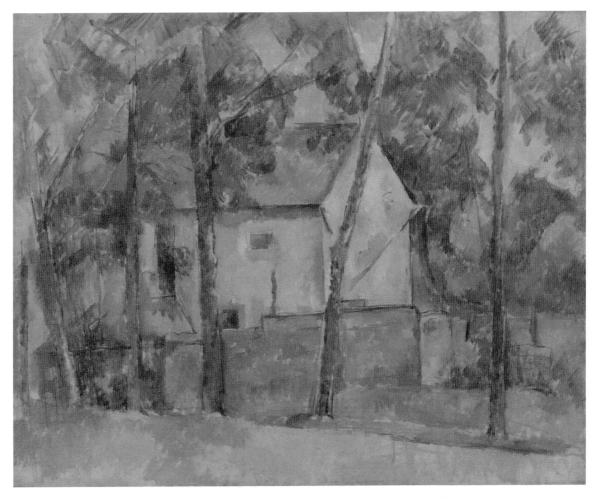

Paul Cézanne, *House and Trees*; *Maison et arbres*, 1888–1890. Oil on canvas, 25¾ × 32 in.
(65.4 × 81.3 cm). BF89
Acquired June 1913 from Ambroise Vollard, Paris, through Galerie Durand-Ruel, Paris

different direction. . . . [His] vision became a theater for the violent
struggles of some one line against terrible odds, for the warring
clashes of inharmonious colours. He saw in nature a chaos of dis-
organized movement, and he set himself the task of putting it in
order.[2]

Cézanne is said to begin with the "chaos" of nature, which is then trans-
lated into a dynamic — even warring — whole that depends upon the
ceaseless movement and interaction of lines and "inharmonious" colors. As a
result, a landscape or portrait by Cézanne was often seen — even by sensitive
critics — as "unfinished." The work was viewed as strong but crude — the

[2]*Modern Painting*, John Lane, London and New York, 1915.

product of an intense painter, but one who was "awkward" and who barely knew his craft.

Wright's volume on *Modern Painting* had begun with the recognition that modern art was largely a target of vilification, and he elaborated on this point in his introduction:

> Modern art has become a copious fountain-head of abuse and laughter, for modern art tends toward the elimination of all those accretions so beloved by the general public — literature, drama, sentiment, symbolism, anecdote, prettiness and photographic realism. This book inquires first into the function and psychology of all great art, and endeavors to define those elements which make for genuine worth in painting.[3]

Just as Fry saw the conventional representation of objects in painting as less significant than aesthetic design or form, Wright wanted to set aside all traces of the sentimental, "literary," symbolic, anecdotal, and "realistic." He intended to identify "those elements that make for genuine worth in painting" — a quest that Bernard Berenson had recently embarked upon, and one that was being pursued by Roger Fry, Clive Bell, and (later) Albert Barnes. What were the distinctive characteristics of modern painting — or indeed of all painting? Did they consist primarily of art's "formal" elements, as contrasted with its capacity to create recognizable images of people, objects, scenes, or dramatic events? These and other questions made clear that the modern movement would inevitably be concerned, not only with the making and criticism of art, but also with aesthetic theory. How should one define works of art, and how could one describe the ways in which art affects the viewer?

There was obviously no single voice — or even choir of voices — that could express what some of the young artists felt as they watched this venture into the realm of modernity. But the talented painter Vanessa Bell (wife of Clive Bell) described the impact of the 1910 exhibition of post-impressionist painters organized by Roger Fry at the Grafton Gallery in London:

> It is impossible, I think, that any other single exhibition can ever have had as much effect as did that on the rising generation. . . . Here was a sudden pointing to a possible path, a sudden liberation and encouragement to feel for oneself which were absolutely overwhelming. Perhaps no one but a painter can understand it and perhaps no one but a painter of a certain age. But it was as if one might say things one had always felt instead of trying to say things

[3]Ibid., p. 8.

that other people told one to feel. Freedom was given to one to be oneself.[4]

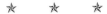

Given the widespread hostile reaction to modern art in the opening decades of the twentieth century, one may wonder how and why a number of pioneering American collectors, in particular, were converted to it — and, in a few cases, quite early. There is no single answer, but it seems clear that the main adventurers were largely guided by artists who were familiar with the Parisian scene. And in the case of the best critics, they too were often tutored by painters who served essentially as mentors.

Willard Huntington Wright's younger brother was a painter who had lived in Paris since 1907 and not only admired Cézanne but may have owned some of his watercolors.[5] Mrs. Potter Palmer of Chicago — an early collector of impressionist art — was a friend of Mary Cassatt, the American painter who had been living in Paris since 1874 and who accompanied Mrs. Palmer on a visit to Giverny — after which Mrs. Palmer began to buy Monet. Louisine Havemeyer was also tutored by Cassatt — who then won the trust of Louisine's husband, Henry Havemeyer. The result, in time, led to the creation of one of the greatest collections of modern art in America.

Other tales were not dissimilar. The expatriate American Steins — Leo, Gertrude, Michael, and Sarah — lived in Paris and quickly came to know not only many of the most important contemporary artists, but also their dealers. Albert Barnes was encouraged primarily by his close friend, the modernist American painter William Glackens, and John Quinn was a friend of the Irish painter Jack Yeats (as well as other artists). In short, while many factors were undoubtedly in play, the majority of the earliest American collectors (as well as slightly later ones such as Katherine Dreier) came to modern painting through artists who were closely attuned to what was happening in France and elsewhere in Europe.

Why American collectors should have entered the scene relatively early and why they amassed collections that were much larger and far more significant than any assembled either in France or England is a more difficult question. There were clearly some exceptional collectors in Germany and Holland (not to mention Shchukin and Morozov in Russia). But the Americans ultimately overshadowed all others — to such an extent that a disproportionate number of impressionist, post-impressionist, and early "modernist" paintings now hang on the walls of American museums from Boston to New York, Philadelphia, Washington, Chicago, and other cities.

[4]Frances Spalding, *Vanessa Bell*, Ticknor & Fields, New York and London, 1983, p. 92.

[5]John Rewald, *Cézanne and America*, Princeton University Press, 1989, p. 237.

Perhaps one reason for this phenomenon is the fact that, unlike France, America had no established tradition of high culture against which to rebel, and no sustained tradition of extraordinary achievements in the visual arts from the "classical" era of Poussin through at least the time of Ingres and Delacroix. In the United States, the major effort was to acquire what Europe and its neighboring countries already possessed. In archeology, this led primarily to Greece, Rome, Egypt, and Mesopotamia. In painting, it led, on one hand, to the acquisition of works by "old masters," and on the other, to the discovery and appropriation of the most recent work being created in France.

It was much more difficult for the French (and the French government) to rebel against their own established traditions than it was for America, in search of "culture," to reach out in any number of directions. Buying modern French art in America undoubtedly required the audacity and courage to go against the grain of all that was conventional in painting. But for certain adventurous spirits who had taste, money, a desire to make a mark, and a willingness to be tutored, the road was open and the possibility of creating collections (and even institutions) that were altogether new was in itself an exciting prospect. Gallatin hoped to create a museum, and during the early decades of the twentieth century, the modernist *Société Anonyme* and the Museum of Modern Art both came into being. Both were led by people of great energy and conviction who believed it was time not only to collect, but to "establish" modern art in U.S. institutions. If the spirit was not quite messianic, it was more than simply enterprising.

Some American collectors (such as Mrs. Potter Palmer) tended to concentrate on specific groups of artists as well as on individuals. Still others, including John Quinn, were exceptionally wide-ranging in their taste, often buying the most advanced work as it was being created. These differences provide a useful context within which to define the nature and goals of particular collections such as that of Barnes. Why, for example, did Barnes purchase such a disproportionately large number of Renoirs — and why did he turn away from Picasso when cubism became the artist's dominant style from about 1907 to 1914? To what extent were his purchases representative of his era, or quite original? How were his purchases related to his aesthetic and educational ideas? These are questions that cannot be answered without some reasonably broad basis for comparison. Providing an outline of such a context, and a brief review of a few major collections (dating from the late-nineteenth to the early-twentieth century) can shed light on Barnes' own approach.

By the middle of the nineteenth century, a new tradition of French landscape painting, largely nonclassical in nature, was beginning to establish itself. Its development was strongly influenced by a number of Dutch and English artists, perhaps none more than John Constable. A few of the so-called "Barbizon" painters — especially Corot, Théodore Rousseau, and Millet, as well as Daubigny and Diaz — achieved increasingly popular suc-

cess. Though the Barbizon painters were controversial in their own time, by the early-twentieth century their pictures seemed quite accessible (even traditional) in composition as well as in their indebtedness to old masters ranging from the Renaissance to Poussin and the French eighteenth century.

Although their styles varied, the Barbizon painters were all — to a greater or less degree — committed to *plein-air* painting, and they tended to ignore the traditional imperative to seek out "picturesque" subjects. Most were also concerned to capture the effects of light: "[W]ithout light," wrote Rousseau, "there is no creation;" it is "the secret of Prometheus."[6] Finally, it was their immediate contact with their natural (and rural rather than urban) surroundings that distinguished them as a group. "On . . . sad days, when the wind moans, it is grand and beautiful to walk," wrote Millet, "under the lofty trees denuded of their leaves, to see those poor beings twisted and tormented by the wind. . . . Or, when the sun has set, to watch the afterglow in the sky." Such direct encounters with nature as a vivid and enduring presence — not as a series of fleeting or momentary experiences — went far to define the Barbizon painters, and this characteristic was described by no one more persuasively than Rousseau:

> See all those . . . trees; I drew them all thirty years ago, I made all their portraits. Look at that birch over there; the sun lights it and makes it a column of marble, a column which has muscles, limbs, hands, and a beautiful skin, white and pallid. . . .[7]

Most collectors of the new French art turned first to these Barbizon painters. They were regarded as "challenging," but several of them exhibited regularly in the official Salons, and they gradually attracted an audience of strong followers (as well as a ready market). It was a clear departure, therefore, when Mrs. Potter Palmer — the *doyenne* of Chicago society — decided to buy "advanced" impressionist works with the advice of her friend, Mary Cassatt. In 1886, Cassatt had helped the Parisian dealer Durand-Ruel organize the first impressionist exhibition in the United States. Indeed, Durand-Ruel had been the dealer for — and provided support for — "his" impressionists since the 1870s, when the painters were misunderstood and widely ridiculed. And his several American exhibitions (except for the 1886 impressionist show) were unfortunately no more successful than his efforts in France or England.

The impressionists, as Roger Fry remarked, were as difficult for most viewers to interpret as Whistler's *Nocturnes* had been not many years before. The new pictorial language — and the very concept of "impressions" rather

[6]Robert Herbert, *Barbizon Revisited*, Museum of Fine Arts, Boston, 1962, pp. 62–63.
[7]Ibid., pp. 67–68.

than more "finished" pictures — disconcerted spectators who felt deprived of the clarity that more traditional images and techniques had provided.

It was Mrs. Palmer's special distinction to have perceived the quality of impressionism, which she quickly began to collect, as well as to promote. In the 1880s, she and her husband had purchased a number of works by Corot, Millet, and Daubigny as well as Delacroix, whom she particularly favored. But in 1891 on a journey to Giverny with Mary Cassatt, she was instantly captivated by the setting and by Monet's work. She bought seven of his paintings, as well as three Boudins and a Degas, before sailing home. Clearly, she was a determined woman with a great deal more than her share of self-confidence.

The following year she bought twenty-two Monets, four Sisleys, six Pissarros, two Millets, and another Delacroix. Moreover, her discovery of Renoir (long before the Steins or Barnes began to collect him) soon led to the acquisition of eleven of his paintings.

These daring early purchases were only a prelude to the ambitious plan Mrs. Palmer was developing for a large exhibition of modern French art at the great 1893 Chicago Columbian Exposition — one of the most important American cultural events of its time. She was a generative force behind the Exposition and emerged as its leading lady, wielding her power with natural if also self-conscious authority. Not surprisingly, she achieved her goals. A major show (organized by Sarah Hallowell) at the Fine Arts Palace of the Exposition, included 126 works lent in large part by individual American collectors and representing a range of styles. There were a good number of Barbizon paintings including Millet's already famous *Man with the Hoe*, as well as works by Corot, Diaz, and Théodore Rousseau. H.O. Havemeyer lent a Courbet, but Mrs. Palmer and other collectors (including Albert Spencer, James Inglis, Martin Ryerson and Frank Thompson) provided works by Monet, Sisley, Pissarro, Raffaëlli, Cazin, Manet, Renoir, and Degas. Some reactions to the exhibition were unsurprisingly negative: J.P. Morgan suggested that the selection looked as if it had been chosen by a committee of chambermaids. But Mrs. Palmer was undeterred. Although she bought much less robustly after the Exposition, her mark had been made, and she proudly continued to show her own personal collection in her Chicago mansion. While the Barbizon school of French painting continued to be popular (especially with wealthy collectors), a significant number of impressionist paintings had finally been exhibited in the United States in a highly visible and authoritative way. Impressionism was still far from generally accepted, but a number of individuals were given fresh impetus to buy examples of it, and their holdings proved ultimately to be far from inconsequential. Several American museums were their beneficiaries — none more fortunate than the Art Institute of Chicago. The Palmers played an active role in creating the museum (founded in 1883), and left a considerable part of their collection to it while encouraging others to emulate them.

✳ ✳ ✳

On the surface, the Havemeyers would not have seemed likely to take the lead in exploring and then embracing the next phase of experimental French art — one even more challenging than the impressionists. Louisine Waldron Elder came from a suburb of Philadelphia, and Henry O. Havemeyer had made an enormous fortune as the nation's leader in the sugar refining business. Louisine was highly intelligent and when they met she already had an emerging interest in art; Henry was a blunt man with a surprising penchant for Asian objects — including Japanese tea jars. They were married in 1883.

Louisine (like Mrs. Palmer) knew Mary Cassatt. Under Cassatt's tutelage, her taste developed quickly. In 1889, the Havemeyers made a trip to Paris, where Henry also came to trust Cassatt's judgment. His conversion from Dutch genre painting (which he greatly admired) to bold nineteenth-century French painting was not immediate, but once it happened, he responded with unusual confidence, buying a Courbet that very year (at the urging of his wife and Cassatt) — the first of what would eventually be thirty-five paintings by the artist. In 1894, he bought his first Manet, only to be pressed again by his two women companions to plunge further and deeper. At the New York Durand-Ruel Gallery, he soon purchased a number of stunning additional works by the artist including *The Balcony*, *The Bull Fighter*, *Bal de l'Opéra*, *Mlle Victorine in the Costume of an Espada*, and *The Alabama*, followed later by *The Dead Christ with Angels*.

By the last decade of the century, Cézanne was widely admired by his peers: Monet, Cassatt, and many other artists had purchased his work, and Maurice Denis had painted his *Homage à Cézanne*. But when the Havemeyers bought two fine Cézannes (from Vollard) in 1901, they were the first American collectors to do so; and they eventually owned eleven important works by the artist.

In spite of his enormous wealth, Havemeyer was anything but a spendthrift. He always bought carefully, with a trained eye. Vollard remembered showing him and Mrs. Havemeyer two Cézannes, one of which was a portrait of the artist's sister:

"How much?" asked Havemeyer.

"Ten thousand francs."

"Why ten thousand, when you are only asking seven for the other picture, which is just as important as this?" she asked.

"It's true," I said, "the two pictures are equal in a sense. But you must admit that in the portrait of the sister, there is that indefinable thing, *le charme*."

"So you want me to pay extra for LA charme?" said Mr. Havemeyer.

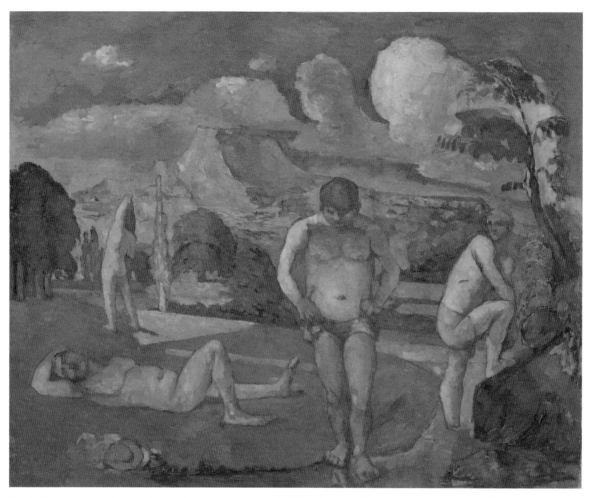

Paul Cézanne, *Bathers at Rest*; *Baigneurs au repos*, 1876–1877. Oil on canvas, 32⁵⁄₁₆ × 39⅞ inches (82 × 101.3 cm). BF906
Acquired March 1932 from La Peinture Contemporaine/Galerie Georges Petit, Paris

"LA charme" did not carry the day, and the painting was passed by.[8]

Over the course of the last decade of the century, the center of gravity of the Havemeyers' collection had shifted beyond the impressionists (Renoir, Pissarro, Sisley, and Monet), who by now were beginning to gain some acceptance among American audiences, to even more challenging artists such as Manet and Degas. In other words, the era of Mrs. Palmer's trailblazing had passed. By the time Henry Havemeyer died in 1907, the collection was widely recognized as the most impressive — in terms of both range and quality — in the United States. More than one museum

[8]Ambroise Vollard, *Recollections of a Picture Dealer*, Dover Publications, Mineola, NY, 1978, p. 141.

director expressed this view, and even the relatively young Albert Barnes was more than usually forthcoming. In a 1915 article ("How to Judge a Painting"), he wrote:

> Havemeyer's is the best and wisest collection in America. There are less old masters. . ., but that is more than compensated for by the large number of paintings by the men that make up the greatest movement in the entire history of art — the Frenchmen of about 1860 and later, whose work is so richly expressive of life that means most to the normal man alive today. One could study art and its relations to life to better advantage in the Havemeyer collection than in any other single gallery in the world.[9]

The Havemeyers collected for their own interest and enjoyment, and they never considered creating a permanent gallery or museum of their own. Mrs. Havemeyer determined that the works should go to the Metropolitan Museum; and if, at a later point, the Havemeyer children wished to add to the original bequest from their own holdings, they should do so. That is exactly what transpired, and by 1930, more than 1,900 works had been given to the Metropolitan — a gift that immediately made its collection of modern French art (and other extraordinary works) one of the strongest anywhere.

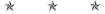

> When I recall those old times, I see on the walls at the Steins' paintings by Matisse and Picasso — certain *Nudes* by Cézanne and the marvelous portrait of Mme. Cézanne in a red armchair. This painting had once belonged to me, and I had lent it to a retrospective exhibition of the "Master of Aix," organized at the *Salon d'Automne* of 1905. Every time I went to the exhibition I saw the Steins, the two brothers and sister, seated on a bench in front of the portrait. They contemplated it in silence till the day came when, the *Salon* being closed, Mr. Leo Stein came in to bring me the price of the painting. He was accompanied by Miss Stein. "Now," said she, "the picture is ours!" They might have been ransoming someone they loved.[10]

Nearly everything about the Steins' art-collecting is revealed in this passage: the concentrated looking, the shared interests and determination, the will-

[9]Frances Weitzenhoffer, *The Havemeyers*, Harry Abrams, New York, 1986, p. 226.
[10]Vollard, p. 137.

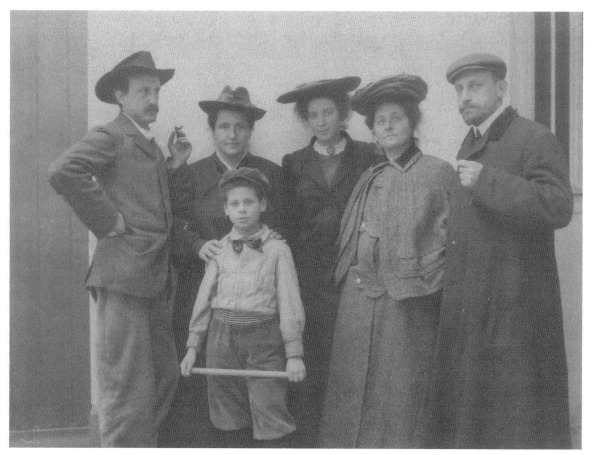

The Stein family: Leo, Gertrude, unidentified, Sarah, Michael, and their son, Allen, 1906
Photographer unknown, Yale Collection of American Literature, Beinecke Rare Book and
Manuscript Library

ingness to make bold purchases (no one else dared to buy the Cézanne portrait during the exhibit), and finally, the leading part often played by Leo.

The tale of the Steins has long since passed into the story of early-twentieth century art and art collecting. Clearly, they broke the implicit divide that had previously existed between nineteenth and twentieth century art. Although they collected Renoir (the artist lived until 1919) and certainly Cézanne — the single nineteenth-century artist who inspired so much twentieth-century painting — they led the way in buying and promoting Picasso and Matisse, as well as Juan Gris among others. The individual members of the family did not share precisely the same taste, but (for a considerable period of time) they did act in concert, with enough common purpose to enable them to make their purchases without many serious disagreements. Only later — when the Michael Steins devoted themselves fully to Matisse, Gertrude mainly to Picasso, and Leo substantially to Renoir — was there an obvious divide among them.

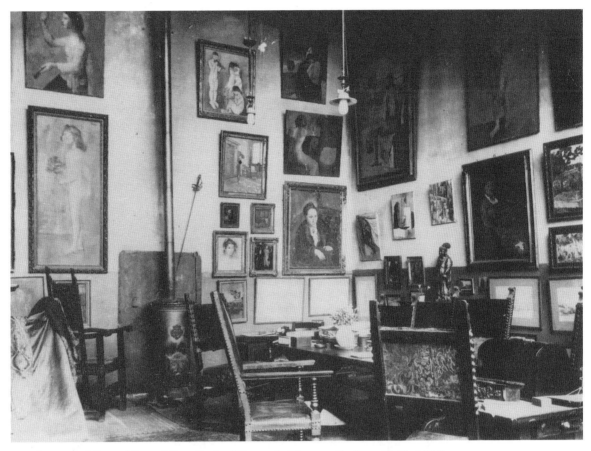

Apartment of Gertrude and Leo Stein, 27 rue de Fleurus, Paris, c. 1912–1913
Photographer unknown, Yale Collection of American Literature, Beinecke Rare Book and
Manuscript Library

It seems clear that Leo was the most broadly cultivated member of the
family, and — at least for several years — he had the best eye. In fact, from
about 1903 to 1907, it is not evident that there was another European or
American collector who was as astute. He was loquacious (occasionally to
the point of boring his friends), but he could talk knowledgably about any
number of subjects. He published two books on aesthetics and art criticism,
and although they are rather rambling, both volumes contain provocative and
incisive passages. His letters are also interesting: there is a good deal of (often
disputatious) correspondence with Barnes, a certain amount of common-
sense criticism of Dewey (and Barnes), and some brief but penetrating
remarks about a number of painters (especially Manet, Renoir, Degas, and
Cézanne).

Leo's real distinction, however, lay in his acumen and boldness, "discov-
ering" and buying the work of major artists early in their careers. Occasion-
ally, he bought works that he did not actually like, but that he nevertheless
understood to be of high quality. And he purchased perhaps more major (and

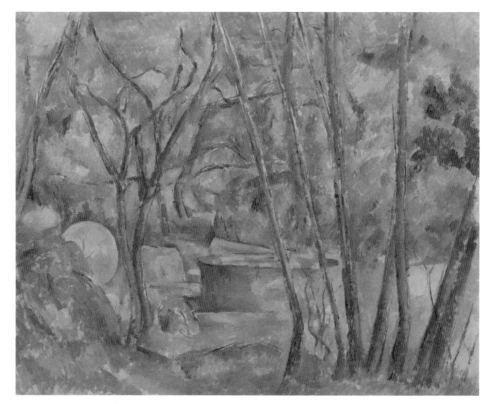

Paul Cézanne, *Millstone and Cistern under Trees; La Meule et citerne en sous-bois*, 1892–1894. Oil on canvas, 25⅝ × 31⅞ inches (65.1 × 81 cm). BF165
Acquired October 1924 from Ambroise Vollard, Paris

difficult) paintings than any of his immediate peers. In 1903, for example, Bernard Berenson advised him to visit Vollard specifically to see the works of Cézanne (which Leo did not yet know). By the time he left Vollard's shop, he had bought one painting (a landscape), and the following summer when he was in Fiesole, he spent a great deal of time (again at Berenson's suggestion) studying the Cézannes owned by Charles Loeser.

On his return to Paris, Leo began to take an interest in Matisse, and he was able to see a great deal, both at Vollard's one-man show (the artist's first) and at the 1904 Salon d'Automne. He did not immediately purchase anything but he found that Matisse had made the strongest impression on him, "though not the most agreeable."[11] By October 1905, however, on his return to the Salon, where Matisse's startling, vibrant *Woman with a Hat* was on view, Leo had strong reactions. First, he was repelled. Then, the painting struck him as more interesting. Then, after studying it for a few weeks, he suddenly decided to buy it.

[11]Margaret Potter ed. *Four Americans in Paris: The Collections of Gertrude Stein and Her Family*, Museum of Modern Art, New York, 1970, p. 25.

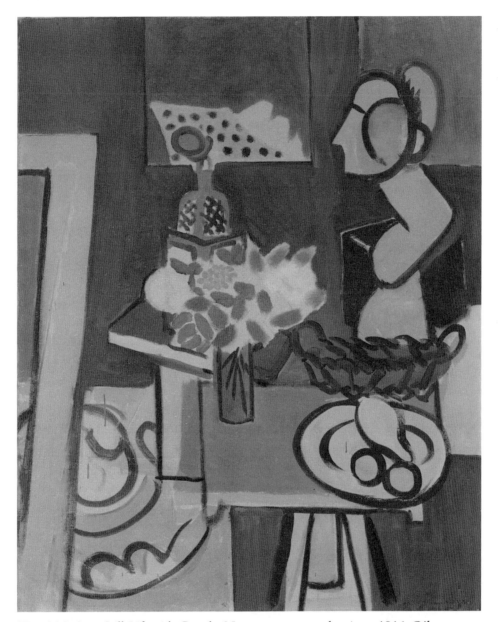

Henri Matisse, *Still Life with Gourds*; *Nature morte aux coloquintes*, 1916. Oil on canvas, 39⅜ × 32 inches (100 × 81.3 cm). BF313
Acquired between June 19 and August 3, 1923, probably from Léopold Zborowski, Paris, through Paul Guillaume, Paris

That same autumn, he heard about Picasso and first paid a visit to Clovis Sagot (Picasso's then dealer) and from there to the artist's studio. By the time he returned to his home at 24 rue de Fleurus, he had acquired his first Picasso — soon to be followed by a second. Meanwhile, other purchases were made: one evening, Leo found Picasso and Braque talking "about nothing except a Renoir they had seen" in a window on the rue

Royale.[12] Leo went to see it: "I looked and looked, and after a long while, I started toward home. But after a few hundred yards, I thought that the picture couldn't really be as beautiful as that — I must go back. . . ." The process of leaving and returning was repeated, until finally Leo went home and said to Gertrude, "I want you and Mike . . . to look at [the Renoir] tomorrow morning and if you like it, buy it," which they did. In the following two years, Leo made perhaps the boldest acquisitions of his life: the groundbreaking *Bonheur de vivre* which he bought from Matisse himself in 1906 — a work that had scandalized audiences at that year's Salon des Indépendents — and then, the powerful *Blue Nude* (as well as Picasso's large *Boy Leading a Horse*).

These purchases demonstrate Leo's superb connoisseurship in action. In the space of a very few years, he saw his first Cézannes, Matisses, and Picassos, and purely on the basis of his intuition and judgment, he bought works by all three, at a time when each was selling very little. Add Leo's slightly later important Matisse (and Renoir) acquisitions, and we see immediately how quickly — and with such acuity — the twentieth-century sound barrier was broken.

Of course, Leo did not accomplish everything on his own. But more often than not, it was he who did the exploration and discovery. Most of Gertrude's claims to "primacy," put forward in *The Autobiography of Alice B. Toklas* and *Picasso*, have been largely discredited. But she stood firmly behind Picasso long after Leo dismissed him (during the cubist period), just as Michael and Sarah Stein stood behind Matisse (long after Leo had chosen Renoir as the artist whose work he most admired). Regardless of how one decides to assign "credit" in the case of the Steins, however, they clearly went far in establishing much of the emerging modernist canon: Cézanne, Picasso, and Matisse as the secure foundation.

In reflecting on changes such as this, it is important to remember that the trailblazers were far in advance of the general museum-going or art-loving public. Many collectors — after the turn of the century — were still becoming acquainted with the work of the impressionists, and only a rather small number had ventured much further. Newspaper reviews continued to report the anger, incredulity, and even contempt expressed by visitors to exhibitions in Paris, not to mention Roger Fry's shows at London's Grafton Gallery in 1910 and 1912. The culmination of these exhibitions was the famous New York Armory Show of 1913, which, in spite of many sophisticated visitors, generated a great deal of fury and laughter on the part of the general public and the press.

A second point to remember is the extraordinary speed with which all the trailblazing changes in artistic styles, in taste, and in collecting were taking

[12]Leo Stein, *Journey into the Self*, Crown Publishers, New York, 1950, pp. 18–19.

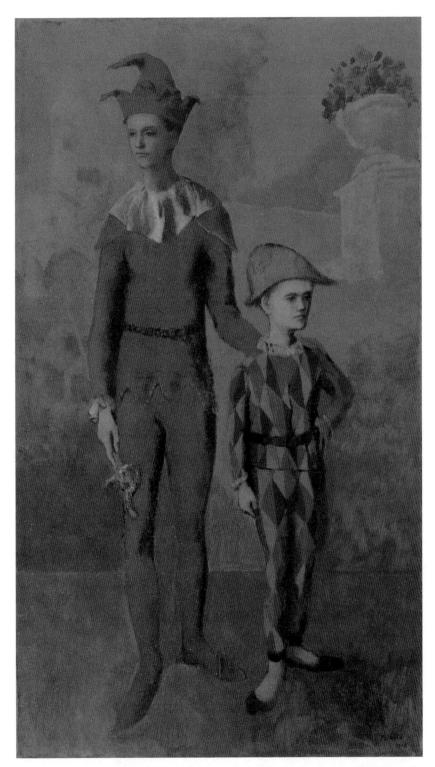

Pablo Picasso, *Acrobat and Young Harlequin*; *Acrobate et jeune Arlequin*, 1905. Oil on canvas, 75¼ × 42¾ inches (191.1 × 108.6 cm). BF382
Acquired October 1924 from Christian Tetzen-Lund, Copenhagen, through Paul Guillaume, Paris

place. Mrs. Palmer was breaking through the phalanx of Barbizon painters to the impressionists during the 1890s; the Havemeyers were buying Manet, Monet, Degas, and Cézanne from about 1890 through the early years of the twentieth century; and the Steins began buying in 1904, with the family "break-up" coming in 1913. In other words, all of these shifts in "advanced" collecting took place within the brief space of two decades, and — with John Quinn's arrival on the scene — the pace showed no sign of slackening.

In a letter to Henri-Pierre Roché, John Quinn wrote (in 1922),

> I buy art for the love of art, for the pleasure of helping artists, to have important examples of the work of artists in whom I believe, and because of my interest in art generally. I enjoy what I call the "rigor of the game." I always like to be straightforward and I dislike very much all indirection.

Quinn was a highly successful New York lawyer (who had interrupted his college years in order to be secretary to Charles Foster, governor of Michigan). He then earned a degree in law from Harvard. Unlike the Havemeyers or Mrs. Palmer, Quinn tended to operate on his own in all his major artistic and cultural activities, which included the creation of his rare book library, his substantial purchases of original literary manuscripts, his patronage of a wide variety of artists, and the building of his own vast art collection. Augustus John offered guidance in the early years, but Quinn soon began to chart his own path. Henri-Paul Roché later played the role of "introducer" to artists in France and of "agent" — but it was Quinn who mainly decided what to buy — not only in the case of individual acquisitions, but also in shaping and reshaping his collection.

During his earlier years — certainly before the 1913 Armory show — Quinn's activities and loyalties extended in several directions. A child of Irish immigrants, he was a strong supporter of Irish nationalism and the Irish literary revival: he knew William Butler Yeats, for whom Quinn once organized an American lecture tour, which provided considerable (and much needed) financial support. Yeats' brother — the painter Jack Yeats — was a friend, as were Lady Gregory and John Millington Synge, who were, of course, closely associated with the Abbey Theater.

In addition to his strong Irish friendships and commitments, Quinn was also a patron of American artists, including Walt Kuhn and Arthur B. Davies. He bought their work, befriended them, and, even after he turned most of his attention to European art, continued to make some purchases. Meanwhile, he helped numerous writers when they were struggling to make a living, including Joseph Conrad, many of whose original manuscripts he purchased.

Through his various connections, he vigorously sought publishers for T.S. Eliot's first volume of poems; for James Joyce's *Dubliners* and *A Portrait of the Artist as a Young Man*; and for Ezra Pound's volume of poetry, *Lustra*. Pound suggested that if thirty philanthropists were to agree to contribute $100 a year for five years, Eliot would be able to quit his job and concentrate on his poetry. Quinn immediately offered $300 a year. For this and other forms of support, Eliot felt so indebted that he insisted that Quinn should have the original manuscript of *The Waste Land*, which Quinn later bequeathed to the New York Public Library.

These and other acts of generosity went unheralded, as did his support of several painters and sculptors. He bought a large proportion of Brancusi's work and essentially kept the sculptor financially afloat at a time when few others were interested in him. Quinn helped (which he later partly regretted) the Vorticists and continued to buy Augustus John's paintings even when his admiration for John had cooled. In short, Quinn was (as others have emphasized) a patron as well as a collector, and — traveling to Europe — he came to know (partly through Roché) Brancusi, Picasso, Derain, Matisse, Joyce, Pound, Dunoyer de Segonzac, Braque, Rouault, Jacques Villon, and Marcel Duchamp. He relished this role as patron and friend and clearly enjoyed belonging to a cosmopolitan world of many of the greatest artists of his time.

Although he was thoroughly a New Yorker and an American, Quinn could not fail, at moments, to compare the (hardly typical) scene that he found in France with his own country: "I hate," he once wrote, "the primitivism of this country, its banality, its crudeness, the insanity of its ideas of speed, its lack of taste and the mechanization of life that is almost universal here."[13] The energy, competitiveness, and dynamism of the United States never ceased to engage him, however, although he finally decided not to leave his art collection to an American museum. Following his death in 1924, it was sold at auction.[14]

It is difficult to characterize Quinn's art collection because of its great diversity. He had personal commitments to the art of figures as different as Jack Yeats, Augustus John, Walt Kuhn, and Gwen John, quite apart from the French and other European artists that he came to know and admire. If we look at even a partial checklist of the works he owned, we find a good deal of Jacob Epstein (which Quinn came to regret); work by Gleizes, Wyndham Lewis, and Metzinger; and examples of Wright, Manolo, and Weber. Quinn's approach was quite explicit: he wanted major works by the best artists, but he also wanted to bet on new or promising painters who needed patronage.[15]

[13]B.L. Reid, *The Man from New York*, Oxford University Press, New York, 1968, p. 553.

[14]Ibid., p. 556.

[15]Judith Zilczer, *The Noble Buyer: John Quinn, Patron of the Avant-Garde*, Smithsonian Institute Press, Washington, D.C., 1978, p. 24.

He had been a clear leader in his bold purchase of Duchamp's study for the *Nude Descending a Staircase*, as well as his acquisition of many works by Duchamp-Villon, Henri Gaudier-Brzeska, and Severini. After the 1913 Armory show, however, he began to chart a somewhat different course. And from 1918 to the end of his life, he decided to buy only masterpieces "of museum quality."[16] In her invaluable study, *The Noble Buyer: John Quinn, Patron of the Avant-Garde*, Judith Zilczer noted that during the six-year period from 1918 until his death in 1924, the character of Quinn's collection was greatly influenced by his focus on the art of Brancusi, Cézanne, Matisse, Seurat, Picasso, and Henri Rousseau.[17] In this regard, we should not forget that Quinn was an exact contemporary of Barnes. From about 1912 to 1924, the two collectors were obvious rivals, but Quinn's reach far exceeded that of Barnes (even though he had only the relatively modest resources of a lawyer's salary at his disposal).

At its best, Quinn's collecting was notable not simply because of his commitment to major artists, but also because of the depth of individual "concentrations" and the daring quality of individual acquisitions. Unlike Leo Stein and Barnes, Quinn continued to buy Picasso through the cubist period and beyond. And in the case of Matisse, his eye was particularly astute: he bought the sketch for *Music* (previously owned by the Steins), *The Blue Nude* (also originally owned by the Steins), *The Cyclamen* (1911), the complex *Italian Woman* (1915), and more than three dozen other works. Meanwhile, Quinn acquired an extraordinary group of pointillist Seurats (regarded at the time by many other collectors as "mechanical"), including *Les Poseuses, Temps gris à la Grande Jatte, La Poudreuse*, the magnificent *Circus* (which Quinn bequeathed to the Louvre), as well as several drawings.

At the time of his death, Quinn's collection numbered more than 2,000 pieces, and an incomplete inventory reveals at least twenty-seven Brancusis, four Gauguins, four Gris, thirty-five Matisses, ten Seurats, twenty-one Derains, five Cézannes, four Braques, four Duchamps, nineteen Duchamp-Villons, twenty-seven Picassos, seven Severinis, one Douanier Rousseau (the great *Sleeping Gypsy*), ten Gaudier-Brzeskas, one van Gogh, one Manet, and a wide selection of small groups (or "singles") including those by Segonzac, Renoir, Redon, Pascin, Jacques Villon, Daumier, Delaunay, Dufy, Fantin-Latour, Laurençin, Puvis de Chavannes, Rouault, Diego Rivera, Toulouse-Lautrec, and Vlaminck.

Lists of acquisitions are invaluable guides, but in some cases, anecdotes are equally informative: in an article in *The New York Times Magazine* of January 3, 1926, Sheldon Cheney described a visit to Quinn's apartment:

[16]Ibid., p. 50.

[17]Ibid., p. 50.

It was an evening some three years ago that I first went to see some of the treasures that were piled apparently without rhyme or reason against the walls, under the beds and in unexpected nooks and corners. . .

What would I like to see most? Well, the one-man Matisse show had been a bit of a disappointment, and I would like to see some of his earlier work. Right then and there my faith in Matisse was fully restored, for the whole pageant of his accomplishment was set before my eyes.

Picasso I had seen only in snatches. So we adjourned to what had been a bedroom, through corridors choked with canvases and sculptures, and from a most unlikely looking corner were drawn a dozen paintings that simply swept me off my feet. Here was Picasso of the Harlequins, Picasso of the "blue period," Picasso the Cubist (and all Cubism rose in my estimation), Picasso painting great sculptural women. . . . All this shown to the accompaniment of John Quinn's quiet enthusiasm, made up an experience which is perhaps my most vivid memory out of all my encounters with art.[18]

Quinn's accomplishment was more than impressive. As an entrepreneur he had pressed to create the 1913 Armory show of "modern" art. Indeed, he lent more works to the controversial exhibition — and bought more from it — than any other individual. In his collecting, Quinn constantly moved forward into new areas. He liked the challenge that Seurat and the Duchamps posed, he took his chances with cubism, and he wagered on any number of artists who were sometimes superb and sometimes superfluous. Alfred Barr — in conversation with B.L. Fried — called Quinn the most outstanding collector of modern art of his era, and Frederick James Gregg wrote — in the *New York Sun* of July 29, 1924:

John Quinn . . . was probably the greatest collector of the arts of his time. It was not his way to wait until men's reputations were made before buying their work. He bought the pictures, sculptures and manuscripts of many whose names, when he made the venture, were known to but few but whose eminence is now undisputed. What was caviar to the general was sure to please John Quinn, provided it had in it the substance of genius.

<p align="center">✳ ✳ ✳</p>

[18]Reid, pp. 650–651.

Barnes as a Collector

Even a modest introduction to Barnes' full career as a collector would take, not a single chapter, but many. His interests were catholic and adventurous, including African sculpture, Asian art, early American decorative arts, American painting, classical Greek, Roman and Egyptian objects, Native American ceramics and weaving, and a modest selection of old master paintings. Objects from some of these cultures and time periods were installed in the permanent gallery; others in the residence building or his early American farmhouse, Ker-Feal. Barnes had an excellent eye and although some of his choices were far better than others, the best were clearly superb.

In the following pages, only a brief résumé of Barnes' chief collecting areas is offered, focusing mainly on those few artists — Renoir, Cézanne, Matisse, and Picasso — in whom he was highly invested, while others (such as Soutine, de Chirico, Lipchitz, and Modigliani) are considered in less detail. The intention is to provide only an outline of how Barnes viewed — or assessed — the major painters with whom he was preoccupied, to give some account of his acquisitions at various stages in his career, and to place him within the context of the other collectors discussed previously.

We know from various sources that Barnes showed an interest in art from an early age and that he tried his hand at drawing and even painting during his years at Central High School. Later, as he began to prove successful in business, he turned to collecting. With the guidance of his friend, the artist William Glackens, Barnes' taste developed quite rapidly, and he eventually focused on some impressionist but mainly post-impressionist painters. By early 1912, he had decided to start buying in earnest, with the explicit aim of building a major collection. He asked Glackens to make a trip to Paris on his behalf, gave him a $20,000 budget, and delegated to him all decisions about what to acquire (although Barnes later disposed of some of Glackens' purchases). In February 1912, Glackens — in the company of Alfred Maurer, who knew the Parisian art scene well — began to visit the leading dealers. He soon discovered that, in spite of the controversial reputation of a number of "modern" painters, market values had risen faster than he had expected: Renoirs were commanding high prices, and he wondered how successful his mission would prove to be. With Maurer's help, however, two weeks of pavement-pounding yielded thirty-three acquisitions, including van Gogh's superb *Postman*, five Renoir paintings (plus four lithographs), a Picasso, two Sisleys, a Pissarro, a Cézanne landscape, and two of his lithographs. As a result, under the guidance of Glackens, the beginning of a groundbreaking collection was in the making, and Barnes was on his way.

The moment marked an important point in his career. He began to study his new works in great detail, discussing them with Glackens and other artists, searching for a method that would help him to analyze works of art

and make judgments about them. The quest would last considerably more than a decade, but this early encounter with post-impressionism made a deep and lasting impression on him; from that moment forward, he was committed.

By the summer of 1912, within a few months of Glackens' return, Barnes was ready to do his own buying, and he set off for Paris. Later trips included Florence, Madrid, Berlin, and London. He wanted to learn as much as he could about the Italian Renaissance, the Spanish old master tradition, and whatever else he might discover in many of the major galleries and museums of Europe.

He took with him a selection of the writings of Julius Meier-Graefe, the German critic whose important book *Modern Art* (first published in 1904, then in English by 1908) contained much of his theoretical thought. He stressed the need to look at art not "vertically" (in terms of its immediate social, historical, and similar contexts) but "horizontally" (in terms of its relationship to other art from other cultures, freed from the constraints of time and space). Meier-Graefe's emphasis on the formal characteristics of art — and their universality — anticipated by two decades some of the ideas put forward by Barnes in *The Art in Painting* (1925), and it is difficult

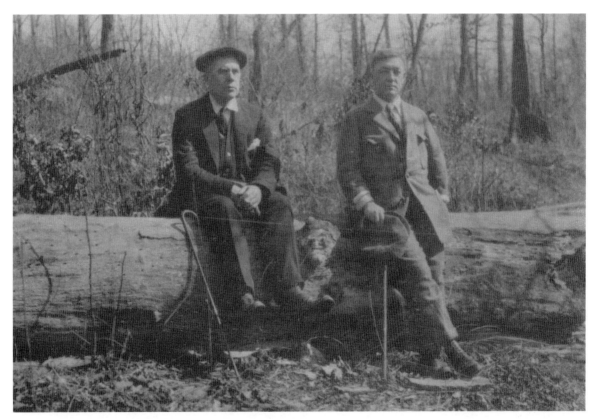

Albert C. Barnes and William James Glackens, c. 1920.
Photographer unknown, Glackens Family Photographs, Barnes Foundation Archives.

to imagine that Barnes was not influenced by the German critic. But far from acknowledging any debt, he later wrote that he found Meier-Graefe to be little of use.

Barnes was also less than generous to Bernard Berenson. We know that he read Berenson's volumes on the Italian Renaissance with their discussions of line, color, space, form, and tactile values. Barnes described Berenson as a "skilled diagnostician," but by the time he published *The Art in Painting*, he offered his own analysis of a good number of Italian old masters, including Fra Angelico, Botticelli, Leonardo, and others. His conclusions usually contradicted (and were invariably inferior to) Berenson's. He had undoubtedly learned a good deal from the master connoisseur, but (as in the case of Meier-Graefe) he found it impossible to acknowledge the fact.

In Paris, Barnes arrived with some introductions. He visited the Steins at 27 rue de Fleurus and — except for a very sympathetic encounter with Leo Stein — neither his initial evening at their salon, nor his later visit to Michael and Sarah Stein could — in personal terms — be described as a success. In temperament, manner, and style, Barnes could hardly have been more different from this Parisian expatriate colony. He asked Gertrude Stein how much Picasso's portrait of her had cost (and was stunned when told that it was a gift from the artist). He asked Michael and Sarah Stein the price of some of their Matisses, and when told that they were not for sale, he registered bewilderment. When he visited dealers, he gave the impression that money alone could enable him to acquire whatever he wanted — seriously misunderstanding the subtly personal and selective ways in which Durand-Ruel and Ambroise Vollard actually operated. But his wealth and his readiness to purchase a large number of works ultimately allowed him to gain *entrée* to the best galleries, since the market for post-impressionist art was still limited. Although Cézanne's genius, for example, had at last been widely recognized in France, a great deal of controversy concerning the style and quality of modern French painting still existed. Barnes' willingness to buy heavily and frequently turned out to be very important to the galleries and, of course, to the artists as well.

Thanks to recent scholarship, we now know a great deal about what Barnes collected, including the dates of many of the purchases. In 1912, in addition to the works bought by Glackens, he personally acquired twenty paintings, including four Renoirs (*Torso, Girl with a Jump Rope, Woman with Bouquet,* and *Woman Crocheting*), three Bonnards, seven small Picassos, a van Gogh, two Matisses (purchased from the Steins), a Gauguin, and works by Daumier and Pissarro. By far his most important acquisitions, however, were six Cézannes — some from the famous collection of Henri Rouart and others through Vollard (including a still life, a portrait of Madame Cézanne, and a small oil sketch of five bathers, for which he paid more than twice the estimated auction price, to the amazement of the audience). He went on to buy several other paintings and soon became an important

presence in the Parisian art market. While he was sometimes characterized as a kind of American madman, he got the works that he wanted and in the process stimulated French dealers (and collectors) to reconsider what they might charge (and pay) for contemporary works by the best French painters.

In March 1913, less than a year after his first visit to Paris, Barnes wrote to Leo Stein that he had already bought about a dozen Renoirs, saying that one could never have too many. By the end of 1914, he had twenty-five Renoirs, a dozen Cézannes, and twelve pre-cubist Picassos. He knew his way around and was becoming increasingly clear about the nature of the collection he wanted to build. When Vollard was asked whether Barnes had real taste as a collector, he replied:

> Mr. Barnes comes to see you. He gets you to show him twenty or thirty pictures. Unhesitatingly, as they pass before him, he picks out this one or that one. Then he goes away.
>
> In this expeditious fashion, which only a taste as sure as his made possible, Mr. Barnes brought together the incomparable collection which is the pride of Philadelphia.[19]

Renoir — greatly admired by both Leo Stein and Glackens — was to become the mainspring of Barnes' growing corpus. Cézanne would be an important presence; Matisse holdings would grow more slowly; the Picasso purchases faltered after the painter's move into cubism, where Barnes (like Leo Stein) was clearly unwilling to follow. In evaluating Picasso's cubist work (and that of others), he wrote:

> The idea of abstract form divorced from a clue, however vague, of its representative equivalent in the real world, is sheer nonsense. In cubistic paintings that move us, there are always sufficient representative indications, as well as reliance upon traditional resources of painting, to stir up something familiar in our mass of funded experience. . . . The great majority of cubistic paintings fail in this respect and, as a result, they have no more esthetic significance than the pleasing pattern of an oriental rug.[20]

For Barnes, in short, much of cubist painting was indecipherable and no more than mere design. While even the most complex "analytic" cubist paintings do in fact contain clues to objects in the real world, Barnes either

[19]Vollard, pp. 138–139.

[20]Albert C. Barnes, *The Art in Painting* (first edition 1925, revised and enlarged 1928, 1937), Harcourt, Brace & World, New York, 1965, p. 357.

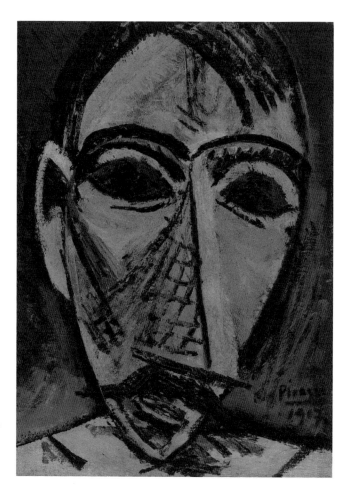

Pablo Picasso *Head of a Man*; *Tête d'homme*,
1907. Oil on canvas, 13 × 9½ inches
(33 × 24.1 cm). BF419
Acquired by 1926

ignored or simply dismissed them. As a consequence, the last Picassos in his
collection included a few very fine studies of "African" mask-like heads
related especially to *Les Demoiselles d'Avignon* and — surprisingly — three
small cubist pictures from 1911 to 1915: two of musical instruments and the
third a still life.

In his later years, Barnes softened his verdict on cubism (adding a few
examples by Braque and Marsden Hartley), but not in such a way as to signif-
icantly affect his collecting. His attitude toward Picasso's subsequent develop-
ment remained largely negative. He saw the artist as "impulsive," constantly
changing styles, without "devotion to a single purpose," as if perennially
engaged in a series of false starts. Barnes attributed this "failure in integration"
to a fatal flaw in the artist's personality or character, which he believed lacked
"resoluteness" and "wholeness." This psychological interpretation — shifting
from the perceived nature of the works of art to the personality of the artist,
and back again — clearly rested on weak assumptions. Since Barnes paid no
detailed attention to biographical material, his arguments remained purely
tautological: the character of the painter was deduced from the nature of the

Pablo Picasso, *Head of a Woman; Tête de femme*, 1907. Oil on canvas, 18⅛ × 13 inches (46 × 33 cm). BF421
Acquired by 1926

paintings, and the paintings were in turn seen as evidence of the artist's personality. This circular reasoning was more than a minor lapse on Barnes' part. In view of his consistent emphasis on psychology, the naiveté of his approach constituted a major problem for his entire system.

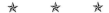

Once Barnes' initial bearings as a collector were established, acquisitions continued at an even faster pace. By 1916, the number of Renoirs had grown to sixty and works by Monet, Sisley, Pissarro, Daumier, and Bonnard had also been acquired. Meanwhile, he developed a taste for Spanish old masters, especially El Greco, who became an important presence in the collection.

In 1920, the extraordinary post-impressionist collection assembled in Amsterdam by Cornelis Hoogendijk came up for auction, and Barnes managed, with the help of Durand-Ruel, to secure thirteen superb Cézannes. He later wrote to Dewey that he now owned more than 100 Renoirs and that his collection of 50 Cézannes was "the best in the world."

Barnes recognized the absolute quality of Cézanne's achievement, just as a number of other collectors, art critics, and especially painters had done. But there were other — more complex — factors that emerged in his 1939 book on the artist. The book's style is systematic (indeed ponderous to a fault). He described what he believed to be the main components of Cézanne's art, the influences upon him, and his influence upon other artists — in a methodologically rigid, unimaginative way. But there are interesting (sometimes illuminating) passages in the analyses of individual paintings, as well as in his attempt to summarize the fundamental characteristics of the work:

> The term which most accurately describes Cézanne's form is architectonic. The characteristics which are absolutely indispensable in architecture — solidity, weight, equilibrium, the balance of forces — are those which are most in evidence in his work.
>
> The departure from representative detail of figures and objects, necessary to obtain the basic architectonic character of Cézanne's design, is often so extreme that the inevitable result is gross distortion of naturalistic appearances which shocks the uninitiated observer. The distortions, however, when studied in relation to the form, are perceived to be abstractions of the essentials of objects ingeniously merged into a harmonious, highly individual total design.[21]

Such "harmony" — or integration — among all the component parts of a picture constituted Barnes' concept of "plastic form." In Cézanne's case the primary characteristic (particularly in his portraits) was one of "power, dignity, and majesty" — values that suggested "Rembrandt, brought down to modern times."[22] In *The Card Players*, Barnes stressed again the values of "coherence, order, power, and drama,"[23] with "power" as the essential quality. "Cézanne's enduring concern with power achieved through dynamic space-composition" (in a late painting such as *The Large Bathers*) revealed a "richer plastic vision and a wider range of human values" than he had ever attained before.

The fact that Barnes placed particular emphasis on Cézanne's "power" is revealing. In his chapter on "Cézanne's Life and Personality," Barnes also stressed the artist's "concentration of purpose, his capacity to undergo endless labor and hardship, his self-imposed isolation, and his renunciation of every interest that could have detracted from his singleness of mind."[24] He had

[21]Barnes and de Mazia, *The Art of Cézanne*, Barnes Foundation Press, Merion, Pa., 1939, p. 4.

[22]Ibid., p. 13.

[23]Ibid., p. 89.

[24]Ibid., p. 106.

Paul Cézanne, *Still Life with Skull; Nature morte au crâne*, 1896–1898. Oil on canvas,
21⅜ × 25¾ inches (54.3 × 65.4 cm). BF329
Acquired July 1920 from Paul Rosenberg, Paris, through Galerie Durand-Ruel, Paris

earlier criticized Picasso for his lack of resoluteness and of devotion "to a
single purpose." In Cézanne, he had found a man (like himself) of unwaver-
ing, relentless determination to achieve his goals. He highlighted the similar-
ity even more clearly in describing Cézanne's social awkwardness and his
complete unwillingness to conform to the world's (or society's) conventions.
"The strangeness, the departure from conventions, the distortions in
Cézanne's paintings are, psychologically, akin to his behavior in social life;
what his whole career, no less than his work, proclaimed to the world, might
justly be given expression in these words: 'I won't conform, I'll interpret
imaginatively, my hand will put down what my eye, experience and feelings,
all working together, say is real, sincere, myself.'"[25]

Barnes' conception of himself was complex, but he was, like Cézanne,
completely identified with his work — impervious to any distraction from
the seriousness of his efforts to collect, analyze, teach, and write about art.
He would not "conform" because he wanted above all to be sincerely,

[25]Ibid., p. 107.

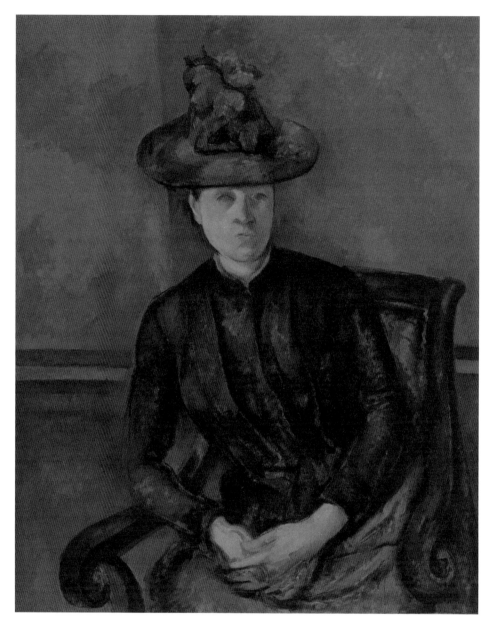

Paul Cézanne, *Madame Cézanne with Green Hat; Madame Cézanne au chapeau vert*, 1891–1892. Oil on canvas, 39½ × 32 inches (100.3 × 81.3 cm). BF141
Acquired April 1915 from Galerie Durand-Ruel, Paris

authentically "himself." The point about Cézanne in Barnes' view was that the "deformations" in his painting were

> akin to his brusque remarks . . . which, when sociability is the rule,
> project new interpretations upon conventionally accepted ideas,
> . . . The significant fact is that when he made these remarks, or
> dressed badly, or secluded himself, [other painters, such as Renoir

or Monet] did not utterly condemn it; when he put into painting the psychological equivalent of this social strangeness, they admired it, saw in it a personality doing and revealing something new, individual, fundamentally significant, with the very subject matter, technique, independent spirit, honesty, sincerity, which they looked upon as their very own. They prized it so much that persecution by either critics or public never swerved them.[26]

Barnes was nothing if not "brusque" and — in many ways — unsociable, as well as often secluded within the confines of his own realm. He also conceived of himself as an unconventional "independent spirit" whose "honesty, sincerity," and similar qualities enabled him to withstand the ridicule and "persecution" that he (and his art collection) suffered from critics and the public alike. In short, Cézanne provided Barnes with an exemplar — a similar spirit who triumphed and was finally vindicated in spite of his estrangement from so much of society, from its conventions, and from its hostility.

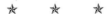

In 1920, Leo Stein was short of funds and sought Barnes' advice about the value of his own paintings, of which the most important were sixteen Renoirs. Leo (who was living in Italy) was unaware that the artist's market value had risen significantly, and he also believed that the value of his own examples might be rather slight. After some delay, Barnes wrote to Leo that he had made careful inquiries and discovered that the Renoirs were indeed less important than he had remembered. He suggested that he could manage to have the entire group purchased for $30,000, or an average of about $2,000 per picture. Leo accepted the offer in 1921. After acquiring Leo's pictures at this very modest price, Barnes kept the best for himself, including *Cup of Chocolate*, which Leo valued among his most prized possessions.

In the following year, more important purchases were made. But Barnes' most significant acquisition was unquestionably Matisse's *Bonheur de vivre*, which (originally ridiculed by both the public and the press) had earlier been purchased by Leo Stein in a very bold move. By the time Barnes acquired it (from the Danish collector Christian Tetzen-Lund), the painting was recognized by the most perceptive critics as a major turning point in Matisse's career.

Other purchases cascaded into the collection in 1922: Renoir's *Children on the Seashore*, Matisse's *Three Sisters*, another Cézanne, forty ancient Greek and Egyptian sculptures, and three European "old masters." In 1925 he acquired *The Card Players*; in 1926, Seurat's *Models* and Matisse's *Interior with*

[26]Ibid., pp. 107–108.

Goldfish. Meanwhile, Paul Guillaume had been cultivating Barnes. He was knowledgeable about African art and the work of emerging artists such as de Chirico, Soutine, Modigliani, and Lipchitz. These represented new territory for Barnes, but he responded with insight and enthusiasm to much of what Guillaume showed him.

His "discovery" of Soutine was perhaps the most dramatic example. Barnes encountered a painting by the artist for the first time at Guillaume's gallery, and despite its distorted figure, strong colors, and heavy brushwork, he instantly recognized it as the work of a brilliant painter. He arranged to visit Soutine's studio and purchased the entire contents — more than fifty works — without hesitation. Soutine was penniless and unappreciated at the time. When Barnes (shrewdly) offered him a lump sum (well under $100 per painting!), Soutine accepted the offer. Barnes was characteristically satisfied that he had acquired virtually the entire output of an artist he considered to be highly significant for virtually nothing, while also taking (legitimate) pride in giving the artist greater visibility. Barnes also encouraged the careers of Lipchitz and Modigliani — both relatively unknown, although Modigliani had had a very successful recent show in London. Barnes' purchase of ten sculptures by Lipchitz was later followed by the commission of five architectural reliefs to be installed in the new art gallery building that Barnes was constructing in Merion.

The 1922 expedition to Paris had been important in more ways than one. Barnes discovered and purchased well beyond the post-impressionists, making the significant leap from Renoir, Matisse, and Cézanne to Soutine. And although he had little taste for cubism, he did respond to Lipchitz's "cubistic" sculpture. Finally, in 1926, de Chirico painted his portrait, which he hung in the residence building in Merion.

By the autumn of 1924, Barnes was in Paris again purchasing another Renoir and a Cézanne from Vollard. During the 1920s, his admiration for Matisse grew steadily, as did his acquisitions, which included Matisse's *Red Madras Headdress, Blue Still Life,* and *Seated Riffian* all purchased from Guillaume. By the end of the decade, his Matisse collection was the largest in the world, and he regarded Matisse as the greatest living painter (easily surpassing Picasso). He decided (with Violette de Mazia) to write a monograph on the artist which was published in 1933 and dedicated to Leo Stein.

Meanwhile in 1930, Matisse made a visit to the United States and, not surprisingly, requested permission to visit the Foundation in Merion. Barnes responded with enthusiasm. Matisse made it clear that he was not only impressed by the collection, but also by the installation, which he compared favorably with that of European collections, where he felt the "pictures are hard to see, displayed . . . in the mysterious light of a temple or cathedral."[27]

[27]Jack D. Flam, *Matisse on Art*, E.P. Dutton, New York, 1978, p. 63.

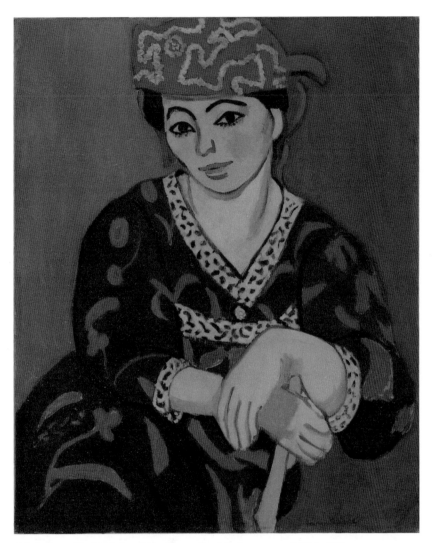

Henri Matisse, *Red Madras Headdress; Le Madras rouge*, 1907. Oil on canvas, 39⅜ × 31¾ inches (100 × 80.6 cm). BF448
Acquired January 1925 from Christian Tetzen-Lund, Copenhagen, through Paul Guillaume, Paris

And he was impressed that in Merion "old master paintings are hung beside the modern ones" which was "very beneficial to the training of American artists."[28] This visit had major consequenes. Barnes offered the artist a commission to create a "mural" along the top of one of the main gallery's walls where the high windows, the architectural pendentives, and the ceiling intersected to create three separate spaces. The work was to entirely "fill" the three "lunettes" and posed several challenges. A visitor entering the gallery would first see the mural from below, looking across the salon and facing the light

[28]Ibid., p. 63.

that streamed through the large windows. In addition, Picasso's *Peasants* and Matisse's own *Riffian* (both very large paintings) were placed at eye level between the three central windows and obviously had the potential to draw attention away from any new work of art above. Nevertheless, Matisse accepted the commission, and after several months (and another visit to Merion), he began developing his ideas. But unanticipated further challenges arose: Matisse discovered that he had mistaken (by a considerable margin) the dimensions of the lunettes and of the pendentives that separated them. He had no choice but to abandon his first version and, ultimately, a second as well.

The final version of *La Danse* (completed in May of 1933) was composed of three related panels (forming a continuous work), each panel embedded in its own architectural space, integrated with the building itself. Matisse insisted on participating in the "installation," and although tensions between him and Barnes had surfaced during the protracted delays in the completion of the commission, both men were deeply satisfied with the result.

In spite of Barnes' approval of *La Danse* and his admiration of Matisse's capacity to use color and pattern in exceptional ways, he expressed some

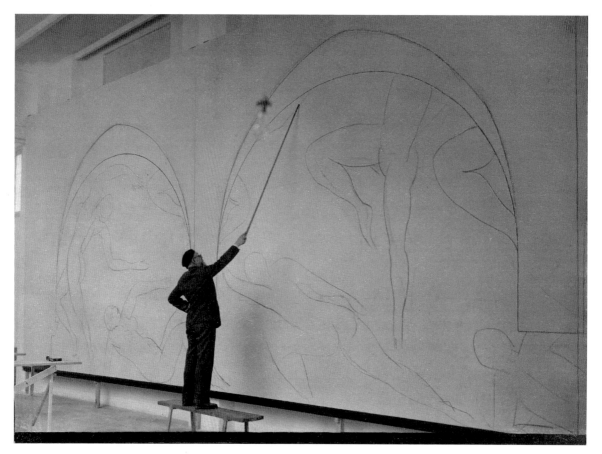

Henri Matisse drawing on the canvases for *The Dance*, 1931
Photographer unknown, Barnes Foundation Archives

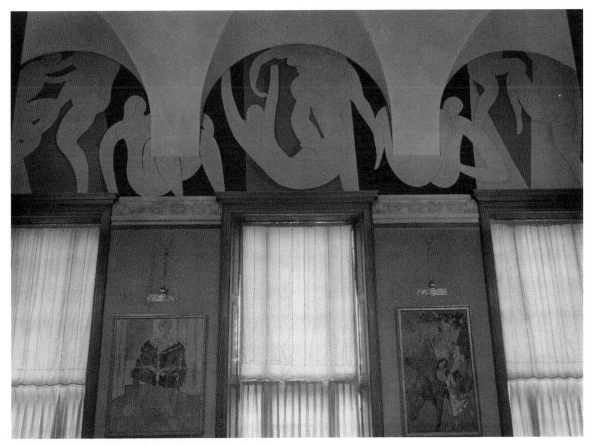

Main Gallery, south wall, c. 1952
Photograph by Angelo Pinto, Barnes Foundation Archives

unease about what he viewed as Matisse's fundamental preoccupation with the "surface" of things: an emphasis on "the immediately pleasing aspects of the world. The ornamental, the picturesque, not the humanly moving or intensely real."[29] Perhaps more than anything, Barnes judged Matisse to be unduly "intellectual:" his skillful planning of every detail prevented him from ever reaching the highest level of artistic expression, and placed him "appreciably below . . . the greatest masters."

In view of these (far from minor) qualifications, Barnes' admiration for Matisse is puzzling. His instinctive taste led him to place an extraordinarily high value on Matisse's art, even though he found it unusually difficult to define the work's qualities. How was he to describe the unique effects of the work when he could not point to the "power" of Cézanne, or the sensuous luxuriance of Renoir, or the deeply moving human values expressed by old masters such as Rembrandt and Titian?

[29]Barnes and de Mazia, *The Art of Henri Matisse*, Charles Scribner's Sons, New York and
 London, 1933, p. 27.

Barnes was clearly critical of any art that was "merely" decorative — and in danger of becoming "mere design," similar (as he said more than once) to an oriental carpet: "All the very greatest painters convey to us, not as a substitute for, but over and above, intense plastic reality, an expression of some such quality as awe, majesty, exaltation, peace, compassion, the pride and triumph of life." Within the framework of these amorphous "values," Matisse could not be readily accommodated, and Barnes skirted the issue. He concluded that Matisse

> has far too much insight, too great an interest in his world, to be a mere decorator, but it is impossible not to feel that he is interested less in objects for what they really are than in the ways in which they can be woven into decorative designs. His imagination, never sinking into mere adroit ingenuity rarely rises to the level of profound inspiration. . . .[30]

> What human value, as distinct from plastic, Matisse's work has, is as a general rule the value of the picturesque. He can depict, with a considerable degree of essential realism and an eye to natural lifelike quality, the pictorially striking but relatively homely and quaint aspects of things. A bourgeois interior, a still-life, a figure strikingly clad and posed, are far from becoming a mere means to decoration: their pictorial qualities are emphasized and an added appeal is lent to them.[31]

We can feel Barnes struggling to account for his view that Matisse was the greatest living painter. But all he can provide is a description of Matisse as "picturesque" — something so wide of the mark that it would have been better if he had remained silent. None of his categories of analysis, nor his chosen (highly generalized) range of values, were supple or precise enough to address Matisse's special genius. As a result, Barnes concluded his evaluation by praising, above all, Matisse's work of the 1920s, because the paintings of that particular decade could find a place in his taxonomy. The pictures of the "relaxed" Nice years, filled with Mediterranean sunlight and the presence of seated or reclining women, represented for Barnes a shift in Matisse's work from the "weight and vigor" of the previous decades to a new "grace and delicacy."[32] The Nice paintings were "airy, luminous and delicate. . . . The charm of these pictures allies them with Renoirs, and they include works as important as any Matisse has ever done."[33] Matisse was, in effect, "elevated" (in Barnes' eyes) by his perceived similarity to the master Renoir. The 1920s — Matisse's least complex and inventive era — became for Barnes the zenith of

[30] Ibid., p. 202.

[31] Ibid., p. 206.

[32] Ibid., p. 195.

[33] Ibid., p. 195.

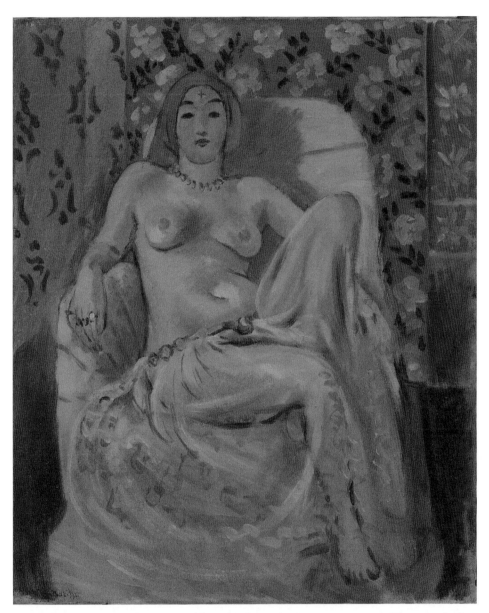

Henri Matisse, *Moorish Woman* (*The Raised Knee*); *Femme mauresque* (*Le genou levé*), 1922–1923. Oil on canvas, 18⅜ × 15⅛ inches (46.7 × 38.4 cm). BF890
Acquired July 1931 from Marcel Kapferer through the Galerie Georges Petit, Paris

his career. The 1923 painting *Repose* attains "an expressive power and depth of color perhaps greater than in any of his other work. . ." In the reds, "Matisse merges the fiery fullness of Rubens with the mellowness of Titian and the juicy richness of Renoir."[34] The final result: "a graceful figure in repose" not unlike several that Barnes describes in detail in his volume on Renoir.

* * *

[34]Ibid., p. 425.

Between 1930 and about 1935, Barnes concentrated on developing the "shape" of his collection. These years were unusually rich in additions to the gallery: eight more Matisses, five Cézannes including *Young Man with a Skull* and *The Large Bathers*, four Renoirs including *La Famille Henriot* and the portrait of *Mlle Jeanne Durand-Ruel*. He had for some time been building an extremely large collection of Renoir's late work (dating from the mid-1880s to the late teens of the twentieth century), and these now constituted by far the largest proportion of his more than 175 paintings by the artist.

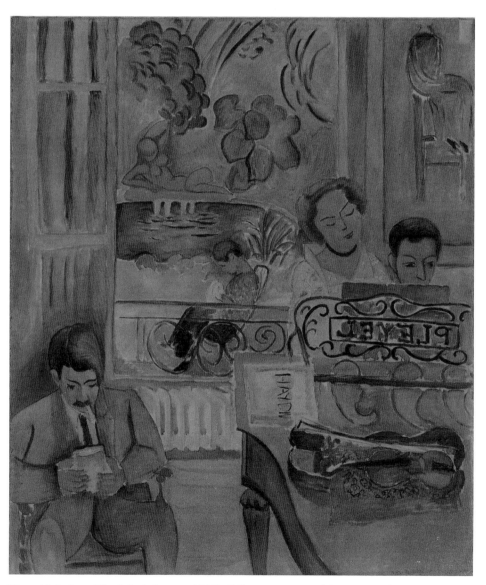

Henri Matisse, *The Music Lesson*, 1917. Oil on canvas, 96½ × 83 inches (245.1 × 210.8 cm). BF717
Acquired July 1923 through Paul Guillaume, Paris

He also added five de Chiricos (1936) and another El Greco. Indeed, Barnes continued to buy (and often dispose of) paintings and sculpture for the next several years, although at a slower pace. At his death in 1951, the collection was (as he had specified) "frozen" — in its size, its specific objects, and its installation. A partial inventory demonstrates not only its range and scope, but also its unmatched depth in some aspects of late nineteenth- and early twentieth-century art: 181 Renoirs, 69 Cézannes, 59 Matisses, 11 Degas, 7 van Goghs, 6 Seurats, 46 Picassos, 16 Modiglianis, 21 Soutines, 18 Rousseaus, 4 Manets, and 4 Monets.

By any standard, Barnes' collection is remarkable — not only because of what he managed to assemble, but also because of his determination to keep it intact. It stands, therefore, as the creation of a particular person at a particular moment in the history of art and of taste, as well as an extraordinary representation of many of the best artists of the time. If we measure Barnes in relation to his approximate contemporaries, we find that John Quinn was more adventurous, but the quality of his collection was more uneven than Barnes', and the works were dispersed after his death. The Steins were brilliant pioneers and led the way in their commitment to Cézanne, Picasso, Matisse and even Renoir. From this point of view, their achievement was unrivaled, but their collection — extraordinary as it was — did not survive. The Havemeyers, meanwhile, maintained a very high level of quality, and were in some ways similar to Barnes. Their munificent gift to the Metropolitan Museum, however, meant that the total impact of their collection was diminished. Among those who collected post-impressionist French art, Barnes' creation ultimately emerged as the single major enduring testament.

Looking back, we can now see that Barnes as a collector was an interesting mix of boldness and conservativism. He bought Cézanne, Picasso, Matisse, and Renoir after a few other collectors had led the way — but nevertheless at a time when these artists (except perhaps Renoir) continued to be ridiculed in many quarters. And he was vehemently attacked when he agreed to show his recent acquisitions in the Philadelphia exhibition of 1923. Moreover, he moved forward quickly — with Guillaume's guidance — once he discovered African art, and he was an early admirer of painters as different as El Greco and Rousseau. Finally, as suggested, his move into the "next generation" work of Soutine, de Chirico, Modigliani, and Lipchitz represented a leap that only an alert collector with a very good eye could have made. In other words, Barnes was often — on several fronts — ahead of his time, and he experienced more than his share of vilification as a result, while maintaining confidence in his own judgment.

Having settled on a relatively small group of painters, he continued to collect them in quantity well after the time when they were regarded as

shocking or absurd. He focused primarily on Cézanne, late Renoir, Matisse (with a preference for the 1920s), and early pre-cubist Picasso. He remained considerably within those bounds — bounds that he established quite early, and continued to respect throughout his more than three decades of collecting. These four artists alone represent more than 300 of the more than 800 works in the permanent gallery. The paintings of Degas, van Gogh, Seurat, Modigliani, Soutine, Rousseau, Manet, and Monet total fewer than ninety. In short, the core of Barnes' collection remained quite "settled" — from the days when its artists were constantly attacked to the time when they were regarded as modern old masters.

We should also bear in mind that Barnes was largely uninterested in a whole range of new developments including the work of the Russian avant-garde, the cubists, surrealists, Dadaists, de Stijl, purism, and American abstract expressionism. Unlike Quinn, Alfred Barr, Katherine Dreier, Walter Arensberg and others, Barnes remained committed to a circumscribed number of primarily French artists from the last decades of the nineteenth and the early decades of the twentieth century.

This led some of the early Dada and surrealist painters to mock not only Barnes but Guillaume for failing to guide the collector to them and their work. Francis Picabia, for example, was angered by the fact that Barnes failed to patronize the new art that was "truly youthful" in the 1920s and that expressed his own epoch as opposed to those of the past. Objectively, Picabia and others were right: new modern artists were obviously inventive in countless ways and in places far beyond France. But one can scarcely blame Barnes for continuing to collect — in large part — the artists whom he loved. For over a century Cézanne, Renoir, Matisse and Picasso have withstood intense scrutiny by art historians, curators, other painters, and the general public — and have retained their stature as among the most important European artists since the Renaissance.

* * *

Late Renoir: Sanctuary and Elysium

Barnes owned 181 Renoirs (more than any other collection or museum in the world) — the greatest number by far dating from the artist's later years. The fact that Barnes was so committed to Renoir's late work is clearly a question of considerable interest. From one point of view, the explanation may be simple: Renoir was nearly the last great survivor and master of the impressionist generation, and he continued to develop, altering his style and technique significantly until the time of his death in 1919. Picasso admired him, and Matisse revered him. Barnes began collecting at a time when Renoir's reputation was growing — and his friends Glackens and Leo Stein encouraged his interest in the painter. In other words, a taste for Renoir was anything but eccentric. At the same time, Barnes' determination to buy as

many Renoirs as possible was more than unusual. It was idiosyncratic in the extreme and signaled a special affinity between the collector and the work of the painter's last two to three decades.

That affinity had several sources. Barnes admired Renoir's ability to "design," as well as his links to the old masters. But Renoir's art also opened for Barnes a view of another world — one utterly different from the abrasive and combative sphere that he inhabited from day to day. This world was sometimes captured in the language of domestic harmony: families, children, and young women who were usually alone in interior scenes. At other times, Barnes responded to the work in religious terms: paintings were "objects of worship," and Guillaume's gallery was a "temple" where kindred spirits communed with one another in a sanctuary never "desecrated by a personal quarrel."[35] In addition, there were gardens, Arcadian landscapes and elysian fields populated by young nude women bathing, or nymphs at play or rest. In short, the main images and qualities that Renoir's late work epitomized for Barnes were "peace," "harmony," "beauty," "sensuousness," and the feeling of being at home, counterbalanced by the feeling of being free in a mythological realm that was simultaneously exuberant, voluptuous, and yet somehow ordered and classical. Above all, Renoir's late work represented a universe in which Barnes might dwell apart, away from the ordinary and often bruising actualities of daily existence, in a land of vivacious color and sunlight where one's spirit could unfold and feel at one with all things. If everyday life was so often a continuous battle for Barnes, Renoir offered him an escape (or entry way) into a world of values and qualities that he treasured, but that he was rarely able to experience in his own life.

Barnes would never have accepted the notion of Renoir as an artist who led one away from everyday reality. Rather, he celebrated Renoir precisely for what he claimed was the artist's profound grasp of the real world as we know it and live in it, reflecting Barnes' great premise that art is always deeply connected to life and human values. But his statements on the subject fail to persuade, because he continually highlights just those characteristics of Renoir's work that might appear to be "real" but are in fact idealizations. In the universe of Renoir's late work, the subject-mater is extraordinarily limited: there are no disruptive forces or stark intrusions from the contemporary world. The scenes are pastoral or domestic rather than urban. There are no wayfarers from different social classes. We do not even find the muted turbulence of country fields riven by rain and storm. In his discussion of *Children at Wargemont* (1884), Barnes describes its "bright and varied colors saturated with light," which renders "with luminous sparkling sunlight and delicate haze, the spirit of a colorful landscape on a hot midsummer day:"[36] The picture embodies a "feeling of the imperturbable placidity of harmonious

[35]"The Temple," *Opportunity*, May 1924, p. 139. BF Archives.
[36]Barnes and de Mazia, *The Art of Renoir*, William J. Dornan, 1994, p. 91.

family life. All the figures are astonishingly alive . . . and the natural charm of childhood is most convincingly realized."[37] Barnes had described Guillaume's temple-sanctuary as a retreat from ordinary life — a place where the "atmosphere is imperturbably peaceful." And he had once characterized religion as "a search for harmony, for an environment which shall meet and satisfy our desires, and in which we can feel at home." Several of these same qualities are present not only in the *Wargemont* canvas, but also in a very late painting, *Landscape with Woman and Dog* (1915–1917), described by Barnes as "saturated with deep, rich, juicy glowing color" that helps to create "the spirit of place:" a luxuriant garden and the "lassitude, repose, peace of a summer afternoon in the Midi." In another picture of the same period, *Woman Resting near a Tree*, Barnes describes an "uninterrupted flow of luminous, glowing and iridescent color" that helps to "render the . . . feeling of a woman at rest in a rich . . . landscape on a warm sunny day."[38]

Meanwhile, *Bathers in the Forest* (ca. 1897) is a paradigmatic "elysian" picture, as is the great 1918 *Nymphs* with its pastoral landscape. For Barnes, this painting had "the qualities of a glorified bouquet of luminous variegated flowers interspersed with clusters of sparkling multi-colored jewels. . . . The picture is a fine example of color conveying the abstract feeling of voluptuousness. . . ."[39]

Paintings such as *Woman Resting near a Tree, The Nymphs, Bathers in the Forest, Landscape with Woman and Dog,* and *Children at Wargemont* are far from unusual in the work of Renoir's last decades. In his book on the artist, Barnes illustrated ninety-one pictures dating from about 1885 to 1918, of which twenty-six (or about thirty percent) are nudes in either a pastoral or a bathing setting; seventeen (nearly twenty percent) are of women in colorful pastoral scenes and gardens; twelve are family ensembles; and sixteen are lush landscapes. The rest include some portraits, as well as some paintings of young women in vaguely defined settings that are rarely detailed. The focus is not (as often in Matisse) on an entire scene of figures, furniture, drapes, and windows, but rather on the close-up face or figure of a woman or girl inhabiting a tranquil sphere of her own: not a "real" world, but one that is scarcely adumbrated, as if the materiality of objects (beyond the principal subject) was fundamentally irrelevant. Indeed, even the main figures (derived largely from the same models) recur with such frequency that they take on the appearance, not of individuals but of types. We are shown a universe in which certain forms of beauty exist as if they were essentially abstracted from time, unhindered by anything that might disturb them.

[37] Ibid., p. 92.

[38] Ibid., p. 133.

[39] Ibid., p. 438.

Finally, it is clear that Barnes' commitment to Renoir also grew out of feelings that were profound in an altogether different way. It was in his book on Renoir that Barnes digressed to discuss religion and mysticism in relation to art, as he attempted to demonstrate Renoir's superiority over Titian. He acknowledged Titian's greatness but judged his reputation to be inflated, on the grounds that his religious subjects (in Barnes' view) evoked feelings that are "totally irrelevant to [the paintings'] plastic excellence."[40]

Barnes believed that science had long demonstrated that traditional religion was a "fancy,"[41] but he felt that there was nevertheless a place for nonreligious "mystical experience, a conviction of essential oneness with the world," which "represents a legitimate demand of human nature."[42] Art, he believed, had the capacity to "profoundly" stir emotions and to call "all our interests into harmonious play." Not only were we able to leave the actual world, but we were granted the capacity to "rebuild" that world as we wished.[43] At such moments we could feel "an immediate warmth of satisfaction, a sense of assured mastery, a perception of ordered relations" characteristic of aesthetic as well as mystical experiences.[44] For Barnes, it was Renoir — above all other painters — who created this sense of harmony and "oneness," surpassing even the Venetians, because they depended upon a world rooted in religion. Renoir was said to possess "all the plastic equivalents of awe, peace, majesty, that the Venetians have, and more."[45] His painting represented "in the highest degree the discovery of human and mystical value."[46]

In short, although Barnes continued to insist that Renoir drew his inspiration from the objects of actual life, his characterization of the late work was significantly idealized and "unreal." It had the capacity to transport Barnes away from what he once called his "wearying" self to a mystical place where the self simply ceased to exist. In this sense, Renoir represented for him a revealing contrast to all that he admired in Cézanne, who spoke to those aspects of Barnes that reflected his determination to carry on despite the adverse forces that always seemed aligned against him. Renoir embodied, not what was perseverant, determined and forceful, but what was harmonious, composed, and free from the continuous need to work against all odds:

[40]Ibid., p. 265.

[41]Ibid., p. 265.

[42]Ibid., p. 165.

[43]Ibid., p. 165.

[44]Ibid., p. 166.

[45]Ibid., p. 166.

[46]Ibid., p. 167.

> [In] Renoir one finds that color sings richly and harmoniously but never stridently; that the composition is made up of . . . sensuous elements [made] dramatically meaningful; that the picture soon ceases to be drawing, color, composition; that it becomes a repose saturated with spirit of place, where self is no more, where all is peace and harmony.[47]

The real world and its objects — including the self — vanish, to be replaced by a realm where all is "peace and harmony," where even time is banished and the painter's work breathes "the spirit of perpetual youth in a garden of perennial June loveliness."

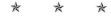

[47]"Renoir: An Appreciation," *Arts and Decoration*, November 1920, p. 167.

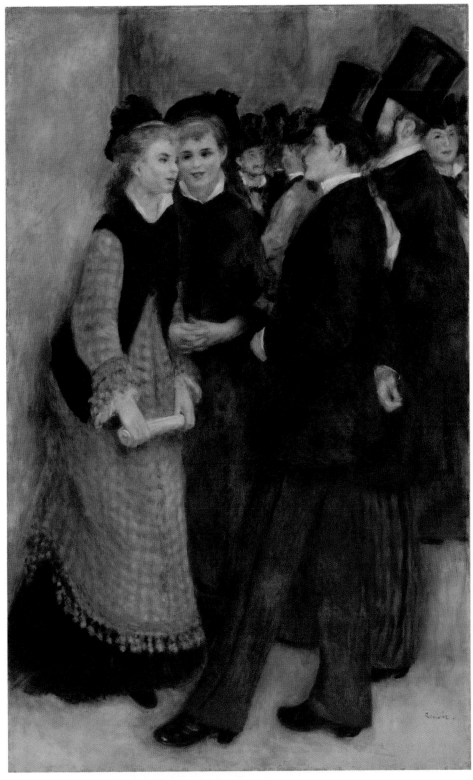

Plate 1. Pierre-Auguste Renoir, *Leaving the Conservatory*; *La Sortie du conservatoire*, 1876–1877. Oil on canvas, 73¹³⁄₁₆ × 46¼ in. (187.5 × 117.5 cm). BF862
Acquired March 19, 1929 through Galerie Paul Cassirer, Berlin

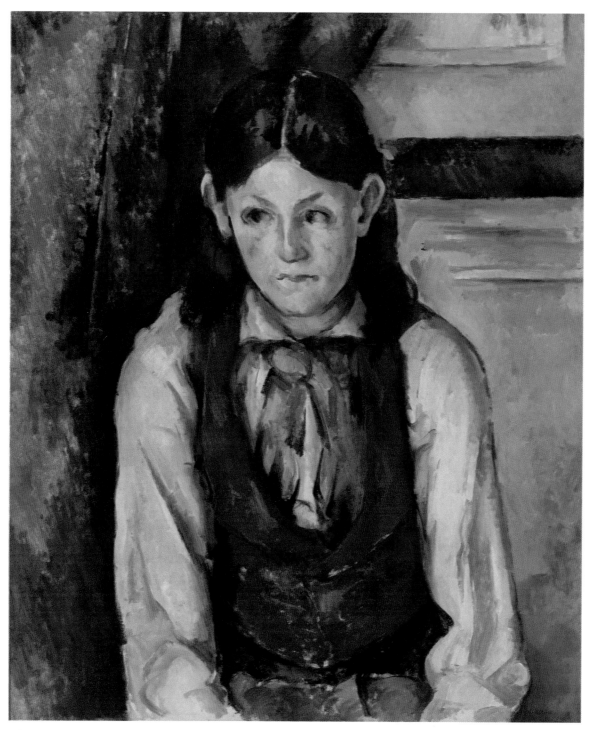

Plate 2. Paul Cézanne, *Boy in a Red Vest*; *Le Garçon au gilet rouge*, 1888–1890. Oil on canvas, 25¾ × 21½ in. (65.4 × 54.6 cm). BF20
Probably acquired July 1923 from Paul Rosenberg, Paris.

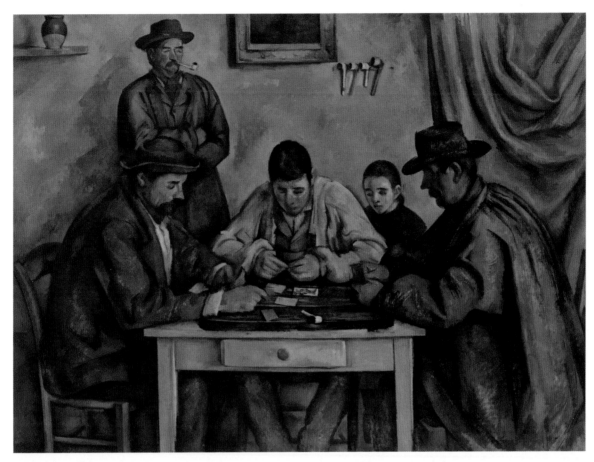

Plate 3. Paul Cézanne, *The Card Players*; *Les Joueurs de cartes*, 1890–1892. Oil on canvas, 53¼ × 71⅝ in. (135.3 × 181.9 cm). BF564
Acquired December 1925 from Ambroise Vollard through Paul Guillaume, Paris

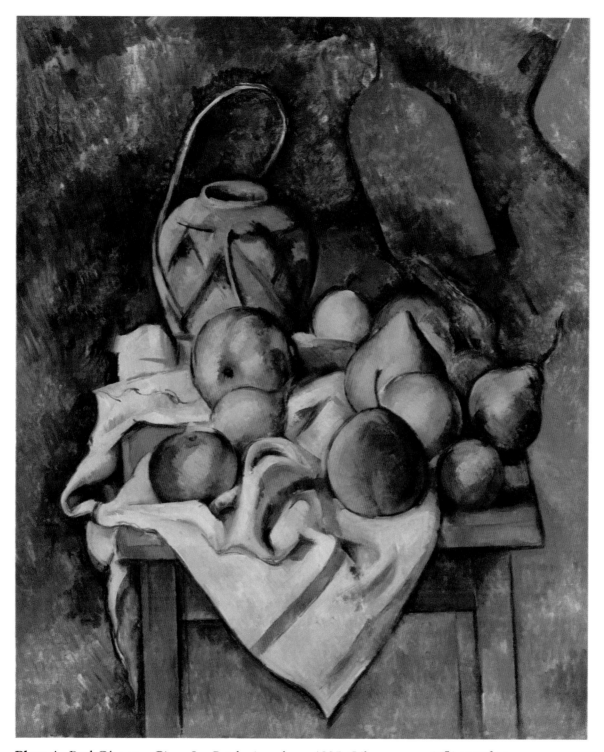

Plate 4. Paul Cézanne, *Ginger Jar; Pot de gingembre*, c. 1895. Oil on canvas, 28⅞ × 23¾ in. (73.3 × 60.3 cm). BF23

Acquired July 1920 from Paul Rosenberg, Paris, through Galerie Durand-Ruel, Paris

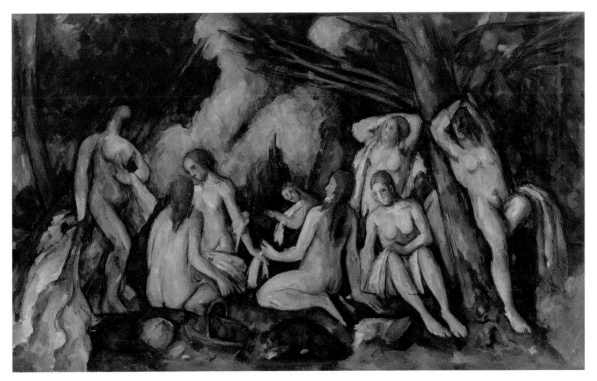

Plate 5. Paul Cézanne, *The Large Bathers*; *Les Grandes baigneuses*, 1895–1906. Oil on canvas, 52⅛ × 86¼ in. (132.4 × 219.1 cm). BF934
Acquired July 1933 from Étienne Bignou, Paris

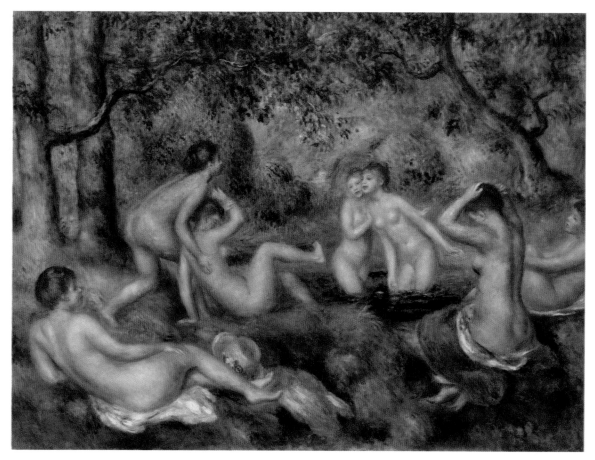

Plate 6. Pierre-Auguste Renoir, *Bathers in the Forest; Baigneuses dans la forêt*, c. 1897. Oil on canvas, 29⅛ × 39⅜ in. (74 × 100 cm). BF901
Acquired February 24, 1932 from Marcel Kapferer through Galerie Georges Petit / La Peinture Contemporaine, Paris

Plate 7. Pablo Picasso, *The Ascetic*; *L'Ascète*, 1903. Oil on canvas, 46⅝ × 31¾ in. (118.4 × 80.6 cm). BF115
Acquired January 1925 from Paul Guillaume, Paris

Plate 8. Henri Matisse, *Le Bonheur de vivre*, also called *The Joy of Life*, 1905–1906. Oil on canvas, 68⅛ × 7ft 10⅞ in. (175 × 241 cm). BF719
Acquired January 1923 from Christian Tetzen-Lund, Copenhagen, through Paul Guillaume, Paris

4

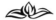

The Many or the Few:
Art and Education in England
and America

Art for the People: England

My principal interest has always been in education first for myself,
then for those less fortunate ones around me, then in the education
of the public in general.
— Albert C. Barnes to Alice C. Dewey, September 20, 1920

When Albert Barnes wrote his "Indenture" stipulating the principles
that were to guide his educational Foundation, he stressed that the
new venture was to be an experiment, intended to advance the
appreciation and study of art as well as to promote the diffusion of democracy.
On days when the Foundation's art collection was to be open, it should be
free of charge to "plain people" of the working class: those "who toil" in set-
tings such as "shops, factories, and schools." Barnes' effort to educate the
workers in his own factory had been a first step, and his Foundation would
attempt to extend that venture by institutionalizing it. On certain days he
would provide access to art for those who were otherwise least able to gain
it. Art students from various institutions were also to be eligible for admis-
sion, but he was ultimately interested in the amount of "practical good" that
could be achieved by teaching "the public" of "all classes and stations of life."

Barnes' own ideas were obviously strengthened and modified by those
of Dewey (Barnes' first director of education at the Foundation), and
Dewey's views were very much rooted in the "progressive" philosophy that
had been gathering force in the late-nineteenth and early-twentieth century.
Although the American version of this philosophy had its own distinctive
character, it was inevitably affected by many of the educational initiatives that
were underway in England by the 1850s. Lecturers from England found
receptive audiences in the United States; journals, articles, and books easily

crossed the Atlantic; and several prominent Englishmen (including Dante Gabriel Rossetti) corresponded with figures such as Charles Eliot Norton at Harvard. A great many of those engaged in this transatlantic educational venture identified *art* as a primary means for transforming individuals and different classes of society.

It was in this context that Barnes was developing his own thoughts about art education in general, and the working poor in particular. Although he was apparently not directly influenced by any specific individual or group, he belonged to a milieu in which ideas concerning education through art were so pervasive as to be inescapable.

It may seem strange that an effort to "improve" art and renovate society should have looked initially to the Middle Ages for a model. But thanks to the ideas of the architect Augustus Charles Pugin (who designed the "new" Houses of Parliament), to John Ruskin, and (rather less) to William Morris, that was precisely what happened. Pugin and Ruskin were Christians, and the Middle Ages had an intrinsic appeal for them. The era was typified by the presence of extraordinary works of art — most obviously by the Gothic cathedrals of France and England. To Ruskin and others, the irregularity and unpredictability of the design of each individual cathedral seemed to suggest a society in which all objects were handmade — the very opposite of the post-industrial, machine-driven nature of the contemporary world as Ruskin, Pugin, and Morris viewed it. Moreover, the simplicity, unity and scale of medieval towns and villages seemed to provide an ideal setting in which the general populace could share in the creation of everything from household utensils to the construction of the cathedrals themselves. All were artisans and therefore creators, engaged in the process of "making" as well as in the enjoyment of the fruits of their labor. "Art was once the common possession of the whole people; it was the rule in the Middle Ages that the product of handicraft was beautiful" — wrote Morris in the *New Review* of January 1891.

The idealization of the Middle Ages characterized much of the nineteenth century, and a concern for fine artisanship, for the reform of English taste, and for the education — in art — of the public remained a major preoccupation. Indeed, the focus on the poor became more intense as the century progressed and led eventually to a broadly based and sustained effort to ensure not only that the working class gained free access to art, but also that they were trained as skilled artisans.

There is no single originating event that sparked this movement. But beginning at least as early as the 1830s, increasing numbers of small-scale exhibition galleries, as well as art societies or academies began to appear on the London scene. The Royal Academy and the British Museum were already in existence; new quarters for the British Museum were opened in 1838, while a major building for the recently created National Gallery was well underway by the 1830s. Reasons in favor of it were put forth in the

June 1836 issue of *Blackwood's Edinburgh Magazine* where Archibald Alison argued for the establishment of a major free art gallery, not only in London, but in "every city of note in the empire:"

> Nothing but refinement and enjoyment, the cultivation of the mind, and the improvement of manners could result from such establishments for opening refined and elevated sources of pleasure to the people. . . . Moral blessings of no light character would flow from such an institution.[1]

If some museums were established "for the people" with the broad and general goal of cultivating, elevating, educating and perhaps "reforming" the public — other institutions were created with different agendas. Henry Cole was one of the founders of the South Kensington Museum (later the Victoria and Albert) with the original goal of creating well-designed useful objects to be manufactured by English companies, all in the service of both art and commerce. Although some individuals feared that commercial goals would compromise the entire venture from the beginning, others thought it was essential to improve the quality of design in all aspects of English life — particularly if one wished to mitigate the perceived horrors of Victorian bourgeois taste.

In 1835, Sir Robert Peel appointed a Parliamentary Select Committee on Arts and their connection with manufacture, and the work of the Committee soon bore fruit. The British School of Design was founded in 1836; a second one in 1837; and one for women in 1843. Meanwhile, the great competition for decorating the new Houses of Parliament in fresco was launched in the spring of 1843, and 140 "cartoons" were placed on view during the summer. To the surprise of many, people from all classes and backgrounds filled Westminster Hall to see the submissions. Lady Elizabeth Eastlake (wife of Sir Charles Eastlake, director of the National Gallery) wrote in her notebook:

> July 22nd 1843. The daily throng is immense; the public takes great interest, and the strongest proof is thus given of the love of the lower orders for *pictures*, when they represent an event. I abridged the catalogue to a penny six for the million but many of the most miserably dressed people prefer the sixpenny ones, with the quotations. . . .[2]

Other large scale exhibitions (especially that of 1851) and other new institutions followed. The Working Men's College was created in 1854, although it was focused less on art or craftsmanship than on the provision of

[1] Bernard Denvir, *The Early Nineteenth Century: Art, Design, and Society, 1789–1852*, Longman, London, 1984, p. 175.

[2] Ibid., p. 68.

a high quality of general education for the working poor. William Morris was teaching there as early as the 1850s. The Trades Guild of Learning emerged later — though it unfortunately failed to attract members of the working class for whom it was intended. Although countless individuals played any number of roles in this large-scale movement, the two figures who clearly dominated and guided it — in very different ways — were John Ruskin and William Morris. Both had similar views of ideal communities, whether Gothic or not, in which the making of art was as important as the viewing of it. Both railed against English middle-class philistinism. Both believed that all people, of whatever social class, had the capacity to become capable artisans, granted degrees of difference in natural talent. Finally, both men laid great stress on the capacity of art to increase the richness, fullness, and joy of people's lives. As Ruskin said, "My efforts are directed not to making a carpenter an artist, but to making him a happier carpenter."[3] He continued, "I teach [my working men] so much love of detail, [that] . . . they are caught by it. The main thing which has surprised me . . . is the exceeding refinement of their minds."[4]

Although Ruskin was in some ways a populist, he did not believe that the major museums of art were likely to be educational for most people, and he promoted the idea that there ought to be alternative museums that contained less "high" art, but art that would be more comprehensible to the working class. "I heartily wish," he once said, "that there were already . . . large educational museums in every district of London, freely open every day . . . for the use of their contents by all classes." In fact, in 1872, the East London Museum for the poor was opened, not only for visits but also for instruction. Some of the instruction (given Ruskin's inclinations) was plainly moral and religious, and was in tune with much of the Pre-Raphaelite art that Ruskin had been championing: indeed, not only art instructors but even clergymen soon began to participate in the educational program. Samuel Barnet, a minister (and friend of Ruskin), preached regularly in museums as well as in his own parish church. Following one "sermon" he delivered in 1884 to working men in a museum, he said that he had never been so conscious of his audience's souls (and their souls' needs) as when he had lectured to them on the subject of George Watts' picture *Time, Death, and Judgment*. Religion, art, inspiring subject matter, and education all converged at such moments.

William Morris was a full generation younger than Ruskin and he began to read Ruskin's work while an undergraduate at Oxford. Although Ruskin's genius expressed itself most forcefully through his voluminous, eloquent, and immensely influential writings, Morris was an artist-designer and

[3]John Ruskin, *On the Old Road: A Collection of Miscellaneous Essays and Articles on Art and Literature*, vol. 2, 1834–1885, Project Gutenberg, 2007, p. 13. http://www.gutenberg.org/ebooks/21263.

[4]Ibid.

a socialist who wanted to change contemporary society in fundamental ways so that people of all classes could lead freer, less impoverished lives, enabling them to explore and appreciate art in all its forms. Only a revolution — through education and peaceful change — could (in Morris' view) achieve this. As matters then stood, England was in danger of widening the gulf between social and economic classes: "to make new classes of elevation, and new classes of degradation. . .; I wish people to understand that the art we are striving for is a good thing in which all can share, which will elevate all."[5]

Morris joined the Democratic Federation in 1883 and later became a member of the Socialist League and then the Socialist Society. From the early 1880s until the early 1890s, he lectured, wrote articles, attended meetings, and published his Utopian vision of socialism in *News from Nowhere* (1890). Ford Madox Ford, in his *Memories and Impressions* (1911), gave a vivid, ironic but also sympathetic picture of Morris in motion: "he would stride up and down between the aisles, pushing his hand with a perpetual irate movement through his splendid hair. And we, the young men with long necks, long fair hair, protruding blue eyes and red ties, . . . uttered with rapt expression long sentences about the Social Revolution just around the corner."[6]

If Morris sometimes seemed quixotic, he was simultaneously practical. He had founded his famous firm in 1861 and was committed to producing high-quality arts and crafts, including wallpapers, rugs, tapestries, weavings, hand-printed books, and other intentionally "useful" objects. The goal was to change taste, to elevate it, and to alter the environment in which people lived, on the simple theory that the constant presence of beautiful surroundings could transform the daily lives of the public of all classes.

The firm had substantial influence but not (ironically) on the poor, simply because most of Morris' products were affordable only by those whose resources far exceeded those of the working class. Nevertheless, Morris and his firm had an enormous impact on the "improvement of taste" in England. By the time of the first Arts and Crafts Exhibition in 1888, it was clear that a steady, gradual but unmistakable revolution in design had taken place. It was far from complete, but progress was greater than anyone could have imagined a quarter-century earlier. Moreover, access to art and to art education for at least part of the working class had been introduced. Objects of significantly improved quality were being created in factories. And, in parts of English society, Morris' work — especially as it expressed itself through the growing arts and crafts movement — was having a powerful effect in England and even beyond.[7] As Hermann Muthesius, author of *The English House*, wrote:

[5]William Morris, *Hopes and Fears for Art*, Roberts Brothers, Boston, 1882, p. 55.

[6]Ford Madox Ford, *Memories and Impressions*, Harper & Brothers, New York, 1911, p. 134.

[7]Peter Stansky, *Redesigning the World*, Princeton University Press, 1985, p. 7.

Morris was a pioneer in all areas which he incorporated in his activities. He laid the ground for the development which all branches of the new art movement experienced later. . . . [In the 1880s] a young generation now stood upon Morris' shoulders.[8]

American Echoes

Ideas about art and its educational power quickly migrated from England to the United States, not only because Americans (and Englishmen) traveled transatlantically, but because the writings of Ruskin, Morris, and others soon reached American readers. Ruskin, in particular, appealed to a broad audience. His work on architecture was read by sophisticated professionals as well as by a wide range of general educated readers. Charles Eliot Norton at Harvard not only corresponded with Ruskin, but also collected his art. When the Boston Museum of Fine Arts held a special exhibition in 1880, Norton lent 160 Ruskin drawings from his own collection.

Earlier in the century, Charles Callahan Perkins (who graduated from Harvard in 1843) went abroad to study art in Rome and Paris, and later became a major art critic — indeed a champion of art and art education. In 1867, he gave a lecture at Trinity College (Hartford) on "The Rise and Progress of Painting."[9] He was soon a member of the Boston School Committee, and introduced the South Kensington Museum's method of teaching drawing and design to children,[10] while also helping to create the Massachusetts Normal Art School.

By 1869, Perkins was sufficiently active and influential to be named chair of a special committee to evaluate the potential educational value of art.[11] The committee had been appointed by the American Social Science Association, and Perkins' report recommended that the feasibility of founding a museum of fine arts should be studied. He wanted to establish a high degree of "aesthetic culture" in Boston and in the nation. "There exists," he wrote:

a modicum of capacity of improvement in all men, which can be greatly developed by familiarity with such acknowledged master-pieces as are found in all the great collections of art. Their humblest function is to give enjoyment to all classes; their highest, to

[8]Ibid., p. 7.

[9]Walter M. Whitehill, *Museum of Fine Arts, Boston,* Harvard University Press, 1970, vol. I, p. 8.

[10]Ibid., p. 8.

[11]Ibid., p. 9.

elevate men by purifying the taste and acting upon the moral nature; their most practical, to lead by the creation of the standard of taste in the mind to improvement in all branches of industry, by the purifying of forms, and a more tasteful arrangement of colors in all objects made for daily use.[12]

Here, in combination, are all the same principles and convictions that were highlighted in previous initiatives in England: the fact that all people should have the opportunity to increase their knowledge and appreciation of art; that "all classes" of people have the capacity to enjoy art; that art can help to elevate taste and also have an important effect upon "the moral nature;" and finally, that acquaintance with great art can improve the quality and aesthetic appeal of manufactured objects made for everyday use.

Perkins recommended that the new institution should be committed to education, and should be based on "the character of that at South Kensington."[13] By February 1870, the Massachusetts state legislature had passed a bill establishing a new museum. It was soon determined that the institution would be "free" to all people four days each month. The building (which had some architectural elements similar to the South Kensington museum) was completed relatively quickly — and opened on Independence Day, July 4, 1876. Attendance in the first year was disappointing, but in 1877, 158,446 people passed through the doors.[14]

The Boston Museum of Fine Arts approached its educational mission with great seriousness. Volunteer docents were trained, weekly lectures were given, training for school teachers was introduced, and "courses" were soon launched in collaboration with Harvard. In 1910, the museum's records tell us that 237 lectures (or similar events) were given, attended by 5,958 visitors. Docents "instructed" a total of 3,611 people — including 119 school and college students. In 1911, Theodore Vail introduced the idea of inviting "slum children" from Boston Settlement Houses to attend classes during the summer — when pictures of the paintings would be shown, and "stories" about the pictures would be told.[15] Charles Perkins had clearly won the day.

The collector James Jackson Jarves was another proselytizer. In 1864 he published *The Art Idea*, declaring that to "stimulate the art-feeling, it is requisite that our public should have free access to museums."[16] He was persuaded that great art could not only "elevate the masses," but also have "a practical

[12]Ibid., p. 9.

[13]Ibid., p. 9.

[14]Ibid., p. 40.

[15]Ibid., pp. 296–298.

[16]Karl E. Meyer, *The Art Museum*, William Morrow, New York, 1979, p. 22.

benefit in terms of improved design and manufacture."[17] Clearly didactic in his approach, he focused on "the moral dimension" of art, seeing it as the hand-maiden of democracy and Christianity.[18] In this latter respect, he was not dis-similar from the collector Thomas Jefferson Bryan, who was concerned about moral values, concentrated entirely on Christian art, and established a gallery of his own in 1853, open to the public with an entrance fee of twenty-five cents.

During and after the 1870s, the number of art museums, art schools, and art societies grew swiftly. The Corcoran Gallery in Washington was founded in 1874, and the Baltimore Walters at about the same time. By the mid-1880s, there were new museums in St. Louis, San Francisco, Cincinnati, Pitts-burgh, Milwaukee, Nashville, and any number of other American cities.[19] Meanwhile, the great Chicago Columbian Exhibition of 1893 (presided over by Mrs. Potter Palmer) gave even greater impetus to the movement already underway. The Central Art Association was born in 1894, dedicating itself to the "promotion of good art and its dispersion among the people."[20] It cre-ated a series of "study courses" in art, which were soon adopted by literally hundreds of clubs across the nation and helped to mount exhibitions which were surprisingly well-attended in many cities.

The Association had been directly inspired by an unlikely phenome-non: the Chautauqua summer "camps" that were initiated by a young minis-ter, John Vincent from Camptown, New Jersey, who set out to enliven his Sunday Bible classes. The response was so enthusiastic that he launched a series of "correspondence courses" in order to spread the word. These, too, were successful, so he decided to try a two-week Bible-reading camp at Lake Chautauqua. Forty men and women attended the first of these, and soon there were Chautauqua camps in about 200 locations throughout the nation. Chautauqua itself never taught art, but some of its offshoots did. Meanwhile, the New York Chautauqua increasingly attracted talented and famous lectur-ers including half a dozen U.S. presidents and academics such as William James. The diffusion of culture — in a range of diverse subjects — suddenly had a powerful, far-reaching effect on thousands and thousands of people. And William James' participation in this quasi-academic populist experi-ment was highly significant: his little volume, *Talks to Teachers*, had a direct impact on Albert Barnes.

Chautauqua — like the Central Art Association — was a broad-based movement, but there were others in the United States that were more pointedly focused on not simply "the people," but on the poor and the working class. When A.C. Bernheim returned to America from a trip to

[17]Ibid., p. 22.
[18]Ibid., p. 22.
[19]Ibid., pp. 148–149.
[20]Ibid., p. 155.

London in 1892, he came home inspired by what he had seen: an art exhibition in Toynbee Hall, which was a place of "free learning" located in a London slum district.[21] He immediately approached the New York Settlement Society to see whether a similar effort could be undertaken in New York. An exhibition of sixty paintings, as well as sketches and watercolors, was mounted within a few months. It remained on view for forty-one days, and more than 36,000 "East Siders" attended. In general, the crowds appeared to prefer "subject" or "story" pictures rather than landscapes — a pattern typical of museum goers of virtually every class throughout most of the nineteenth century.[22]

Not to be outdone, the city of Boston held similar shows in the North End and South End organized by Settlement Houses in 1892–1893. Approximately 100 pictures were on view, and about 1,500 people of all classes came to visit every day. Perhaps not surprisingly, the show's favorite pictures included the sentimental *Sleeping Innocence*, as well as the portrait of a spaniel named *Correy* and an admirable version of *The Village Smithy*.[23]

Beginning in 1895, Chicago's well-known Hull House gave courses in art history to enthusiastic audiences, and the city itself had a substantial "Art in Schools" program.[24] This and similar ventures continued (in a variety of forms) well into the early decades of the twentieth century. One may wonder about their effects, but at least one point is beyond doubt: a strong and sustained effort to bring art to the people, including the poor and working class, had firmly (and widely) established itself in the United States, building upon the English example. This was the milieu in which John Dewey and Albert Barnes began to formulate their own ideas about a "democratic" education in art that might enrich the lives of those who "toiled" in jobs that were uninspiring as well as those from various backgrounds who sought to learn from a study of "aesthetic objects." A passage from *Harper's Weekly*, commenting on the potential benefits of the Boston 1892–1893 exhibition, managed to capture the combination of qualified optimism and qualified skepticism — as well as the tone of rather unqualified condescension — that was common among those who were sympathetic to "the art idea" but not directly involved in it:

> Though many have been led to visit the Art Museum through this exhibition, it would be idle to say that any strong artistic impulse has been given to the majority of these people; but into the minds and souls of hundreds of them a light has surely come from another world — a world in which sordidness and toil are not the

[21]Ibid., p. 157.

[22]Ibid., pp. 157–158.

[23]Ibid., p. 158.

[24]Ibid., p. 159.

only things of moment, and where it may be seen that there is other work to be done besides brawn.[25]

Art for the Few: France and England

If John Ruskin and William Morris believed in the importance of some form of art education for people of every class, their views were far from universal. In the eyes of a significant part of the population, art was either irrelevant or else sanctified — the province of only a chosen few who could understand and respond to it. For Théophile Gautier, art was the heritage of the "élite," far beyond the reach of the public at large ("la foule"); every poet possessed his own "lyre" and "sang alone."[26] "I have always done my sketches," said Aubrey Beardsley in an 1897 interview with Arthur Lawrence, "for the fun of the thing . . . I have worked to amuse myself, and if it has amused the public as well, so much the better for me!"[27] "Art," wrote James McNeill Whistler, "has become foolishly compounded with education — that all [people] should be equally" able to appreciate it — an idea that Whistler thought absurd. The hapless populace "have been harassed with Art in every guise, and vexed with many methods. . . . They have been told how they shall love Art, and live with it. Their homes have been invaded, their walls covered with paper, their very dress taken to task."[28] William Morris and his "wallpapers" were one obvious target, just as Ruskin was the victim of a rapier thrust by Beardsley: there is, he said, "nothing so depressing as a Gothic cathedral. I hate to have the sun shut off by saints."[29]

In 1879, Sir Frederic Leighton, president of the Royal Academy, was prompted to confess his own perplexities:

> [In] the days in which we live [art] is subjected to an ordeal of which it knew nothing in the past; the questioning spirit is now abroad, it asserts itself on all sides, and is paramount; it leaves nothing unassailed, takes nothing for granted, calls every belief to account, casts everything into the balance — so at some period in our lives most of us will be asked to ask themselves, "What is Art in the world?"[30]

[25] Ibid., pp. 158–159.

[26] P.E. Tennant, *Théophile Gautier*, Athlone Press, London, 1975, pp. 15–16.

[27] Denvir, *The Late Victorians: Art, Design and Society, 1852–1910*, Longman, London, 1986, p. 293.

[28] James A. McNeill Whistler, *The Gentle Art of Making Enemies*, Dover, New York, 1967, pp. 136, 150.

[29] Denvir, p. 230.

[30] Ibid., p. 50.

Despite Leighton's uncertainties, he himself could not entirely resist the new directions that were proving to be so troublesome. When it was suggested to him that pictures with admirable subject matter were needed in order to inspire and educate people, Leighton replied (in an 1890 letter to the *Manchester Courier*):

> Now, direct ethical teaching is specially the province of the written or spoken word.... It is only by concentrating his attention on essentially artistic attributes that you can hope to intensify in the spectator the perception of what is beautiful in the highest order, ... through which he may enrich his life by the multiplication of precious moments akin to those which the noblest and most enhancing music may bestow him through different forms of aesthetic emotion. It is in the power to lift us out of ourselves into regions of such pure and penetrating enjoyment that the privilege and greatness of art reside.[31]

Leighton's statement is perhaps more sweeping than he intended, because he has in fact set forth an aesthetic theory that — in its effort to move "ethical" or moral teaching to one side — has led him quite far in the direction of a formalist view of art. Ethical matters are said to belong to literature; "artistic attributes" of paintings are to be predominant; and — very significantly — "spectators" are to experience "aesthetic emotions" born of "precious moments" of heightened perception, similar to the feelings evoked by "the noblest and most enhancing music." Once subject matter and moral considerations were removed from (or at least greatly subordinated to) aesthetic considerations, and once the spectator's responses to art, in search of heightened precious moments of experience, were declared to be a central part of the aesthetic quest, it was far from clear how one could define or circumscribe the kind of paintings that would be "acceptable" to refined taste or determine the range of intense experiences that might be permissible. "In everything," wrote Gautier in the introduction to his novel *Mademoiselle de Maupin*, "I like what goes beyond ordinary limits;"[32] and later in the novel, one of the main characters declares, "I always fasten upon what is eccentric and odd."[33]

Perhaps the most intriguing and compelling vision of a hero engaged in such an eccentric aesthetic quest "beyond the limits" was the central character in Huysmans' *À Rebours* (1884). Huysmans' hero sees very little in the world except the poverty, squalor, vulgarity, and ugliness of modern society.

[31]Ibid., p. 31.

[32]Théophile Gautier, *Mademoiselle de Maupin*, Modern Library, New York, p. 15.

[33]Ibid., p. 180.

In this respect, he perhaps resembles William Morris, but his response to what he saw could hardly have been more different from Morris' effort to transform society. Huysmans' alter ego decides to leave it altogether in order to create an aesthetic retreat of his own:

> Once he had cut himself off from contemporary life, he had resolved to allow nothing to enter his hermitage which might breed repugnance or regret; and so he had set his heart on finding a few pictures of subtle, exquisite refinement, steeped in an atmosphere of ancient fantasy; wrapped in an aura of antique corruption, divorced from modern times and modern society.
>
> For delectation of his mind and the delight of his eyes, he had decided to seek out evocative works which would transport him to some unfamiliar world, point the way to new possibilities, and shake up his nervous system by means of erudite fancies, complicated nightmares, suave and sinister visions.

Huysmans' entire book is a continuous search on the part of the hero to find new forms of delectation, stimuli, and perceptions of "antique corruption" or "sinister visions." We watch him designing and redesigning room after room in his chateau to produce more and more exotic experiences. By the end of the book, he has suffered what today would be called a nervous breakdown, and he is ordered by his doctors to return to the real world in order to find amusement and regain his health. But this prescription only leaves the hero in despair: the world of art and "heightened" fantastic perceptions have proved to be fatal, and the real world remains repugnant to him. For a brief time, he considers another form of retreat — a turn to religion in the form of Catholicism. But his conception of religion is far from that of Ruskin or Samuel Barnet, because it is the aesthetic, ritualistic, and liturgical aspects — including the incense — of Catholicism that attract him most, not the moral, ethical or spiritual elements of the Church.

French aesthetic ideas inevitably made their way to England, largely because a number of English and American artists were impressed by the diverse views of writers and painters ranging from Henri Murger, Gautier, Huysmans, Baudelaire, the Goncourt brothers, and Flaubert — as well as some of the work and ideas of Manet and Degas. Whistler was probably the most important of these cosmopolitans, although he was at least partly seconded (in England) by others who shared some of the new ideas. The younger generation of Pre-Raphaelites, for instance, had moved in a more aesthetic direction than their predecessors (although they certainly kept their distance from Whistler himself). Burne-Jones, for example — a member of Morris' firm — had a private view of art and its purposes: "In the main," he wrote, "I should like to keep all the highest things secret

and remote from people; if they wanted to look, they should go a hard journey to see."[34]

The principal English intellectual force behind the "aesthetic" movement was the rather secluded, bookish, idiosyncratic Oxford don Walter Pater. Pater ventured far in terms of creating aesthetic (and moral) theories, based particularly on his own distinct view of the constant flux — the continuous flow of sensations and perceptions — of human experience. Since one was allotted only a limited time in life, it was essential, Pater believed, to discover and experience those rare sensations and impressions that were most intense and enriching.

He began to publish in the late 1860s and 1870s, and was even then having a strong effect on English and American students. By the 1880s, Bernard Berenson read Pater while still an undergraduate at Harvard, and his enthusiasm for Pater's work was only partly dashed by the admonitions of Harvard's senior professor in art, Charles Eliot Norton, who considered Pater's work to be highly suspect from a moral point of view. Pater's writings, nevertheless, continued to gain a strong hold on an entire generation and beyond.

To understand this phenomenon, one need only consult the group of essays that Pater gathered in his now-famous book, *The Renaissance* (1873). His view of art seemed to synthesize much of what was new in French aesthetics and criticism, and his prose was at least as potent as his ideas: the language was simultaneously poetic, hypnotic, insidiously persuasive, and always personal in its expressiveness. His conception of the Renaissance was utterly different from prevailing views, including those of writers as different as Burckhardt and Berenson. Attributions, dates, "objective" descriptions of paintings or events, and historical "background" were absent. Instead, one became imbued with Pater's own interpretations of individual artists and works, and these were so original and liberating that any effort to prove him right or wrong seemed entirely beside the point. He was *sui generis*, and he had the talent and ideas that made him seductive. Discussing Medusa, Pater observed:

> Leonardo alone cuts to its centre: he alone realizes it as the head
> of a corpse, exercising its powers through all the circumstances
> of death. . . . About the dainty lines of the cheek the bat flits
> unheeded. The delicate snakes seem literally strangling each other
> in terrified struggle. . . .[35]

And about the *Mona Lisa*:

> She is older than the rocks among which she sits; like the vampire,
> she has been dead many times, and learned the secrets of the grave;

[34]Penelope Fitzgerald, *Edward Burne-Jones*, Hamish Hamilton, London, 1989, p. 256.

[35]Walter Pater, *The Renaissance*, Macmillan, London, 1910, p. 106.

and has been a diver in deep seas, and keeps their fallen days about her; and trafficked for strange webs with Eastern merchants.[36]

In Pater's world, the tone is often elegiac, and the objects are strange, elusive, tinged with hints of mystery, and expressive of a shadowed and saddened — or doomed yet perpetual — realm of beauty. He has simply absorbed, as if unconsciously and without specific references, the world of French aestheticism:

> In its primary aspect, a great picture has no more definite message for us than an accidental play of sunlight and shadow for a few moments on the wall or floor. . .: [It] is itself . . . caught as the colours are in an Eastern carpet: *All art constantly aspires to the condition of music.* For while in all other kinds of art it is possible to distinguish the matter from the form, . . . it is the constant effort of art to obliterate it. . . [That] the mere matter of a picture, the actual circumstances of an event, the actual topography of a landscape — should be nothing without the form, the spirit, of the handling, that this form, this mode of handling, should become an end in itself, should penetrate every part of the matter: this is what all art constantly strives after, and achieves in different degrees.[37]

Pictures have no "messages." They aspire to the condition of music, where form and "matter" are indistinguishable, and where matter can be obliterated, so that "the form, the spirit of the handling" becomes "an end in itself." Pater does not look for a balance between form and matter; he obviously desires an art in which form triumphs, and is its own end or purpose.

The culmination of Pater's *Renaissance* comes in its very last pages — a section that he omitted in his second edition because "it might possibly mislead some of those young men into whose hands it might fall." He then restored it (with slight modifications) in the next edition, and it became one of the great aesthetic "manifestos" (to borrow Kenneth Clark's term) of modern art and modern sensibility. Pater concluded that, in spite of the swift passage of time, the apparent chaos of all that we perceive need not overwhelm us. "Philosophy" or "speculative culture" can lead us to distinguish among experiences; its purpose is to

> rouse, to startle [the human spirit] to a life of constant and eager observation. Every moment some form grows perfect in hand or face; some tone on the hills or the sea is choicer than the rest; some mood or passion or insight or intellectual excitement is irresistibly

[36]Ibid., p. 125.

[37]Ibid., pp. 133–135.

real and attractive to us — for that moment only. Not the fruit of experience, but experience itself, is the end. . . . How shall we pass most swiftly from point to point, and be present always at the focus where the greatest number of vital forces unite in their purest energy?

To burn always with a hard, gemlike flame, to maintain this ecstasy, is success in life.[38]

Pater concludes by saying that the most powerful way to experience and sustain this "ecstasy" is through encounters with art: "the poetic passion, the desire of beauty, the love of art for its own sake" will give "the highest quality" to our fleeting irrecoverable minutes as they pass.[39]

Pater's credo offers no guide — certainly no moral or ethical standard — to lead us in the choice of one experience or gemlike moment as compared to any other. It is the intensity — the ecstasy — of experiences that matter, not their substance or the nature of their "matter." And this dilemma — arising from the effort to disentangle form from subject — will remain a vexing and deep problem throughout the entire formalist movement that followed (for several decades) in the aftermath of Pater's beguiling and inimitable formulation. "I believe," said Lord Henry in the opening pages of Oscar Wilde's *The Picture of Dorian Gray* (1890),

> that if one man were to live out his life fully and completely, were to give form to every feeling, expression to every thought, reality to every dream — I believe that the world would gain such a fresh impulse of joy that we would forget all the maladies of mediaeval-ism. . . . But the bravest man among us is afraid of himself. . . . Every impulse that we strive to strangle broods in the mind and poisons us. . . . The only way to get rid of a temptation is to yield to it. Resist it, and your soul grows sick with longing for the things it has forbidden to itself. . . .[40]

The world (and the individual) might indeed gain an extraordinary "fresh impulse of joy" by experiencing the most intense sensations and pleasures, but these might also lead one down pathways that were anything but medieval (or Christian) or even Hellenic (as Lord Henry soon intimates). Dorian takes to these new pathways, and in this sense he is a clear cousin to Huysmans' hero in search of new forms of "subtle, exquisite" aesthetic and other pleasures — new kinds of "delectation." Indeed, Huysmans' and Wilde's

[38]Ibid., p. 236.

[39]Ibid., p. 239.

[40]Oscar Wilde, *The Picture of Dorian Gray*, Oxford University Press, 1989, pp. 17–18.

novels had a common lineage, and their books (as well as Pater's) played at least some role in encouraging the extravagances — sometimes tragic — of Algernon Swinburne, Simeon Solomon, Aubrey Beardsley, and Wilde himself in the 1880s and 1890s.

Pater's life of "gemlike flames" is a rarified one, and it was likely to be open only to those few artists and connoisseurs of experience who were able to respond to the intensity of passion found in aesthetic form. Whistler was hardly Pateresque in this rarified way, but he was unquestionably the most conspicuous and articulate figure of the aesthetic movement's early phase in England. He had spent a great deal of time in Paris, and he soon began to make clear — indeed, to broadcast — his total disregard for the "public" and its possible education in art. He also declared, with *sang froid*, that painting was a matter of forms, colors, and patterns, not of "subjects."

It was not surprising, therefore, that major figures such as Morris and Ruskin took up arms against all such ideas. Morris sounded a major alarm against

> an art cultivated professedly by a few and for a few, who would consider it necessary — a duty if they could admit duties — to despise the common herd, to hold themselves aloof from all that the world has been struggling for from the first, to guard carefully every approach to their palace of art. It would be a pity to waste many words on the prospect of such a school of art as this, which . . . has for its watchword a piece of slang that does not mean the harmless thing it seems to mean — art for art's sake. Its foredoomed end must be, that art at last will seem too delicate a thing, even for the hands of the initiated to touch.[41]

Morris was contemptuous of art for art's sake, but not interested in pursuing the issue aggressively. The great heroic battle of the era — as suggested earlier — was the sensational trial initiated by Whistler, who sued Ruskin for defaming his reputation and thus endangering his livelihood. The triggering event was an art exhibition at the Grosvenor Gallery in 1878. The exhibition included paintings such as *The Days of Creation* by Burne-Jones, *The Bath* by Alma-Tadema, some portraits by Sir John Millais, and Watts' *Love and Death*. Among them, however, were works by Whistler that included a portrait of a friend posing as Philip of Spain, titled *Arrangement in Black No. 111*. There were also some apparently indecipherable works titled *Nocturnes* (*Nocturne in Blue and Silver* or *Nocturne in Black and Gold*). In his review of the show, Ruskin wrote "I have seen and heard much of Cockney impudence before now but never expected to hear a Coxcomb [that is, Whistler] ask 200 guineas for flinging a pot of paint in the public's face."

[41] *Hopes and Fears for Art*, p. 54.

In the suit and trial that followed, the symbolic overtones were obviously immense: Ruskin's concept of art for the public and for its moral values, confronting Whistler's art for the few, for its aesthetic values. Toward the beginning of the trial, the prosecutor asked Whistler what a "Nocturne" was. Whistler responded that it was a composition presenting an arrangement of lines, colors, and shapes or forms. One of the *Nocturnes* — *The Falling Rocket* — was then produced as evidence (although the painting was unwittingly shown upside down). When asked about the picture, Whistler said it referred to fireworks seen at Cremorne. The prosecutor asked whether it was not therefore "a view of Cremorne." Whistler replied, "If it were called a view of Cremorne, it would certainly bring about nothing but disappointment on the part of the beholders. It is an artistic arrangement."[42] Whistler was then asked how long it took him to paint pictures of this kind or — in the language of the prosecutor — how long did it take you to "knock it off?" Whistler answered that it might have been a couple of days, or perhaps one day. "The labor of two days, then," asked the prosecutor, "is that for which you ask 200 guineas?" To which Whistler replied, "No; I ask it for the knowledge of a lifetime."[43]

Whistler won the case, and Ruskin never entirely regained his enormous reputation as the major expositor of art in England. In spite of his victory, Whistler was awarded no financial damages. He found it more and more difficult to sell his work, and ultimately went bankrupt. In effect, no one really won the battle, but several points had been pressed forward in a way that would leave a strong impression for a very long time to come. It was clear that one could now conceive of excellent art that did not convey moral or spiritual qualities; indeed, it did not even require a self-evident subject. Beyond that, Whistler managed to raise serious questions about the need to adhere to certain traditional categories of excellence in painting, mainly because of the testimony of some artists, especially Burne-Jones, who appeared as a witness on behalf of Ruskin but declared that Whistler's *Nocturnes* did indeed contain genuine artistic quality. He thought that the use of color and the creation of atmosphere were particularly impressive. When asked whether "detail and composition" were not essential to works of art as well as "finish," Burne-Jones agreed that these qualities were important, and he was emphatic in stating that Whistler's painting was not worth 200 guineas. But the final effect of his testimony was ambivalent. It suggested that new criteria — including tone and interesting uses of color — might go far toward the creation of a genuine work of art, even if detail, composition, finish, and overt subject matter were lacking.

[42]Stanley Weintraub, *A Biography: Whistler*, Weybright and Talley, New York, 1972, p. 202.

[43]Ibid., p. 203.

The Whistler-Ruskin trial (and the Oscar Wilde trial that followed some years later) brought the aesthetic movement in England to an inconclusive end. But if "art for art's sake" — in its most extravagant form — was in most respects dead, it left a lasting (if more muted and variegated) legacy, notably among the Bloomsbury group that would soon be coming of age: Roger Fry, Virginia Woolf, Vanessa Bell, Clive Bell, Duncan Grant, and Lytton Strachey. Roger Fry and Clive Bell proved to be precisely the critics and theorists whom Barnes was compelled to take into account as he began to develop his own ideas about art. It may seem strange that he would have turned to those who — at least in certain respects — inherited the tradition of "art for art's sake." But Fry in particular addressed centrally important issues that Barnes had to confront, and in his confrontation, he actually drew heavily on Fry's own work.

5

Formalism: Rival Aesthetic Theories

Fry and Formalism

> One runs a theory as long as one can and then many theories accumulate . . . and you have to break the mould and start afresh.
> — Roger Fry

During the early decades of the twentieth century, Roger Fry was indisputably the most important art critic and theorist in England and America. He was not a moralist. He was not a populist. He was certainly not a socialist. But he had clear affinities to Ruskin and Morris insofar as he proselytized inexhaustibly on behalf of fine art and design, as well as music and dance. When he introduced the post-impressionists to London in his 1910 and 1912 exhibitions at the Grafton Gallery, he responded with resilience and determination when the work of artists such as Cézanne, van Gogh, Gauguin, and Seurat was almost universally greeted with laughter, outrage, and cries of "madness." He lectured, he sent letters to the press, and he produced a steady stream of articles and eventually some lucid, penetrating monographs.

In his introduction to Fry's *Last Lectures* (1939), Kenneth Clark wrote, "In so far as taste can be changed by one man, it was changed by Roger Fry." Clark did not exaggerate: by the time he made that statement the post-impressionists, thanks largely to Fry, were accepted as grand masters, and the work of Matisse and Picasso (including his previously reviled cubist paintings) were long since highly prized.

Fry was brilliant, eloquent, kind, and loyal. He could also be withering. But he had no rivals of any consequence in England or America when it came to championing and elucidating the advanced art of his era. By the time his influence was waning, a talented new generation of Anglo-American critics and scholars of twentieth century art had begun to emerge, some of whom had learned from his example and writings, including Lawrence Gowing, David Sylvester, Adrian Stokes, and Alfred Barr.

Fry is significant, not only because of his remarkable gifts, but also because he was the most compelling (if also unsystematic) aesthetician of his time and place. A few other writers (such as George Santayana and John Dewey) wrote ambitious and consciously philosophical works on aesthetics. But none of them had the "practical equipment," so to speak, that Fry had. None were serious painters, and none had a comparable capacity to understand and analyze individual works of art with sensitivity and acumen, while also developing general principles to define the nature of art, the creative process, and art's effects on the "spectator."

Fry was rarely if ever authoritative; he was (instead) committed to a dialectical method:

> I am afraid that my attitude to aesthetics is essentially a practical and empirical one. I go about the world continually looking at works of art, endeavoring to train myself to appreciate them and using the faculty of appreciation thus developed to test their relative values. In carrying out this work of comparison, I find myself obliged from time to time to sum up my results in a theory of aesthetic which I always regard as provisional and in the nature of a scientific hypothesis, to be held until some new phenomenon arises which demands that the terms of the theory shall be revised so as to include it. It is only such an inductive aesthetic that I can offer you.[1]

He continued to take this position throughout his career, offering no absolutes or single theory — convinced that none could be relied upon as unassailable. He saw the process of testing, revising, disproving and reconstructing as the norm, precisely because he expected to constantly encounter new forms of art that would inevitably be intellectually disruptive. He confronted virtually every major aesthetic question and theory (including their various terminologies) that was debated in England and America from the 1880s through the 1920s and beyond.

Albert Barnes became inescapably part of this debate, and it had an enormous influence on his own thinking. Perhaps not surprisingly, the rival theories of the time had a great deal in common. Indeed, as the debate continued, the distinctions among several views (and terms) seemed to diminish, while, paradoxically, the arguments (especially in Barnes' case) grew more heated. Fry (more than anyone else) established the main parameters of the entire discussion. Having done so, however, he — unlike Barnes — continued to modify his views in the light of new insights and more searching reconsiderations.

[1] Christopher Reed ed., *A Roger Fry Reader*, University of Chicago Press, 1996, p. 61.

The issues were complex, but the main points were not difficult to identify. The central problem concerned the relationship between the subject matter of a work of art (its "literary" associations) and its form (or aesthetic characteristics). A growing focus on the aesthetic or formalist elements grew quite naturally towards the end of nineteenth century with the development of professional connoisseurship and art history. Connoisseurs and scholars were drawn to look more closely at the formal details of paintings — the handling of paint, the interplay of colors, the precise use of (or lack of) traditional drawing, and the composition or design or "architecture" of a work. As the consideration of formal issues became more important, the subject matter became less relevant. In 1896, Bernard Berenson warned that those people

> who have not yet differentiated the specific pleasures of the art of painting from the pleasures they derive from the art of literature, will be likely to fall into the error of judging the picture by its dramatic presentation of a situation or its rendering of a character; will, in short, demand of a painting that it shall be in the first place a good illustration. . . .[2]

An additional reason for the reaction against subject matter was the fact that so much nineteenth-century English (and other) art was sentimental. Dramatic moments and situations — often from middle-class life — were chosen as subjects in order to evoke feelings of sympathy, suspense, religious inspiration, fear, and similar emotions. These included subjects such as *A Huguenot, on St. Bartholomew's Day, Refusing to Shield Himself from Danger by Wearing the Roman Catholic Badge*; *The Awakening Conscience*; and *Compositional Study for a Converted British Family Sheltering a Christian Priest from the Persecution of the Druids*. For many observers, such "dramas," vividly illustrated, became the main point of art, and one has only to consider the titles — even without reproductions — to understand why members of a new generation of artists and critics would begin to favor art entirely devoid of "stories" and literary "matter." Whistler could not restrain himself from offering a vivid commentary on such pictures:

> [A]t last . . . there was the subject in all its glory — wonderful! The British Subject! Like a flash the inspiration came — the Inventor! — and in the Academy there you saw him: the familiar model — the soldier or the Italian — and there he sat, hands on knees, head bent, brows knit, eyes staring; in a corner angels and cogwheels and things; close to him his wife, cold, ragged, the baby

[2]Bernard Berenson, *The Florentine Painters of the Renaissance*, G. P. Putnum's Sons, New York and London, 1896, pp. 7–8.

in her arms — he had failed! The story was told — it was clear as day — amazing! — The British subject![3]

Roger Fry's own views on the problem of the "subject" — British or otherwise — evolved over time. Having begun his career as a scholar and connoisseur of early Italian art, he corresponded with Berenson about attributions, and (in 1901) wrote about Giotto's Assisi frescoes, stressing their literary and dramatic power. Similarly, he published a book on Giovanni Bellini, and wrote brief commentaries on Uccello, Piero della Francesca, and Signorelli (among others). During this period, he also wrote admiringly about the work of the Victorian artist George Watts who "did not despair of humanity" and could "still think of the human form as capable of large and stately gesture, of grave and lofty mien."[4] Indeed, at that time, Fry was explicit about the power of art's subject matter as well as its literary associations, noting that "the objection to literary art, if pressed, would rule out all the ready-made material of the imaginative life, would exclude representations of biblical scenes and all historical and dramatic painting."[5]

By 1906, however, Fry had discovered the work of Cézanne, whose paintings made a strong impact on him, and moved him to express his response in lectures and writings. Years later, he described the sudden revelation of this first encounter:

> I had heard of [Cézanne] vaguely from time to time as a kind of hidden oracle of ultra-impressionism, and, in consequence, I expected to find myself entirely unreceptive to his art. To my intense surprise, I found myself deeply moved. I have discovered the article in which I described this encounter, and though the praise I gave would sound grudging and feeble today — for I was still obsessed by ideas about the content of a work of art — I am glad to see that I was ready to scrap a long-cherished hypothesis in the face of a new experience.[6]

In Cézanne and the post-impressionist movement, Fry found that "art had begun to recover once more the language of design and to explore its long neglected possibilities," which had almost been lost in "the fervid pursuit" — since the Renaissance — "of naturalistic representation."[7] From this moment, Fry's approach to the theory and criticism of art was transformed.

[3]E.R. and J. Pennell, *The Life of James McNeill Whistler*, William Heinemann, London, 1908, vol. 1, pp. 81–82.

[4]Reed, p. 33.

[5]Ibid., p. 35.

[6]Roger Fry, *Vision and Design*, Chatto & Windus, London, 1929, p. 289.

[7]Ibid., p. 290.

In "An Essay in Aesthetics" (published in the *New Quarterly* of 1909), Fry laid out a number of ideas that continued to dominate aesthetics in England and the United States for at least the next two decades. He tried, for example, to make a distinction between instinctive behavior in actual life (such as immediately running away in fear at the sight of a bear) and "imaginative" behavior (when we see such an event depicted in art, "which presents a life freed from the binding necessities of our actual existence").[8] Without the need to act, Fry suggested, one can be detached from "moral" considerations and simply respond to works of art as aesthetic objects: "Morality, then, appreciates emotion by the standard of resultant action. Art appreciates emotion in and for itself."[9] This distinction was to be echoed (and sometimes modified) by writers such as Clive Bell, and the question of what "happens" to the spectator when he or she views a work of art (as contrasted to experiencing an actual event in life) became a central one.

But Fry's most important contribution in "An Essay in Aesthetics" was his effort to define forthrightly what he believed to be the chief elements of aesthetic design, particularly those that are most conspicuous and significant in the art of painting. He had certainly been influenced by Denman Ross' *A Theory of Pure Design: Harmony, Balance, Rhythm* (1907). But it was Fry himself who specified succinctly, "the rhythm of the line — the record of a gesture" drawn by the artist; then "the element of mass," indicating the potential movement (or inertia) of objects seen in three dimensions; and finally "space; light and shade; color; and the role of planes."[10]

In other words by 1909, Fry had already articulated (for his own era) the central characteristics that should be taken into account in any effort to describe the aesthetic elements of design, composition, or form in painting. Berenson had pointed out the importance of line, color, space (and tactile values) long before. But Fry was both more comprehensive and more precise: rhythm/line, mass/movement, light/shade, color, space, and planar relations were all noted as essential to any "formalist" analysis of a work of art. In the two decades after Fry, some critics or writers emphasized certain of these aesthetic elements rather than others; some omitted one or more; some altered an important term or two and, in doing so, tended to become doctrinaire about what was absolutely essential, and what was not. But Fry himself in his approach to works of art, kept all the "categories" in play (without drawing on them mechanically). He addressed every work on its own terms, commenting only on those aesthetic and technical elements that he saw as crucial to its particular character and effect, while seeking to describe it as a unified whole, rather than a set of categories or "boxes" to be checked off. In

[8]Ibid., p. 21.

[9]Ibid., p. 27.

[10]Ibid., pp. 33–34.

its flexibility, Fry's method provides a striking contrast to that of Barnes, who tended to proceed systematically and "scientifically," taking account of a great many details while evaluating each separate element, as well as rendering a final judgment of a work's quality.

Because Fry was the first Anglo-American critic to write in depth about the post-impressionists, he had to create a great deal of his own analytic framework, his terms of reference, and his critical vocabulary. His description of Cézanne's *La Femme à la cafetière* is a case in point:

> It is a portrait of the *bonne* of his home at Aix. In sitting for her master, she evidently took the pose which all uneducated people take before [a] camera. It was like Cézanne in his maturity to accept this without question, without any attempt to arrange things for pictorial effect and to trust to the extraordinary resources of his art to pull him through. He even seems to delight in the rudimentary simplicity of the situation. He does not hesitate to repeat everywhere the perpendiculars, even to the point of putting the spoon and the coffee spout directly facing him, and emphasizing the fastening of the servant's dress by a line which divides the figure symmetrically.[11]

Fry begins by describing aspects of the composition of the picture, while also highlighting its natural simplicity and even the awkwardness of the *bonne*. He then comments on the handling of spatial relations, the use of light, and other precisely chosen features:

> All is posed full face and in front of a flat door parallel to the picture plane . . . like a defiant renunciation of all those devices which painters had adopted since the High Renaissance . . . to increase the recession of the picture space. . . . Cézanne knew that a flat door could reveal to his searching analysis as many complexities of movement, as great a play of surface, as any object whatever, under the play of light. . . . Every part has the vibration and movement of life; . . . [The] modeling of the hands is very much simplified whereas the surface of the door is infinitely varied. This exemplifies [Cézanne's] . . . feeling that the plastic sequence must be felt throughout the whole surface of the canvas.[12]

For Fry, Cézanne is a "classic" artist whose work is characterized by fundamental simplicity, unselfconscious gravity, "perfectly lucid organization,"

[11]Roger Fry, *Cézanne*, Noonday Press, New York, 1958, p. 66.
[12]Ibid., pp. 66–67.

and the utter legibility of the design's "plasticity." With respect to what he calls Cézanne's "smouldering glow of colour," he writes,

> The basis of the whole web of colour is a blue somewhat like Vermeer's, of whom one is reminded again by the opposition of pale yellows something between citron and Naples yellow in the chair-back. The robe gleams with tints of old rose modulated with endless variations of violet. . . .[13]

Although Fry's main focus at this time was on the development of a formalist critical framework, his exceptional versatility and constant search for meaning at all levels made clear that he was open to a variety of analytic approaches. The work of van Gogh had been ridiculed and dismissed out of hand at the Grafton Gallery exhibition of 1910, but Fry was powerfully moved by its deep revelation of the artist's experience:

> Those who have laughed at this great visionary because he became insane, can know but little of the awful adventures of the imagination. . . . To Van Gogh's tortured and morbid sensibility there came revelations fierce, terrible, and yet at times consoling, of realities behind the veil of things seen. Claiming his kinship with Rembrandt, Van Gogh became a portrayer of souls; souls of broken, rugged, ungainly old women like the *Berceuse*, whose greatness yet shines in the tender resignation of her folded hands; souls of girls brutalized by the associations of utter poverty, and yet blazing with an unconscious defiance of fate. And souls of things — the soul of modern industrialism seen in the hard splendor of midday sun upon the devouring monsters of a manufacturing suburb; the soul of the wind in the autumn corn and, above all, the soul of flowers. Surely no one has painted flowers like Van Gogh. . . . [We] know that modern European art has almost always maltreated flowers, dealing with them at best but as aids of sentimentality until Van Gogh saw . . . the arrogant spirit that inhabits the sun-flower, or the proud and delicate soul of the iris.[14]

Fry describes with precision some of the salient aspects of van Gogh's "visionary" style and art; but he moves beyond detailed formalist analysis, to describe the artist's tormented nature, his madness, and his capacity to understand and penetrate the essence of old women, impoverished girls,

[13]Ibid., p. 69.

[14]Reed, pp. 91–92.

industrialism, and the actual character of different flowers. In other words, the "subject" and all its power have re-entered Fry's critical vocabulary as he finds himself unable to write about the work without capturing the personalities — the qualities and characteristics — of the people and other objects that inhabit van Gogh's world.

In short, Fry found it perfectly natural — even in his most formalist phase — to allow very specific and yet highly varied human values to enter his response to art. Indeed, continued reflection on the place of subject matter in art led him to state, later in his career, that painting had indeed a "double nature" — representation and plastic design — because it was simply impossible to keep "the subject" out of great painting. In a lecture he delivered in 1932 (but not published until 1969) Fry concluded that the "heroic attempt" by painters to escape into "a pictorial art almost devoid of any natural representation" had effectively failed: "So I revert to my idea that, in spite of these attempts at abstraction, painting has always been, and probably will remain, for the greater part a representational art."[15] True to his own theoretical stance, Fry (in a letter of 1928) acknowledged that he was once again about to switch gears: "One runs a theory as long as one can and then too many difficulties in its applications — too many strained explanations accumulate and you have to break the mould and start afresh."[16]

The fact that Roger Fry changed his mind (more than once) about the relationship between subject matter and design (or form) did nothing to settle the issue. Some critics and theorists (and members of the general public) continued to insist on the importance — if not primacy — of the subject, while others (particularly with the growing emphasis on abstract art) were increasingly focused on formal and aesthetic qualities.

Meanwhile, the effect of works of art on the spectator or viewer emerged as an additional subject of debate. The issue was important in itself, but was equally significant because of its profound educational implications. If art was to play a significant role in education — as Barnes believed it should — then it would be important to know and describe what the nature of its impact might be. Would art "elevate" people, or inspire them? If it moved them, was it possible to state with any precision what they actually felt? Was there a particular set of emotions that characterized their response to aesthetic objects *per se*? Or did such feelings vary enormously — not only because of the particular work of art in question, but also because of the character or personality of the individual viewer? Speculation abounded, but evidence was in short supply.

[15]Ibid., p. 381.

[16]Ibid., p. 318.

Fry wrote extensively about the potential effects of painting on viewers in his letters, speeches, essays, and books. After reading Tolstoy's *What Is Art?*, he rejected most of his ideas because Tolstoy judged art primarily from a moral point of view. But Fry was struck by the Russian's assertion that art was "a means of communication" between human beings and that it was "*par excellence* the language of emotion."[17] Fry's first response to this view was to assume that artists drew upon their "real life" experiences and emotions and then "translated" them into an aesthetic composition that could express their feelings. The spectator was then left to decode or interpret the work of art, in order to gain access to those original feelings. As Fry said, the form or composition of a work is

> the direct outcome of an apprehension of actual life by the artist. . . .
> I also conceived that the spectator in contemplating the form must inevitably travel in an opposite direction along the same road which the artist had taken, and himself feel the original emotion which it conveyed as being inextricably bound together in an aesthetic whole.[18]

Fry quickly grasped, however, the simplistic nature of such a theory. Through his conversations with artists about post-impressionist art, he recognized that his ideas were simply unsustainable:

> It became evident through these discussions that some artists who were peculiarly sensitive to the formal relations of works of art, and who were deeply moved by them, had almost no sense of the emotions which I had supposed them to convey.[19]

If the work of many — perhaps most — artists did not draw directly on their own "real life" experiences and emotions, Fry was inevitably led to ask what the artists were in fact feeling when they were painting or sculpting. Were they primarily engaged by the straightforward task of creating the work, attempting most of all to ensure its final "rightness?" It was at this point that Fry was struck by Clive Bell's assertion (in his 1914 book *Art*) that the artist need not be concerned at all with the emotions of ordinary life, but "only with the expression of a special and unique kind of emotion, the aesthetic emotion."[20] According to Bell (paraphrased by Fry), "[A] work of art had the peculiar property of conveying the aesthetic emotion, and it did this in virtue of having 'significant form.'"[21]

[17]Fry, *Vision and Design*, p. 293.

[18]Ibid., p. 294.

[19]Ibid., p. 294.

[20]Ibid., p. 295.

[21]Ibid., pp. 294–295.

For Fry, this effort on Bell's part to isolate "the purely aesthetic feeling" from all others, had "immense value." He thought that an important clarification might have been made, but he continued to wonder whether this was in fact the case:

> Supposing then, that we are able to isolate in a work of art this purely aesthetic quality to which Mr. Clive Bell gives the name of "significant form." Of what nature is it? And what is the value of this elusive and — taking the whole mass of mankind — rather uncommon emotion which it causes? I put these questions without much hope of answering them, since it is of the greatest importance to recognize clearly what are the questions which remain to be solved.[22]

Then, surprisingly, Fry decided to change course and attempt a description — in purely personal terms — of the potential nature and effects of "significant form." The passage (which concludes the essay "Retrospect") shows Fry stopping just short of the "gulf" of mysticism toward which significant form seemed to be leading him:

> We feel that a work which possesses [significant form] . . . is the outcome of an endeavour to express an idea rather than to create a pleasing object. Personally, at least, I always feel that it implies the effort on the part of the artist to bend our emotional understanding by means of his passionate conviction to some intractable material which is alien to our spirit.

The creation of a work of art is here seen as an immense test of the artist's strength to compel us to confront and understand some "intractable material" that is "alien to our spirit:" not alien in the sense of absolutely divorced from us, but alien in the sense of being beyond the reach and imagination of our ordinary selves. Art seeks to express a type of idea that seems otherwise inaccessible to us. Having gone this far, Fry pauses to confess his uncertainties, if not doubts:

> I seem unable at present to get beyond this vague adumbration of the nature of significant form. Flaubert's "expression of the idea" seems to me to correspond to exactly what I mean, but, alas! he never explained, and probably could not, what he meant by the "idea."
>
> As to the value of the aesthetic emotion — it is clearly infinitely removed from those ethical values to which Tolstoy would

[22]Ibid., p. 301.

have confined it. It seems to be as remote from actual life and its practical utilities as the most useless mathematical theory. One can only say that those who experience it feel it to have a peculiar quality of "reality" which makes it a matter of infinite importance in their lives. Any attempt I might make to explain this would probably land me in the depths of mysticism. On the edge of that gulf I stop.[23]

If the effects on the spectator were at all similar to those just described, the task of designing an educational program (as Albert Barnes intended) with art as its central component, would clearly be a formidable one. What kind of a curriculum could lead students to something like the elusive emotional experience suggested by Bell and Fry? The answer is that Barnes in fact drew heavily on Fry in creating a course of study that centered largely on the formal elements of works of art. He came to believe that students could learn to respond to art with increased intensity through such a method. Moreover, Barnes tried to sustain — at least for some time — the connection between formal analysis, on the one hand, and (on the other) the democratic vision of education that he and Dewey emphasized so persistently. For Barnes, a democratic approach meant that every individual, from every background, should be given the opportunity to learn and to develop his abilities. As a result, people of all social classes were to have access to Barnes' gallery and to his educational program. Indeed, such a program should achieve a large measure of "practical good." These views were clearly reinforced by Dewey's own vision as expressed in 1920:

> Government, business, art, religion, all social institutions have a meaning, a purpose. That purpose is to set free and to develop the capacities of human individuals without respect to race, sex, class or economic status. And this is all one with saying that the test of their value is the extent to which they educate every individual into the full stature of his possibility. Democracy has many meanings, but if it has a moral meaning, it is found in resolving that the supreme test of all political institutions and industrial arrangements shall be the contribution they make to the all-around growth of every member of society.[24]

Dewey's (and Barnes') "supreme test" was obviously a difficult one to meet. It was an exceptional challenge for a program such as Barnes' that was

[23]Ibid., p. 302.

[24]John Dewey, *Reconstruction in Philosophy* (1920), *Intelligence in the Modern World*, Joseph Ratner ed., Modern Library, New York, 1939, pp. 629–630.

devoted entirely to education through an intense exploration of the main aesthetic elements of art. How Barnes attempted to meet this challenge, and whether he succeeded, are critical questions to be addressed in the context of his own writing — especially *The Art in Painting.*

<p style="text-align:center">✳ ✳ ✳</p>

The Art in Painting

Albert Barnes was in many respects prodigious — in his collecting, his pursuit of ideas about art, and in his writing. He produced five substantial books on aesthetics, art education, and the work of Cézanne, Renoir, and Matisse. This would have been an impressive accomplishment for a trained art historian, critic, or aesthetician who had devoted an entire lifetime to scholarship and teaching. For an autodidact such as Barnes, who lacked any formal education in art, the feat was more than exceptional, and in the late 1920s and 1930s, his books were far from overlooked. He developed his central ideas about art in his first 500-page book, *The Art in Painting* (1925), which received several favorable (though not unqualified) reviews by Alfred Barr, Ezra Pound, Leo Stein, and John Dewey, among others.

He had prepared himself for his study in a formidable way, with repeated journeys to Europe, visiting collections, taking voluminous notes, and constantly refining his observations. Nor did he arrive at conclusions quickly. In July 1914, he wrote to Leo Stein about his effort "to find out what is a good painting; who was the man behind the painting, what broad principle of psychology would explain those paintings which appealed to me, and . . . which painter or group of painters represent what I consider the principles of true art. After all this effort I feel that I am still far away from my goal."[25]

The Art in Painting was ambitious and thoughtfully conceived. His analyses of individual paintings were often perceptive and his attention to detail was exceptional at the time. Following Berenson, Whistler, and Fry (among others), Barnes argued that the subject of a painting can distract viewers from the most important elements of a work of art — the aesthetic aspects, or its "plastic form." "We miss the function of a painting if we look to it either for literal reproduction of subject matter or for information of a documentary character," he wrote. Rather, "[W]e should look for the qualities that are significant, which have the power to move us esthetically." This was a position that became central to Barnes' theory, seeming to place him directly in the tradition of strict formalist analysis, although he himself would have mobilized his considerable energy to deny the fact. In his own eyes, he was anything but a formalist, and he frequently tried to soften his position on

[25]Barnes to Leo Stein, July 17, 1914. BF Archives.

subject matter, treating it as an integral part of a painter's work in order to highlight his concern for the "human" elements in art:

> We have seen that the value of a painting resides in its plastic form, not in its subject matter, but that does not mean that the appeal of a painting, as a concrete reality, is not due in part to what is shown in it. Plastic form and subject matter are not in any absolute sense separable.[26]

In comparing Renoir and Cézanne, Barnes stressed the fact that both move us by mirroring "so vividly, a world that we know by having lived in it, that we get an actual sense of going through an experience. . . . [They] make art and life one."[27] But in his continuous effort to relate particular works of art to human values he was forced to confront the challenge of bringing together overt subject matter; the analysis of plastic elements; and the experiences and values of actual life in a way that might possibly lead to a satisfactory "unified" theory — something that he was never able to achieve. Indeed, in *The Art in Painting*, Barnes' theories often drove him substantially away from a unified conception. He was explicit in stating that any "relevant judgment or criticism of a picture" should consider "only the plastic means" used by the artist. If we ask what those plastic means consist of, we find a deep dependence on his predecessors, especially Roger Fry. In his discussion of "Plastic Form,"[28] Barnes lists (and briefly discusses) the elements of color, drawing or line, mass, rhythm, spatial depth (including "solidity" and the "rendering of planes one behind the other"), and light and shadow. Sixteen years earlier Fry had identified a similar list — "the rhythm of the line," "the element of mass," space (including depth), light and shadow, color, and the role of "planes." Fry's order (and his strong emphasis on some components other than color) differ from Barnes (who valued color above all), but the principal terms are essentially the same.

Perhaps it was Barnes' sensitivity to these parallels that led him to insist that his concept of "plastic form" offered the only valid way to analyze and evaluate a genuine work of art. He could not resist disparaging critics "of the so-called advanced school who prove by their writings that all they see in painting is mere pattern, although they endow it with the oracular mystification of terms such as 'plastic design' or 'significant form.'"[29] Fry and Clive Bell are the clear targets here, dismissed with sarcasm even though Barnes had derived so much of his own work from their ideas. Evidence of his debt to Fry in particular is clear from an analysis of their respective writings, and

[26] *The Art in Painting*, p. 72.

[27] Ibid., p. 71.

[28] Ibid., pp. 55–71.

[29] Ibid., p. 61.

Barnes explicitly referred to Fry's influence more than once. In his article "The Temple" (published just a year before *The Art in Painting*) he described the impact of a conversation with Fry at Guillaume's gallery: "[I] took possession of Roger Fry and had a talk on Renoir and Cézanne which I will remember for the rest of my life."[30] And in early 1913, when Barnes subsidized a New York gallery show of Maurer's work, he insisted that excerpts from Fry's (and Bell's) writings be printed in the catalogue. In addition, he went out of his way to praise Bell enthusiastically in his article "How to Judge a Painting."

His lack of generosity was all the more glaring, since his attack reveals that he had not read Fry carefully enough. After all, it was Fry who had written so poignantly about van Gogh. Nor did he ever fully embrace Clive Bell's conception of "significant form." Indeed, Bell was skeptical about his own terminology — and he also recognized that Fry never accepted his ideas. As he wrote in *Old Friends*:

> [Fry] never quite swallowed my impetuous doctrine — Significant Form first and last, alone and all the time; he knew . . . too much, and saw raw morsels stuck in his scientific throat. He came near swallowing it once; but always he was trying to extend his theory to cover new difficulties. . .[31]

In short, in his determination to establish the superiority of the term "plastic form" over Fry's "plastic design" (or Bell's "significant form"), Barnes missed much of the actual nature of Fry's work, failing to acknowledge the complexity of his criticism (as well as his willingness to change his mind in the face of new insights).

Despite Barnes' critique of Fry, he faced a similar dilemma. He was committed *de facto* to a formalist analysis of art when he set aside subject matter, identifying the chief elements of painting as color, line, mass, light and space. Yet he continued to believe that art was deeply related to significant human experience, and he needed, therefore, to find ways to reconnect such experience to the formal aspects of art. Having complained that Fry never moved beyond a discussion of mere patterns, Barnes was unable to provide a persuasive alternative of his own:

> The painter is not debarred from the use of the visible world . . . but the qualities which lie most immediately in his province are

[30]"The Temple," *Opportunity*, May 1924, p. 139. BF Archives.

[31]Clive Bell, *Old Friends*, Chatto & Windus, London, 1956, p. 73.

those more directly apprehended by sight. Color, line, light, mass — these things, as immediately experienced, are illuminated for us by the painter. Upon them he focuses the funded experience which, richer in him than in the ordinary man, enables him to single out whatever is moving or significant, and set it in the context of relations needed to reveal its intrinsic nature.[32]

The obvious problem here is the extraordinarily vague nature of the process that Barnes attempts to describe in this passage. How does the painter "directly" apprehend such elements as color, line and mass, and then "illuminate" them by infusing them with part of his "funded experience"? What kinds of experience does the painter draw upon, and what makes them "moving" or "significant"? Barnes avoids all such questions, and soon moves toward a conception of art that is fundamentally abstract — or "abstracted from" the realm of human events and values:

> [J]udgment or criticism of a picture involves the ability to abstract from the appeal of the subject matter and consider only the plastic means in their adequacy and quality as constituent of plastic form. In that sense, a picture of a massacre and one of a wedding may be exactly the same types as works of art. We may abstract from each the form, which is made up of the plastic elements, and determine the quality of that plastic form as an organic unified fusion of those elements. Until one has formed by study and long experience the habit of doing so, the intrinsic appeal or repulsion of the subject matter itself will constitute the chief interest found in pictures.[33]

As Barnes abstracts the "plastic means" from each painting, the picture becomes purely a composition of these "means." In fact, the level of abstraction is so complete that one may come to see only the essential "form" — made up of curves, colors, diagonals, lines and similar characteristics — of each painting. At that level, Barnes concludes, "a picture of a massacre and one of a wedding may be exactly the same types" of work. Subject matter has now been completely obliterated. Even the artist — with his fund of experience — has vanished from the scene. The viewer is relegated to a world where the emphasis falls upon pattern-like similarities or dissimilarities to be identified and discussed. This radical shift has now made Barnes' original challenge — to connect the formal aesthetic elements of art with the reality of human experience — even more formidable, if not impossible.

[32] *The Art in Painting*, pp. 13–14.

[33] Ibid., p. 72.

He attempted to address this difficulty in his later writings (especially in his books on Renoir and Cézanne). Meanwhile, he insisted that "long experience" and serious "study" were essential prerequisites to an understanding of the plastic and abstracted forms of art that he described. But this fact had serious implications for his original conception of the Foundation's educational program and its proposed "experiment" in fostering democracy. He had stressed the need to enhance the appreciation of art among different kinds of people from various backgrounds. We have seen that this goal (and Dewey's progressive ideas) reflected broad movements in both England and America to use art as a powerful means of providing "benefits" to people of all social classes. There was, however, an inherent conflict between that vision and the notion that only people who had considerable experience with art (and who were prepared to study it in depth) would be qualified to view it appropriately, in such a way as to resist "the intrinsic appeal or repulsion of the subject matter." In fact, Barnes' conception of education (as he continued to develop it) was increasingly narrow, focused, and tailored to his own theories. It soon became "art for the few," not in the sense that Pater or Whistler would have used the phrase, but in a way that proved in the end to be equally (if not more) exclusive.

Despite Fry's influence, Barnes' several attempts to demonstrate the connection between art and life were also indebted to Dewey. For Dewey, art and experience were always closely related. And for Barnes, of course, art was never to be studied in an esoteric or academic, "lifeless" way: indeed, it was part of life — similar to, but heightened and more intense than ordinary experience.

This view depended in large part on the ideas that Dewey formulated in a systematic way at a rather late date, in his *Art as Experience* (1934). He argued that "an" experience (as distinguished from experience broadly conceived) consisted of a challenging situation, event, or set of ideas brought to a successful "conclusion." This process of constantly overcoming new complexities — or obstacles — enabled one to "grow" as an individual. But Dewey's examples were mundane and simplistic:

> a game is played through; a situation, whether that of eating a
> meal, playing a game of chess, carrying on a conversation, writing
> a book, . . . is so rounded out that its close is a consummation and
> not a cessation. . . . It is *an* experience.[34]

[34]*Art as Experience, Intelligence in the Modern World*, p. 963.

Such experiences, according to Dewey, are said to have "balance," "harmony," "equilibrium," and "form." Struggle and difficulty have been transcended; the "stability essential to living" is achieved, and the result "bears within itself a consummation akin to the esthetic."[35] In other words, for Dewey, "an" experience is proto-aesthetic in nature — it has a form analogous to a work of art — and the "moment of passage from disturbance into harmony is that of intensest life."[36] In effect, experience and art — or art and life — become one; the two are reconciled, even unified. At such moments of conquest over difficulties, a "heightened vitality"[37] is achieved.

Barnes' ideas follow those of Dewey very closely, although his use of some terms (such as instincts, sensations, and perceptions) derives from the realm of psychology — especially the writings of William James as well as other psychologists whom Barnes had read. Despite these differences in terminology, however, the fundamental theoretical model is Dewey's: a situation or challenge must be confronted, and if one successfully rises above it, one feels "harmoniously united" and "fulfilled." "To say that an experience is of positive value," wrote Barnes, "that it is worth having for its own sake, is to say that in it an instinctive prompting finds fulfillment."[38]

What is true in the realm of action, moreover, is also true (for Barnes) in the realm of perception, where every individual has the capacity, if he will exercise it, to "organize" and learn from his experiences. When this happens — when "any individual makes it his established purpose to see his world as significantly and comprehensibly as possible" — then "his experience is esthetic."[39] Here, as elsewhere, the full resolution of a challenge — such as organizing one's perceptions — is itself an "esthetic" experience. The process creates a sense of order that is valued for its own sake. Life and art become one.

In expanding on his ideas, Barnes also echoed Dewey in providing examples that could lead to individual "growth:"

As long as we are really alive, we continue to grow by extending the application of our funded experience, perceiving things more and more discriminatingly, and at the same time investing them with constantly enriched meanings. This process is exemplified in every activity of life, from playing tennis, to driving a motor car to practicing medicine or engaging in scientific research.[40]

[35]Ibid., p. 961.

[36]Ibid., p. 961.

[37]Ibid., p. 963.

[38]*The Art in Painting*, pp. 8–9.

[39]Ibid., p. 13.

[40]Ibid., p. 6.

These examples are — unfortunately — as mundane as Dewey's ("playing a game of chess, carrying on a conversation, writing a book"). They run the risk of oversimplifying life's actual complexities, while also suggesting that the process of individual growth is not very difficult. They also give the impression that most experience is amenable to being fully understood and "rounded."

Barnes underscores this sense of easily achieved understanding and "shaping" in a passage (already quoted) concerning the art of Renoir and Cézanne:

> Both treated the familiar everyday events that make up our lives. We see, feel, touch the particular quality that gives an object its individual identity. . . . Each [artist] mirrors, so vividly, a world we know by having lived in it, that we get a sense of going through an actual experience. Both are great artists because they make art and life one. . . .[41]

The statement suggests that the "meaning" of Renoir's and Cézanne's work is transparent, and that the relationship between the world they depict in art, and the world one experiences in life, are so similar that the two are united: the painters "make art and life one."

But is such full comprehension — and unity — so easy to achieve? Is our experience of life, or our experience of art, so readily understood? And can the challenges presented by new situations and difficulties in life be so readily overcome by bringing our actions to successful conclusions (Dewey), or by enabling our instincts to be entirely fulfilled (Barnes)?

The answer, of course, is that they cannot. And Dewey recognized the problematic nature of the ideas he had set forth, as did Barnes. Dewey's effort to distinguish between a special form of proto-aesthetic experience and the complexity of *all* experience was clearly unsustainable, and he himself pointed out the difficulty:

> Oftentimes, however, the experience is inchoate. Things are experienced but not in such a way that they are composed in *an* experience. There are distraction and dispersion; what we observe and what we think, what we desire and what we get, are at odds with each other. [We are subject to] extraneous interruptions or lethargy.[42]

[41]Ibid., p. 71.

[42]*Art as Experience, Intelligence in the Modern World*, pp. 962–963.

For Dewey, inchoate experiences were by definition the result of failure (interruptions or lethargy). Clearly, however, much if not most of human experience is inherently "incomplete." It is multifarious, fragmented, ambiguous, and often impenetrable. Yet this very complexity is rich in its implications, and has obviously been — throughout time — a well-spring of very great art. Dewey's inability to take account of such complexity in a positive way left him and his theoretical ideas utterly vulnerable.

Barnes also confronted the problem of "incomplete" — even unintelligible — experiences, but his response, while equally unsatisfactory, was different:

> In general, the ideal [situation] is approached as our instinctive promptings are harmoniously united in every act. Then every experience gains value, . . . and suffers loss from no sense of desire thwarted, or damage done to any of the interests which we have at heart.[43]

Barnes realized, as did Dewey, that the desire to satisfy one's instincts may sometimes be "thwarted" (or that "damage" may be done to one's interests). He believed, however, that such difficulties could be overcome either by persistent effort and determination, or by deciding to ignore them. "At any moment," he writes,

> the sum total of our actual sensations is a chaos: we are besieged by a medley of sights, sounds, feelings . . . which have no connection with one another, and which could not possibly enter into any single experience. To be conscious of anything in particular, to retain our sanity, we must disregard nearly all of them, fixing our attention upon those which fit into some intelligible scheme or picture.[44]

Here, the fragmented, random, chaotic nature of experience threatens one's sanity, and Barnes deals with the problem, not by trying to be as receptive and inclusive as possible, but by deciding to "disregard" everything that does not "fit" into a scheme or picture that is his chosen point of focus. In other words, his approach is highly selective and subjective. He himself creates the unity that he finds in experience. All that might interfere with unity is set aside. If Dewey defined such "interference" as a sign of failure —

[43] *The Art in Painting*, p. 9.

[44] Ibid., p. 5.

because an individual could not always conquer his thwarted or divided feelings — Barnes relegated everything that was "inchoate" to outer darkness. In effect, he dispensed with an enormous part of life in order to create the kind of order and harmony that he so deeply desired. Neither approach — Dewey's or Barnes' — was theoretically satisfactory or persuasive. Neither was able to deal successfully with the variegated and even disorienting nature of experience in all its elusiveness.

6

Science and Objectivity in Art

Objectivity

Over the course of a dozen years, Barnes continually modified — indeed substantially changed — important aspects of his aesthetic theory in an effort to address the problem that continued to bedevil him: if one sets aside subject matter as an integral part of a work of art, how is the work capable of affecting the viewer in human and emotional terms?

Barnes put forward a number of provisional ideas to solve his dilemma. As early as *The Art in Painting*, he tried to define a special relationship between the artist and the viewer, connecting the two as a way to re-unite life and art. "The artist," wrote Barnes, "has embodied an experience in his work, and to appreciate his painting. . ., we must reconstruct his experience, so far as we are able, in ourselves:"

> There is no essential difference in kind between the experience of the artist and that of the observer of his work. . . . The experience of an artist arises out of a particular background, a set of interests and habits and perceptions which . . . are potentially sharable with other individuals. They are sharable, however, only if one is willing to make the effort involved in acquiring a comparable set of habits and backgrounds. To see as the artist sees is an accomplishment to which there is no shortcut.[1]

Here, art and life are "one" because the work of art becomes essentially a transmitter. The artist's feelings are communicated directly through his work, and this enables the viewer to share in — and be moved by — the painter's experience and life. The theory is beguiling, but also unconvincing: it assumes that an artist invariably draws on his own personal experience, which is clearly far from the case. Even when aspects of personal life play a

[1]*The Art in Painting*, p. 7.

role, the artist is very unlikely to understand the full nature of them: enough is known about unconscious motives and feelings for us to recognize that the complex intentions of an artist are essentially impenetrable, either to himself or to others.

Given these difficulties, how can an artist "embody" a fully known, coherent part of his life's experience in a work of art? And how is the viewer able — by looking at a painting — to decode and then reconstruct for himself the artist's own experience and feelings, whatever they may have been? Finally, how can one acquire a "set of habits and backgrounds" comparable to the artist's? This would be impossible even under optimal conditions — and infinitely so in those instances where no acquaintance with the artist exists. In short, neither we (nor the artist) can fully know his feelings, habits, background, and intentions when he is undertaking the painting of a picture (or any other work of art). On this point, Dewey proved to be more perceptive — if rather too open-ended — than Barnes:

> It is absurd to ask what an artist "really" meant by his product: he himself would find different meanings in it at different days and hours and in different stages of his development. If he could be articulate, he would say "I meant . . . whatever you or anyone can honestly . . . get out of it."[2]

Barnes' theory was hardly new and had been discarded years earlier, even by Fry who in his 1920 essay "Retrospect" acknowledged that — as we have seen — he had once entertained similar ideas, but soon recognized that they were unsustainable:

> [Initially], I conceived the form of the work of art to be its most essential quality, but I believed this form to be the direct outcome of an apprehension of some emotion in actual life by the artist. . . . I also conceived that the spectator in contemplating the form must inevitably travel in an opposite direction along the same road the artist had taken, and himself feel the original emotion. I conceived the form [of the work of art] and the emotion which it conveyed as being inextricably bound together in the aesthetic whole.[3]

Fry had considered the possibility that an artist's emotions could be embodied in a work of art and then conveyed to the viewer, who would have to be an active agent, traveling "the same road" until he was in a position to experience the artist's original emotion. But Fry soon abandoned this view,

[2]*Art as Experience, Intelligence in the Modern World*, pp. 629–630.

[3]Fry, *Vision and Design*, p. 294.

acknowledging that "some artists who were peculiarly sensitive to formal relations of works of art, and who were deeply moved by them, had almost no sense of the emotions which I had supposed them to convey."[4] By way of contrast, Barnes continued to press his own ideas forcefully because he wanted to achieve in the world of art the kind of finality that he believed could be attained in science. Perhaps as much as anything, he always desired closure. Ambiguity, irresolution, incompletion, obscurity — these and similar "states" were difficult if not impossible for him to tolerate. He wanted to define, unequivocally, the way in which the exact experience and feelings of the artist and the viewer could be connected, despite all the evidence to the contrary.

When Barnes published his book on Renoir in 1944, he included a revised set of the introductory chapters he had written for *The Art in Painting*. In particular, he elaborated on his ideas concerning plastic form and scientific "objectivity." One significant shift in these later writings involves a much greater emphasis on a painter's creative response to objects in the world around him, rather than on his internal experiences drawn from his personal life. This change enabled Barnes to discuss his concept of objective "seeing" and the interpretation of works of art. "No real science was possible," he wrote, "until a method of investigation was discovered, a method which wholly eliminated the idiosyncrasies of the particular observer from the object to be understood." This methodological process took the place of fanciful "dreaming" on the part of the investigator, and "made the observations and interpretations of one individual verifiable by another. . . . The scientific ideal, in other words, is that of complete objectivity." A similar progression "from dream to reality in the world of art can be made only by the same means — the use of method based upon objective fact . . . [Finally], the appreciation of art, like the understanding of science, requires a grasp of the artist's specific purpose."[5]

Barnes believed that the painter, like the scientist, makes "discoveries" in his work which can be verified by a trained observer. As a result, he saw the interpretation of a work of art as a process that can (theoretically) lead to a single inevitable conclusion, comparable to the results of a successful scientific experiment. He believed that as an artist paints, he organizes

> the visible appearance of things, their shape and color, their texture
> and the manner in which they are composed into groups. These

[4] Ibid., pp. 294–295.

[5] Barnes and de Mazia, *The Art of Renoir*, p. 4.

discoveries he embodies in colored pigments applied to canvas, and his command of his medium appears in his ability to make his picture a true record of what his senses and imagination have grasped in the external world...

What is important for the present is the objective reference of any work of art, the fact that it records a discovery and that the discovery can be verified, the artist's experience can be shared, [but] only by one who has himself learned to see.[6]

The passage is problematic in several respects, but especially because Barnes uses the terms "objective" and "verified" in ways that differ radically from those of a scientist. A painter makes no discovery in the scientific sense. Rather, he *creates* or makes a work of art based (as Barnes himself notes) on his own individual "senses and imagination" — reflecting his own interests, style and inventive capacity. As a consequence, the work will give rise to any number of interpretations that cannot be reconciled with one another. In fact, Barnes himself recognized that such interpretive differences do occur, but he insisted that the variations were "the outcome chiefly of confusion or distraction, such as irrelevant preferences in subject matter," and that, with a "shift of interest to plastic essentials, these [variations] may be more and more uprooted."[7] One task of the teacher, therefore, was to eliminate such divergences by moving from the "literal" level of a work to a more abstract realm where verification could presumably be achieved — although one does not know how, and Barnes does not tell us.

He may well have recognized that his explanation of "objective" was inadequate, since he returned to the subject again in later sections of his Renoir volume, where he offered a different form of "proof:" a viewer's feelings could serve as a guide to his capacity to grasp the artist's intentions and his "discovery." Progress in learning to "see" could properly be identified when a student "becomes conscious that his senses are feeding on the objective traits of the painting, that the nutriment furnished is stirring his imagination, and that a *feeling* of warmth pervades his whole organism:"

The word *feeling* is italicized in order to emphasize the fact that Nature herself furnishes experiential evidence, that the perceptive process is not a cold intellectual affair, fundamentally different from the emotion that takes possession of a person when a work of art is fully appreciated. This warmth is ... the emotional factor productive of the consciousness of heightened vitality characteristic of every genuine experience.[8]

[6]Ibid., pp. 5–6.

[7]Ibid., p. 9.

[8]Ibid., p. 17.

The real test of a person's capacity to "see" now depends upon the person's feeling of warmth — "a consciousness of heightened vitality." In deciding to make feeling a major test of an individual's capacity to respond to art appropriately, Barnes has moved far from the notion of scientific verification. The viewer's ultimate recognition that he has made "progress" is now entirely subjective: it rests upon an emotional response to aesthetic objects (or indeed to "every genuine experience"), and this criterion eliminates the possibility of any scientific verification or replication. How is one to know whether one person's feeling of "warmth" is less than another's, not because he is failing to make progress in the appreciation of painting, but simply because his temperament and personality are different? Indeed, how does one even detect such feelings in other people, or measure the disparities among different observers, all of whom may (or may not) be learning to "see" correctly?

From Barnes' point of view, the more "progress" in feeling one made, the closer one moved toward a state he considered mystical. Later, in his Renoir book, he declared,

> [W]hen an artist has shown us a vision of things which profoundly stirs our emotions, he calls all our interests into harmonious play, which strips from material things all the accidents, irrelevances, discrepancies with which they are usually encumbered, he has rebuilt the world according to his heart's desire, and the sense of mystical union ceases to be illusory, and becomes a realization of substantial fact. . . .[9]

Here, Barnes comes precariously close to Roger Fry's discussion of Clive Bell's "aesthetic emotions," although Fry, as mentioned earlier, wisely stopped short of trying to explain such an emotion: "Any attempt I might make to explain this would probably land me in the depths of mysticism. On the edge of that gulf I stop."

While Fry remained firmly in the sphere of rational analysis, Barnes proceeded to enter the realm of "mystical union" without pausing to consider the consequences that this sphere might have for his concept of scientific objectivity. The fact that he was prompted to follow this route indicates at least as much about him as a person — including his contradictory impulses — as about his aesthetics. Art, as he wrote, calls all one's interests into "harmonious play." It strips away all that is cumbersome and discrepant in life, enabling one to dwell in a world constructed by the artist's vision — where one can exist freely, unembattled, and fully in possession of oneself and one's desires. Given what we know about Barnes' special affinity for

[9]Ibid., p. 165.

Renoir's late painting, it is not surprising that he may have viewed his passion for *all* painting — not simply Renoir's — as a refuge from himself as well as from the world, offering him a domain where he could experience life in an utterly different "unifying" and even mystical way. In Merion, he was in full control of his gallery and could savor — as collector, viewer, victor, and sole possessor — the works that stirred his feelings profoundly, and that excluded the "accidents, irrelevancies, discrepancies" (and conflicts) that consumed so much of the rest of his existence.

Painting and Meaning

Although there were times when Barnes moved toward highly subjective tests of whether students were making progress in learning to see, he continued his search for ways to derive meaning from objective and scientific analyses of works of art. His books contain literally hundreds of pages of commentary (difficult to digest) describing in great detail the formal elements of individual paintings, with barely any conceptual relief. In a relatively early court case concerning the tax-exempt status of his downtown office building, he offered a description of his method:

> The way it is done is this. . . . I take [a] stenographer with me . . . and I get in front of a picture and I dictate, and when that stenographer falls over we get another one. . . . And then we correlate that [information] . . . and we go back the next day to see if it is right. The next year we go back to the same path. . . . In that summer we work up that material and see how it lines up, and the next summer we go back. . . . [And] this year I thought the book was all done, and in the third season we went over there and found a lot of new material, and I came back from Europe with five hundred typewritten pages. . . .[10]

Barnes conscientiously checked and double-checked his notes on every painting, until he believed that his observations were fully corroborated and correct. This method of repeated verification played — in his view — an essential part in making his theory genuinely scientific.

But the analogy was clearly wide of the mark: in science, the accuracy of a description of specimens can be tested by technical analyses or experimentation. In art there is no parallel, and no way to arrive at replicable

[10]*The Barnes Foundation, a corporation, vs. Harry W. Keely. Receiver of Taxes.* Court of Common Pleas, Philadelphia, April 22, 1931, pp. 129a–130a. BF Archives.

results. The attempt to describe a work of art — its color, line, use of space, and so on — is inevitably an interpretive act. One observer will select certain elements that seem predominant and significant, while another may choose quite different ones. Barnes himself (as he acknowledged) had to return again and again to each painting in order to correct earlier versions of his own descriptions, until he could create a "final" one. But how does one know that the latest attempt is actually final, when there is no way to test the matter? How does one know whether, if one were to return a year later, there would not be a need for further corrections — and so on, indefinitely?

It is not difficult to demonstrate the problematic nature both of Barnes' descriptive method, and of his various attempts to move from the sphere of purely plastic or aesthetic elements to the realm of human values and meanings. What did this shift — from one level to another — yield, and how valid were the results? In discussing Renoir's *Bathers in the Forest*, Barnes noted the work's "wealth of plastic and profound human values," and in *Maternity*, there are "human values intrinsic to the subject matter [that] are conveyed with . . . charm, poignancy and reality." Barnes goes no further in describing these values, but we are bound to ask which elements (in *Maternity*) give rise to them. If they are indeed "profound," can we explain why (and how) they touch such depths? Finally, Barnes fails to offer any explanation of why the subject-matter of the picture should suddenly be allowed to play such a prominent role in his analysis.

If Barnes intends to say that any sympathetic and effective depiction of the relationship between a mother and child — as in *Maternity* — will intrinsically express profound human values, we are left with so general a statement that, even if true would not be very illuminating. Yet that does, in fact, seem to be Barnes' assertion: values are, he claims, "universally" shared by all people at all times and are necessarily broad in nature. In his Matisse volume, he notes the capacity of art to express the human values of "awe, majesty, exaltation, peace, compassion, the pride and triumph of life."[11] Elsewhere, he dwells on feelings of harmony. An excellent scholar recently drew attention to the fact that Barnes was primarily concerned with "broad human values that can be discerned in the world around us" — values such as "gracefulness, poise, gentleness, coupled with weight, firmness, complexity, power, and drama."[12] Although this is an accurate account of Barnes' approach (as expressed in some of his writings), it leaves us with a theory (about "universality") that is highly vulnerable and a set of terms that are so abstract that they could be applied to countless works of art, of totally different kinds, with no way of making the finer and more illuminating discrimi-

[11]Barnes and de Mazia, *Matisse*, p. 201.

[12]Richard J. Wattenmaker, "Dr. Albert C. Barnes and The Barnes Foundation," *Great French Paintings from The Barnes Foundation*, 1993, p. 13.

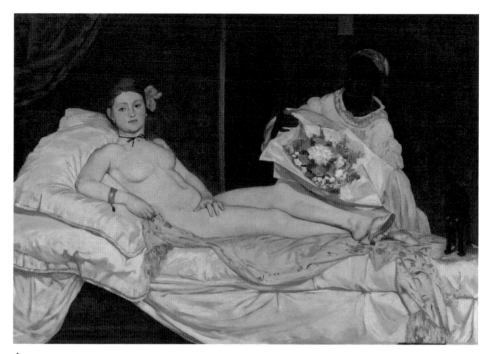

Édouard Manet, *Olympia*, 1863. Oil on canvas, 51⅜ × 74¾ inches (130 × 190 cm).
Paris, Musée d'Orsay. RF644
Photograph by Hervé Landowski. © Réunion des musées nationaux/Art
Resource, NY

nations that actually distinguish one work and its meaning, or its power of
evocation, from another.

In his discussion of Manet's *Olympia*, Barnes offers what he considers to
be a literal "objective" description of its "plastic values" as well as a character-
ization of its "human values:"

> Each area of the picture is replete with pictorial and compositional
> effects: the decorated shawl and the red and ivory bed clothes paral-
> leling the nude; the vivid black cat wonderfully set in space —
> and the color-relationship with its contrasting white and green
> context; the delicately colorful compact planes of the simplified
> bouquet of flowers; the big pattern of folds in the background
> draperies; the bold division of the background by a central vertical
> band; and the extremely picturesque figure of the negress which
> counterbalances the slant of the upper part of the nude's body and
> helps incorporate the longitudinal rhythm of the bed and nude.[13]

[13] *The Art in Painting*, p. 465.

When Barnes attempts to identify *Olympia's* human values, he uses terms — power, simplicity, grace, picturesque — that are very similar to those embedded in his initial "objective" description (big, bold, simplified, picturesque). In short, the process is circular, and the result is tautological. Moreover, his list of human values is far from persuasive: *Olympia* conveys no feeling of "grace," of the "picturesque," or "simplicity." Most important, Barnes makes no attempt to interpret the meaning of either the painting's individual elements (such as the cat) or of the composition as a whole.

For such meaning, one might turn to a very different moment in the history of art when T.J. Clark in the 1990s offered a profoundly complex analysis of the same painting, as a work in the long pictorial tradition of prostitution — relationships where money and sex come together in more or less explicit form depending on the social mores of the time. In Parisian society of the nineteenth century, with its class distinctions, Clark points out that money cannot be shown nor can the client, and least of all a matter-of-fact relation between the buyer and seller of sex. The picture is about the absence of such things:

> We might sum it up by saying that in *Olympia* prostitution has become more extravagant and threatening; and that seems to have been an accurate description of the state of the trade in the late-nineteenth century. Relations between prostitute and client involved, among other things, matters of social class; they often meant a transgression of normal class divisions — a curious exposure of the self to someone inferior, someone lamentable.[14]

As a result, the "buyer" does not appear in Manet's painting. Instead, there is an effort to make the transaction "conventional," the flowers serving as a token of what is intended at some point in the future, out of view.

Barnes would have had no desire to probe the social or art historical implications (or complex meaning) of Manet's work, since all such considerations were, in his view, irrelevant. So rather than an "objective" description that leads to an interpretation of the painting's full meaning, the viewer is simply left with Barnes' personal description of the work, and no comprehensive interpretation at all. We are confronted with a radical disconnect between the plastic and the semantic elements of the painting — with no discernible way to bring them together.

Alfred Barr dwelt at length on this problem in Barnes' work, when he reviewed *The Art in Painting* in 1926. He found much to admire in the book, and admitted that he — like Barnes — was inclined to stress formalist

[14]T.J. Clark, *The Painting of Modern Life*, Alfred A. Knopf, New York, 1985, p. 144.

elements in art. But he also suggested that Barnes had taken the approach too far:

> Only a few are interested in plastic value. Nor has this few up to our own time included many influential critics. . . . But even if it were possible, would it be wise to emphasize plastic values to the exclusion of subject matter, historical and biographical backgrounds, archaeological problems, stylistic differentiation, literary association, and all the ancillary baggage which is customarily presented in a book on painting or a college art course? So far as education is concerned, some carefully devised compromise is the obvious solution. But extreme as it may appear, Mr. Barnes' position is temporarily very powerful. In the light of history and experience neither fashion is final, though at present the latter is crescent.[15]

There is no simple way to summarize Barnes' aesthetic and educational theories. In the preceding chapters his main ideas are placed in historical context to highlight the major issues at stake — relating them in varying ways to Berenson, Meier-Graefe, Wright, Fry, Bell, Dewey, and Barr. The intention is to clarify not only Barnes' dependence on earlier or contemporary critics and the nature of the major debates, but also the various ways in which he attempted — unsuccessfully — to solve important problems that were current at the time. These problems sometimes seemed to turn less upon matters of substance than upon the use and definition of competing terms to characterize works of art — Berenson stressing the role played by "form;" Fry "plastic design;" Bell "significant form;" Barnes "plastic form." While it is possible to make distinctions among these terms, their general similarity (especially when dealing with "modern" art) indicates the relatively circumscribed nature of the Anglo-American "playing field" from the late-nineteenth century to early in the twentieth century.

Barnes' failure to arrive at persuasive conclusions should come as no surprise. Aesthetic problems are by their nature speculative, subject to continuous criticism, correction, and reformulation. Indeed, only the least dogmatic of theorists — Roger Fry — was always open to new ideas, new viewpoints, and new efforts to include unfamiliar art in his empirical approach. Barnes' various theories, on the other hand, were too often the result of actual inconsistencies expounded so confidently that when they clashed, the reader was left with no way to reconcile them.

[15]Alfred H. Barr, Jr., "Plastic Values," *Saturday Review of Literature*, July 24, 1926, p. 948. BF Archives.

Nevertheless, Barnes made a contribution in his effort to describe the way in which many individual paintings were composed. A number of his descriptions — despite their shortcomings — helped people to focus on the "architectural" structure of works of art, or the relationships among different colors, or the role of line. Moreover, the highly detailed nature of these analyses was unique in its time. Alfred Barr (in his 1954 monograph on Matisse) described them as sometimes "eloquent" as well as illuminating, in spite of their cumbersomeness. Barnes' technique (although clearly not leading to "objective" results) could on occasion yield sophisticated insights for those who might otherwise neglect the formal aspects of art. But his single-minded approach was only one among a variety of possible theories and methods, and his notion of an "objective" or scientifically verifiable description of painting never gained credibility.

In his *New Republic* review of *The Art in Painting*, Leo Stein pointed out that Barnes' analyses were exceptional for their "systematic thoroughness." As a method of teaching art, however, Stein warned that Barnes is "not satisfied to help the student approach all art intelligently; he also insists on telling the student what of good and bad he ought to find in different works." Stein himself insisted that "valuations," interpretations, and analyses "are personal and not systematic." Barnes' "scale of values points very clearly in the direction of his own interest" but it would be "a great mistake on the part of any student to direct his effort towards a similar vision" because Barnes' evaluations have "no validity" except in relation to his own experience.[16]

* * *

[16]Leo Stein, "The Art in Painting," *The New Republic*, December 2, 1925, pp. 56–57. BF Archives.

7

The Foundation

Genesis

I have been trying for ten years to buy the Wilson Arboretum (the finest collection of trees in America) and place therein a gallery for my paintings and turn the whole thing over to the public for educational purposes. I now own the arboretum. . . . I thought I'd open the place three days a week to the public, and three days only to such organizations as the Pennsylvania Academy of Fine Arts . . . and to the University of Pennsylvania. . . . How can I cover in a constitution and a set of bylaws explicit statements of those principles of democracy and education . . . that will make my purpose concrete. . .?

— Letter to John Dewey, October 16, 1922

Barnes' initial ideas about his foundation were (as the letter to Dewey suggests) very loosely defined. His conception of its purposes (and its degree of openness to the public) changed over the course of several years. In fact, he had once thought (in 1912–1915) that he might leave his entire collection to a Philadelphia municipal museum, and he remained for some time quite expansive in terms of its public nature. In a 1923 article in *The New Republic*, he stated that the Foundation would offer "a sensible use of leisure in a class of people to whom such doors are usually locked." Clearly, the working poor were very much on his mind, as well as students from nearby institutions. Moreover, when the Foundation opened in March 1925, Dewey stressed in his inaugural address that a great many of life's experiences can be conceived as aesthetic in nature: potential "sources of joy for all people." Here, as elsewhere, he was implicitly echoing the ideas of Ruskin and Morris. Indeed, in a 1925 article published in the Barnes' *Journal* — he emphasized that art "is not something apart, not something for the few, but

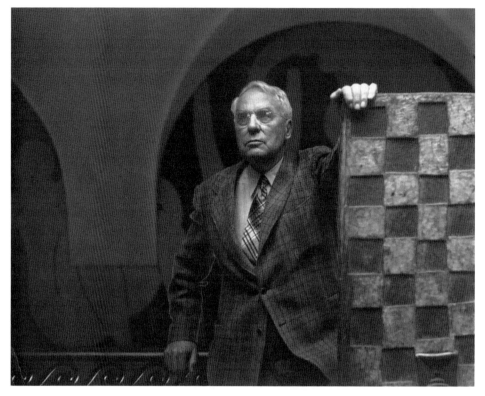

Albert C. Barnes (with a door by Baule peoples, Côte d'Ivoire), c. 1946
Photograph by Angelo Pinto, Barnes Foundation Archives

something which should give the final touch of meaning . . . to all the activities of life."[1]

Several of these ideas were echoed in the original guiding principles as described in the Indenture of the Foundation. It was declared (somewhat ambiguously) that the gallery would be open to the "public on not more than two days a week," and the trustees were instructed to "make regulations" ensuring that "the plain people, that is, men and women who gain their livelihood by daily toil in shops, factories, schools, stores and similar places, shall have free access to the art gallery upon those days when the gallery and arboretum are to be open to the public." The same kind of people for whom Barnes had created "seminars" in his factory would be especially welcome at the Foundation, the central purpose of which was to "determine how much practical good to the public of all classes and stations of life may be accomplished."

If the Foundation's Indenture emphasized the institution's "openness" and declared democratic purposes, it was remarkably unclear about its educational methods or its potential curriculum. It neither discussed in detail nor pre-

[1]*Journal of the Barnes Foundation*, May 1925, pp. 5–6.

scribed any specific way of teaching art. The intellectual mission was stated very generally as "the promotion of the advancement of education and the appreciation of the fine arts." Near the end of the Indenture an additional brief statement alludes to the program and its connection to the field of psychology:

> [The] art gallery is founded as an educational experiment under the principles of modern psychology as applied to education, and it is the Donor's desire during his lifetime, and that of his wife, to perfect the plan so that it will be operative for the spread of the principles of democracy and education.

Despite the vagueness of this (and other) language, it is clear that Dewey and Barnes both believed that the Foundation's program could have far-reaching results. Barnes thought that if he could form alliances with a set of influential institutions, his ideas about education and art could gradually be adopted throughout higher education, and could in time become the single

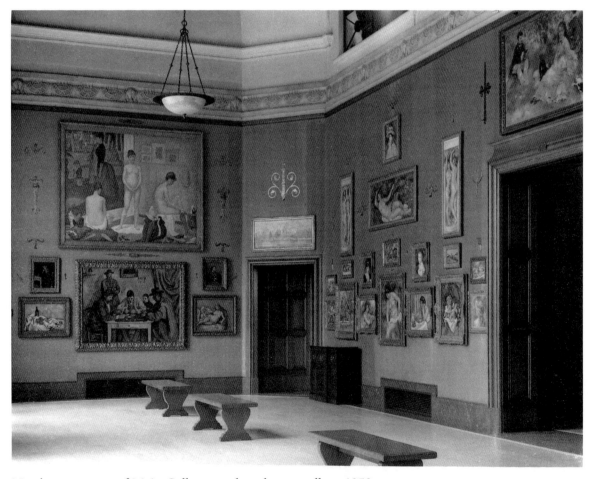

Northwest corner of Main Gallery, north and west walls, c. 1952
Photograph by Angelo Pinto, Barnes Foundation Archives

most effective way — in fact the only correct way — of teaching and study-
ing the subject. Why Barnes (and Dewey) could have entertained such an
expansive vision is itself an interesting question. Dewey was not an especially
"visual" person, and by his own admission he learned most of what he knew
about art from Barnes. But Barnes pursued the development of his ideas
incessantly and eventually could envisage no serious alternative to his own
approach. Even this assumption, however, would not have been enough to
lend the Foundation's aspirations any plausibility if it had not been for the
broader educational context that existed when Barnes began his new institu-
tion in the early 1920s.

Art history was a comparatively new field of study at the time, having
been established (in the United States) toward the end of the nineteenth cen-
tury. By 1910, few colleges or universities had a "department" of art history,
and it was rare for an institution to have more than one or two faculty mem-
bers teaching the subject. In a 1912 survey circulated by the International
Committee on Art History, about 400 American colleges and universities
responded. Of these, ninety-five offered at least some courses in art history,
but only sixty-eight institutions had established professorial chairs in the sub-
ject. Nationwide, only 120 teachers out of 4,500 faculty in higher education
taught art history as their exclusive field of study.

Only under such special historical circumstances could Barnes have
believed that a new approach might be the only "right" one, capable of
transforming the entire field of study. With his collection, his theories, and
his resources, he was in an unusual position, and it is not difficult to under-
stand why he (together with Dewey) thought that he could have a major
impact.

A final factor encouraged Barnes to believe that his method was cor-
rect, and that virtually everyone else was wrong. The fact that post-impres-
sionist art was still reviled and denigrated in so many quarters led Barnes to
assume that the many negative polemical responses to his collection virtually
guaranteed similar negative responses to his ideas. His serious effort to
explain the nature and value of modern painting in the introduction to his
1923 Philadelphia exhibition had been in vain. It became easy for him to see
all hostility as motivated by personal animus, academic bias, or social-class
prejudice. It was not difficult for him to slip into the role of victim sur-
rounded by philistines, or a heroic lone defender of truth in art. Indeed, he
could fall back on either or both of these roles quite naturally because he had
(whether consciously or not) been cultivating them for so many years.

The Foundation entered the public arena in a combative way, with a
deliberately provocative style. The first issue of the *Journal* contained an
introductory essay by Mary Mullen (who had become a key staff member),
stating that the general purposes and scope of the Foundation's educational
mission was to foster education that would not be "servile but free." It would
not inculcate a system of "lifeless erudition or . . . meaningless uniformity,"
but would instead encourage initiative, and independence "in all relations

and activities of life."[2] Mullen noted that many of the ideas behind this "manifesto" derived from William James, Dewey, and Santayana, and she implied that the establishment of the Foundation was already far-advanced: courses in the "appreciation of art" were being taught by faculty at Columbia and the University of Pennsylvania; two new courses were being planned at Penn for the following year, and other advanced courses were underway at the Foundation itself. Furthermore, the Foundation "supplies separate lectures by qualified specialists for colleges, schools, and clubs." Three books, explaining the Foundation's method of study, had already been published and (as she wrote) "have been adopted for use by a large number of universities, colleges, schools and museums in the United States and in Europe."[3]

In short, Mullen suggested that Barnes' dream was rapidly becoming reality, but this was at best wishful thinking. By the end of the academic year 1926–1927, the tentative alliance with the University of Pennsylvania had collapsed; faculty and students from the Pennsylvania Academy and New York's Art Students League were considered to be inadequately prepared, and were banned from the Foundation; Dewey resigned his post as director of education (while remaining on very warm terms with Barnes); and the only two "specialists" then teaching at the Foundation, Laurence Buermeyer and Thomas Munro, had also left. The core faculty of the Foundation had dwindled to Miss Mullen, the newly hired instructor Violette de Mazia, and Barnes himself — none of whom had ever studied art history systematically and all of whom were committed to Barnes' developing method of analysis.

De Mazia became, over the years, a central figure at the Foundation and was ultimately Barnes' closest collaborator, appearing as co-author of all his books (except *The Art in Painting*). Born in Paris in 1898, she had studied painting at the Hampstead Conservatory in London and the Camden School of Art. She came to the United States in the early 1920s and later attended one of Thomas Munro's courses at the Barnes. She was quickly drawn to the Foundation's purposes and methods, and remained single-mindedly committed to the Barnes until her death in 1988.

Given the reduced size of its faculty, and its total embrace of Barnes' approach to the study of art, the Foundation soon found itself shrinking to a small group of insiders who had already begun to exclude not only many visitors to the gallery, but also students and faculty who wished to study the collection in depth. There was more than a hint of this turn of events in Mary Mullen's programmatic outline of how the Foundation proposed to carry out its work:

(a) By active defense, in the *Journal* . . . and elsewhere, of individuals manifesting intelligence, progressiveness, and public spirit in the art world.

[2] Ibid., p. 5.

[3] Ibid., pp. 6–7.

(b) By active attack, through public discussion, upon the enemies
 of intelligence and imagination in art, whether or not those
 enemies were protected by financial power or prestige.[4]

According to Mullen, the Foundation would also attempt to develop an
appreciation of art in public schools, but this (she insisted) could not be done
"in Philadelphia and its vicinity until the existing and antiquated and unin-
telligent methods of art instruction and supervision are reorganized."[5]

An attitude of exclusion at the Barnes was obviously very much in the
air. Mullen's threat to "attack" was characteristic of the new *Journal* (espe-
cially in Barnes' own articles that soon followed), and the growing identifi-
cation of so many outsiders as unintelligent and unimaginative unfortunately
reflected the *modus vivendi* of the new institution. In another essay, Mullen
discussed the subject of "Learning to See" and quickly concluded that the
capacity to do so was lacking in most human beings. Watching invited stu-
dents and faculty visitors in the gallery,

> [we] were handicapped at the start that a majority of our students
> had dabbled in art in college courses, art academies, public lec-
> tures, etc. . . . In each of these cases . . . the common factor was the
> demonstrable *inability to see*. How almost universal is that defect is
> not suspected until specific tests of aesthetic vision are made.[6]

The tests of "aesthetic vision" were not described, but we know from
other passages that they involved some demonstration of a ready willingness
to "see" paintings as Barnes believed one ought to see and analyze them. In
addition, Mullen gave examples of the "blunders" some students and faculty
had committed, and she described in some detail the "utter blindness" exhib-
ited by "an instructor at the Corcoran Gallery in Washington," who made the
mistake of "undervaluing" the quality of Matisse's *Three Sisters* and Pascin's
Femme Assise:

> Protean variations of this disorder are duplicated a dozen times in
> our records of the observations of the behavior of men and
> women, in the presence of paintings, who teach art in universities,
> colleges, schools, public galleries and art academies throughout
> America.[7]

[4]Ibid., p. 7.

[5]Ibid., p. 7.

[6]"Learning to See," *Journal of the Barnes Foundation*, April 1925, p. 8.

[7]Ibid., pp. 9–10.

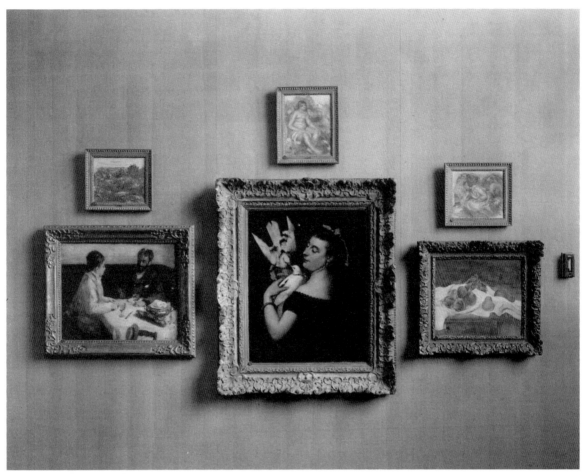

Gallery 5, wall ensemble, 1928
Photograph by W. Vivian Chappel, Barnes Foundation Archives

Mullen, Barnes and other staff spent hours observing visitors in the gallery, taking notes, and then developing (precisely how, we do not know) ways to cure them of their blindness. Clearly, the Foundation had, in a very short period of time, drifted a long way from its original stated goal to foster independence, and to be a citadel of openness for the spread of the principles of democracy to people of all classes and stations of life.

If the educational program at the Barnes Foundation was becoming highly restricted, one should nevertheless try to understand its actual goals and methods. Some sources are available for the early years of the new venture, but the most helpful material comes from comments and analyses in Barnes' own books, from articles by Violette de Mazia, and from examples of the actual syllabi of selected courses.

In a December 1942 article for *House and Garden*, de Mazia outlined the underlying conception of the Foundation's approach to teaching, which was intended to sharpen and deepen the students' "alertness" to all things visual.

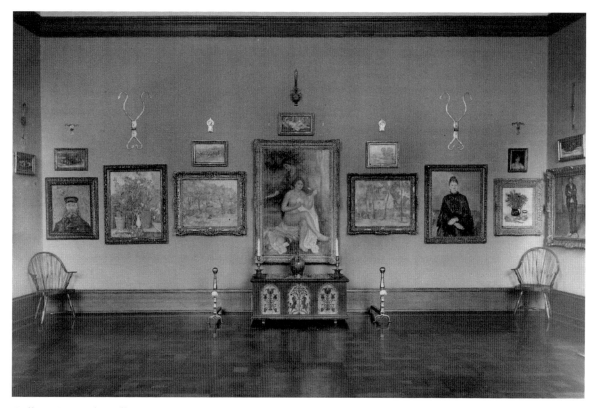

Gallery 2, north wall, c. 1952
Photograph by Angelo Pinto, Barnes Foundation Archives

She, like Dewey, emphasized that in the Foundation's courses "art is taken out of the usually detailed, esoteric world and is linked up with life itself:" it was "a fragment of life presented to us enriched in feeling by means of the creative spirit of the artist."[8]

Because the Foundation assumed that academic approaches to art (or art history) were elitist and detached from life, Barnes and de Mazia adhered strictly to the method of formal analysis discussed earlier, concentrating on color, line, space, mass, and other characteristics that Barnes himself used in his publications. In the curriculum, certain courses were required: for first-year students, there was an emphasis on teaching them to "see" in Barnes' formalist terms; for second-year students, an advanced course placed individual artists within the tradition of earlier paintings — for example, relating Renoir to the Venetians of the Renaissance, or to French eighteenth-century artists such as Fragonard and Boucher. Classes took place directly in front of pictures in the gallery: Barnes had a life-long aversion to color reproductions, firmly believing that the only serious way to study works of art was

[8]Violette de Mazia, "The Barnes Foundation," *House and Garden*, December 1942, p. 38. BF Archives.

to confront the originals directly. Class sizes were, therefore, strictly limited, and students were required to arrive an hour early in order to work on their assignments alone.

Beyond the detailed analysis of individual pictures, de Mazia highlighted the principles that she and Barnes had outlined in their book on Renoir (and elsewhere): that the "inherent attributes of human nature have remained the same" throughout time, and that "there is no essential difference between the great art of the past and that of the present." Serious study "reveals certain objective features that endow the work of art with the power to call forth feelings of aesthetic pleasure in the observer."[9] As a result, the

> student, at first disconcerted by the break with the conventional, seeks a new orientation; he soon begins to discern similarities in line, shape, color or rhythm between the apparently dissimilar objects; that is, he discovers their common denominator of human values and meanings and their common source in human nature.[10]

In addition to the dubious theory that all the "inherent attributes of human nature" are the same everywhere, de Mazia stressed the idea that there are significant similarities in "line, shape, color, or rhythm" among very different types of art, and this conviction was obviously a cornerstone of the Foundation's educational approach, as reflected in the collection's installation where the arrangement of "ensembles" (conceived by Barnes himself) are predominantly based on formalist rather than other principles. Once again, however, there is no explanation of how one can derive "human values" from the study of purely aesthetic elements.

The fundamental principles governing the Barnes method of education did not change over the years. The "categories" of analysis described in *The Art in Painting* and elsewhere have remained constant even in syllabi of the last two decades. Introductory courses have continued to focus on subjects such as "Line and Shape, Types of Line, Line Direction, Contour and Gesture, Line Quality" or "Curvilinear Shape, Positive/Negative Shape, Integrated Shapes, Confusion, Rhythm." Other objectives have been to develop "an analytical understanding of plastic space" and the identification of "various materials in the expression of form and space," so that a student would be able to "verbalize experiences" or "analyze works of art." In short, the Foundation's educational program has generally followed the methods of analysis described in Barnes' books and other writings. The Indenture (as already noted) did not prescribe such an approach, although it directly and strongly encouraged experimentation. In the event, the established formalist tradition

[9]Ibid., p. 38.
[10]Ibid., p. 40.

has been steadfastly maintained, and virtually no "experimentation" has taken place.

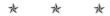

Exodus

From the earliest days of the Foundation, access to the gallery was entirely unpredictable. Barnes had no consistent guidelines or rules to determine who should (or should not) be allowed to see the collection, and his *ad hoc* decisions were at best quixotic. Only a fraction of the cases are documented, but enough is known to indicate the lack of principles and logic involved. Some "refusals" involved misguided "academics;" others wealthy or highly placed individuals; still others "enemies" (having perhaps written unfavorably about Barnes or the Foundation).

The list includes distinguished artists and art historians Meyer Schapiro, Erwin Panofsky, John Rewald, and Barnett Newman; museum directors Alfred Barr of the Museum of Modern Art and Lloyd Goodrich of the Whitney; writers including Alexander Woolcott, T.S. Eliot, and Archibald MacLeish; collectors Walter Chrysler and Lily Bliss; and the architect Le Corbusier. Academics were a particular target, but countless others in any number of professions or other occupations were denied admission. During the early legal case concerning the tax-exempt status of his downtown Foundation building, Barnes said that his only reason for pursuing the matter was to demonstrate the seriousness of the Foundation's educational work. In discussing the institution's policy, he emphasized how important it was to keep virtually all people from entering the gallery, so that students enrolled in the Foundation's courses (or Barnes himself) could study the paintings in peace. This policy even excluded most of the working poor. There was no place for "the rabble," Barnes said in the court hearing. He had nothing against the rabble:

> only that it is a rabble. I came from the rabble ranks, as I think most of our people did. . . . The only thing is, we have risen. I am making no social criticism at all. The only thing is that the great mass of people aren't so very much interested in pictures as they are in killing time. . . .[11]

Many of Barnes' rejections were accompanied by whimsical or offensive messages. A correspondence with Alexander Woolcott (who was fashioning his own barbs) began with an obviously provocative ("collect!") telegram

[11] *The Barnes Foundation vs. Harry W. Keely*, p.134a. BF Archives.

in which he requested permission to see the gallery's paintings. Barnes responded with a letter over the signature of his dog (Fidèle-de-Port-Manech) declaring that the Foundation did not have adequate funds to pay for the telegram and explaining that Dr. Barnes was "out on the lawn singing to the birds and that it would cost me my job if I should disturb him at his regular Sunday morning nature worship."[12]

Walter Chrysler was told that Barnes could not take the time to read his letter because he was busy trying to break the world record for swallowing goldfish. T.S. Eliot and Le Corbusier received brief, offensive rebuffs. The journalist Ben Wolf of the *Philadelphia Art News* received a longer (even less gracious) reply from Barnes when he had the temerity to ask that the Gallery be open to the public at least one day a week:

> Your letter of January 25 confirms the opinion I formed of you by reading the stupid, ignorant, gossipy, sensation-hunting "tripe" published in your paper; in other words, you hope to climb out of the intellectual and commercial slums by pandering to the ignorant, uninformed tribe that infests the fringe of art.[13]

On occasion, Barnes' rejections were civil, as in the case of Archibald MacLeish, who in 1935 had invited him to write an article about the Foundation for *Fortune* magazine. In declining, he gave no direct explanation, but described (in hyperbolic terms) the extent to which his "experiment" was original and its impact demonstrably effective:

> What we are trying to do at the Foundation has never been attempted before — that is, to link an objective study of pictures to the powers possessed by every normal human being and to do it with the aid of respectable educational methods. We've been doing just that for twelve years and the rumor has circulated that we have succeeded to some extent; ... every class is filled and we have a waiting list of about four hundred.[14]

This letter was written a decade after all Barnes' attempts to establish a joint program with a college or university (including Penn) had failed, when the *Journal* had long since ceased to be published, when the Barnes had no specialized academic teaching staff, and when the graduates of the educational program were having no perceptible effect on the teaching and study of art in any major college, university, or museum in the country.

[12]Meyers, p. 220.

[13]Greenfeld, p. 251.

[14]Barnes to MacLeish, September 4, 1935. BF Archives.

Among those who did manage to gain access were Joseph Alsop (then a student at Harvard), Ben Shahn, Henri-Pierre Roché (who would certainly not have been admitted if Barnes had realized that he was John Quinn's Paris "agent") and Charles Laughton (who became a friend of Barnes). Perhaps most surprising, Sir Kenneth Clark, then director of the National Gallery in London, and Lady Clark paid a visit, which he recalled many years later in his autobiography:

> After careful scrutiny by a man who could properly be called a roughneck (one could have struck a match on his neck) we were admitted, and found our host in his fabulous Gallery sitting on a kitchen chair, listening to a tape recording of his own speech of welcome to Vollard. We did not disturb him but ran rapidly round the other rooms, expecting at any moment to be chucked out. . . .[15]

Surprisingly, Clark and Barnes actually did have a conversation on that occasion, and it led to what Clark described as a friendship that became "almost embarrassingly warm. I put it like that because Dr. Barnes was not at all an attractive character. His stories of how he extracted Cézannes and Renoirs from penniless widows made one's blood run cold. But his passionate love of painting made him supportable."[16]

Barnes' faculty members fared little better than many of his would-be visitors. Thomas Munro was fired after barely a year because he was not sufficiently responsive to Barnes' analytic methodology. Fred Geasland was hand-picked by Barnes, and taught at the Foundation from 1934 to 1938. He was an excellent instructor but made the mistake of questioning one of Violette de Mazia's statements during a class. Difficult questions were generally discouraged and only a few ever surfaced. Geasland's was regarded as unusually challenging — even offensive. A contretemps followed, and Barnes went so far as to ask other members of the faculty to speak out against him, which they refused to do: within days, Geasland was forced to resign.[17]

The tale of Jack Bookbinder is better known. He had been an excellent student at the Foundation, and was hired as a member of the staff, where he remained for seven years. By general account, he was a fine teacher and in spite of some minor transgressions, Barnes promoted him to Senior Instructor. In 1943, however, the relationship between them exploded. Bookbinder had been asked by the board of education of Philadelphia to write an account of his experience as a part-time teacher in the city's summer workshops,

[15]Kenneth Clark, *Another Part of the Wood: A Self Portrait*, John Murray, London, 1974, p. 243.

[16]Ibid., pp. 243–244.

[17]Greenfeld, pp. 238–239. Meyers, p. 239.

which he did in a cogent report. It was published as a brochure for general circulation, identifying Bookbinder as a member of the Barnes Foundation faculty. Barnes was enraged. In his view, the Philadelphia school system's method of teaching art was hopelessly misguided, and any association of the Barnes name with that of the board was fatal. In spite of the fact that John Dewey had praised the publication, Barnes ordered Bookbinder to have the brochure withdrawn immediately or else resign. Unmoved by Barnes' threats, Bookbinder gracefully gave up his teaching position.

Other instructors came to similar ends. The most notorious case was that of Bertrand Russell, which has been widely published, but is particularly illuminating in the present context. In the winter of 1940, Russell was invited to serve as visiting professor by City College in New York. Russell was, of course, an international (in some quarters controversial) figure who had written widely, not only on philosophical subjects, but on any number of less technical matters. *Marriage and Morals* (and "The Free Man's Worship") caused only a moderate stir while he was a visiting professor at the University of California at Los Angeles during the autumn of 1940; but in New York, any number of moralists objected to his views. Letters to the press denouncing him followed the announcement of his City College of New York appointment, and the Episcopalian Bishop William Manning wrote an open letter — published by a number of newspapers — criticizing Russell's attacks on both "religion and morality."[18]

A countermovement was soon underway, with academics and even students from across the country (including Alfred North Whitehead and Albert Einstein) rising to defend Russell's academic freedom (and that of the City College of New York). Dewey succeeded in organizing the Committee for Cultural Freedom to speak out in Russell's favor. But a lawsuit against the philosopher's appointment was soon filed by the parent of a City College of New York student, and the matter went to the courts just as the New York board of education was reconsidering its invitation. The suit quickly made its way to the Supreme Court of New York[19] and Justice John McGeehan ruled in favor of the parent, stating that the board of higher education was essentially creating a "chair of indecency" at the university.[20] An appeal was launched but would take time, and Russell found himself and his family with no employment for the remainder of the year and no ready funds at hand.

Outraged by Russell's treatment, and very much to his credit, Barnes offered Russell an appointment at the Foundation, with full freedom to teach whatever he felt would be relevant to an educational institution devoted to art, aesthetics, and related subjects. He would have a five-year

[18]Bertrand Russell, *Why I am Not a Christian*, Simon and Schuster, New York, 1957, p. 209.

[19]Greenfeld, p. 199.

[20]Ibid., p. 200.

contract in exchange for lecturing once a week during term time. Russell was very grateful, and even though he was not certain what he would be teaching, he accepted the offer. Perhaps one of the more revealing aspects of the entire episode is that Barnes clearly saw Russell as an alter ego — vilified by a retrogressive, moralistic, ignorant society, and under attack from philistines similar to those who had been shocked and appalled by the 1923 exhibition of Barnes' "modern painters." As he wrote to Russell:

> I've had many doses of the same bitter medicine you've been forced to swallow recently; for example, in 1923 the principal Philadelphia newspaper printed an editorial denouncing me as a "perverter of public morals" because I exhibited, wrote and talked about such painters as Cézanne and Renoir. . . . In short, if you want to say what you damn please, even to giving your adversaries a dose of their own medicine, we'll back you up.[21]

Barnes already seemed ready to do battle, with Russell as an ally. Although Russell's fame was undoubtedly appealing, the philosopher's victimization and notoriety as a fellow martyr clearly played a part in Barnes' decision to rescue him.

Russell's course was a great success. Oversubscribed, it impressed not only those who attended but also Barnes himself, who soon wrote to Dewey that it is "simply a knockout. It consists of the history of ideas and he began with the earliest Greek philosophers . . . through Socrates and Plato. . . . Personally, he has made a great hit with everybody."[22] The lectures were indeed impressive, and eventually became the basis for Russell's remarkable volume, *The History of Western Philosophy*. Barnes was delighted by the prestige that Russell brought to the Foundation, but the early promise of the relationship was not to last. In Barnes, admiration mixed with hyperbole usually portended an eventual reversal of feelings, with trouble to come. In this case, the feelings of outrage were initially aimed at Lady Russell (the philosopher's wife) who became the target of his irritation and antagonism. Accused of bursting into the Foundation one day, "demanding" to know where her husband was, she was soon characterized by Barnes as aristocratic, disruptive, and "undemocratic," although she had previously attended Russell's lectures at any number of colleges and universities without incident.

Barnes' impatience with her resurfaced not long afterward in reaction to her regular attendance at her husband's lectures, quietly knitting in the front row. In October 1941 (nine months after the Russells' arrival), he instructed a member of his staff to write to Lady Russell, informing her that the "Trustees" (actually Barnes and the two Mullen sisters) wished to inform her that the Foundation was not a place "where people may drop in occa-

[21]Barnes to Russell, June 24, 1940. BF Archives.

[22]Barnes to Dewey, March 4, 1941. BF Archives.

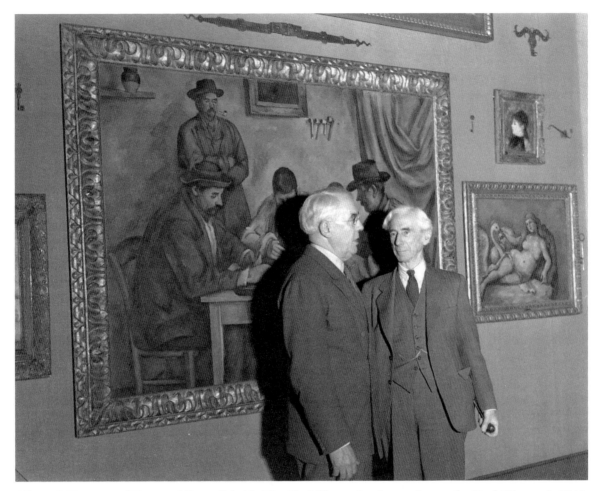

Albert C. Barnes and Bertrand Russell (with *The Card Players*; *Les Joueurs de cartes* by Paul Cézanne), 1941
Philadelphia Evening Bulletin, January 2, 1941; Temple University Libraries, Urban Archives

sionally, at their own volition, nor is any person whosoever allowed to do things that interfere with the rights of others. . . . Admission to the gallery is restricted to persons enrolled in the classes."[23] In the future, Lady Russell would be denied access to the Foundation.

Such startlingly uncivil actions were not untypical of Barnes' behavior toward those whom he saw as "transgressors." But Lady Russell was not to be intimidated: in a lengthy response, full of irony, she registered a number of her own counterpoints:

> My husband has . . . recalled to me an occasion when Miss Mullen appeared to him to have been annoyed by me; and so, fantastic as the charge appears, I must suppose that you are referring to the following incident: On a particular day last winter my husband asked me to be not a moment later than 3:45 in calling for him, as he had

[23]Meyers, pp. 227–228.

an important engagement elsewhere. . . . [I] was told indirectly that my husband was busy talking to a reporter and did not wish to be disturbed, [and] I knew that someone had presumed to interpret my husband's wishes, and that in fact he could not have been told of my arrival. I therefore went into the building and spoke to a white-haired lady who approached me, and whose name I did not know, saying in a normal voice, "Where is Mr. Russell? Will you please let him know that I am here?" I then left the building. If this seems to the Trustees of the Barnes Foundation a disturbance of the peace, may they long continue to enjoy the unreal paradise where such trifles may be so accounted, for I cannot suppose that they would have the fortitude to endure a true disturbance of the peace: for example bombs tearing through the roof.

As for my occasional attendance at my husband's lectures: I have always acted as his assistant in research for and preparation of his lectures, . . . In every other institution in which my husband has taught since I was his assistance[sic], . . . permission has been most readily and courteously granted.

As for my knitting: it was with some hesitation that I took it with me — on two or perhaps three occasions — to the Barnes Foundation; but when I consulted my husband he remarked that I had disturbed no one by knitting at far more difficult and technical lectures at the Universities of Oxford, Chicago, California, and Harvard, and that therefore, I might assume that I would be giving no offense. I am distressed that in fact I did disturb someone, and would be glad if you would convey to all students my sincere apologies. . . .

My knitting is in no sense an "indulgence" . . . [It has] a purpose that seems to me to be serious, the wish to diminish the number of those who suffer from cold. . . . If I am sometimes a little cold myself in future, . . . I will knit with more zest. . . . I will marvel that . . . anyone should wish, in a world so full of mountains of hostility, to magnify so grandiloquently so petty a molehill.[24]

Within days, Barnes replied (under the name of Nelle Mullen):

It was . . . sweet of you to tell us . . . how low class the Foundation is compared to Oxford, Harvard, etc. — in short, that a superior, well-bred, learned, charitable, kind-hearted soul should not be informed by barbarians that her presence in their midst is undesirable. How to bear up under the disgrace is our most serious problem at the moment.[25]

[24]Lady Russell to Trustees of the Barnes Foundation, November 1, 1941. BF Archives.
[25]Nelle Mullen to Lady Russell, November 5, 1941. BF Archives.

Russell quickly responded in his wife's defense, and the correspondence degenerated, ending in December 1942, with the abrupt termination of Russell's five-year contract. Acrimonious public and private exchanges followed. Barnes stated that Russell had always been a dull lecturer and had abandoned his students in midstream, having "no conception of democracy as a sharing in significant experience." Barnes declared that Russell "contributed little or nothing to the education of his class."[26] In the end, Russell sued Barnes and won his case.

<p style="text-align:center">✴ ✴ ✴</p>

Misalliance

In the early days of the Foundation, Barnes initiated conversations with several educational institutions in an effort to broaden the influence of his ideas. His strategy was to underwrite positions in art history departments, with the understanding that they would be filled by faculty committed to his conception of "plastic form." His goal was to "take over" the teaching of art at one or more major colleges or universities that would then become the advance guard on behalf of his own methodology, fostering its dissemination to other institutions (including public school systems) across the country.

Because of his friendship with Dewey, Columbia initially seemed a likely participant, but Barnes' main focus was to be on his own *alma mater*, the University of Pennsylvania. The university was located close to the Foundation, simplifying collaboration. Penn had only one professor of art history at the time and very few students, so there was something close to a vacuum waiting to be filled. Barnes' standing as a very wealthy alumnus and leading art collector might, he thought, gain him a receptive hearing that would not be readily available elsewhere.

In January 1924, he wrote directly to Penn's provost, Josiah Penniman, offering to endow a professorship in art or aesthetics, and indicating that the post should be filled by his long-time associate Laurence Buermeyer, himself a Penn alumnus with a PhD from Princeton. While still in graduate school, Buermeyer (whose specialty was aesthetics) had tutored Barnes informally in a number of subjects — starting with the work of William James and branching much further afield. In view of his excellent academic credentials, he struck Barnes as the ideal candidate for such a professorship, and in his letter to Penniman he went so far as to propose specific terms: Buermeyer should offer two lectures a week at Penn and two classes on site at the Foundation.

The proposal was of course wholly inappropriate. Universities had long since won the right to appoint their own faculty, to assign teaching duties, to

[26]Barnes, *The Case of Bertrand Russell vs. Democracy and Education*, 1944, p. 12. BF Archives.

define the substance of their curriculum, and to decide on the general direction of studies to be undertaken by departments. Guarding these rights was certainly not a matter of protecting narrow-minded bureaucratic interests. These prerogatives together with other aspects of academic freedom were at the heart of a university's guarantee of intellectual independence.

Nevertheless, the Penn administration was tempted to find a way to work out an arrangement with Barnes if it could be done without compromising such basic university principles. Barnes had shared with Penniman details of the Foundation's financial resources and the estimated value of his collection, indicating that Penn would be designated one of three institutions to control the resources of the Foundation after his death and that of his wife, if mutually acceptable terms could be formulated. Nothing was actually promised, and Barnes clearly implied that Penn's future role might change if his specific proposals were not accepted.

Provost Penniman consulted with his dean of architecture, Warren Laird (who had oversight of the art department), and a compromise arrangement, for a trial period, was made: Buermeyer would be hired as a limited-term "visiting" professor (rather than as a full member of the tenured faculty), giving all participants a chance to demonstrate what could be achieved. Unexpectedly, Buermeyer was taken seriously ill, but (with Dewey's help) Barnes swiftly proposed a substitute, Thomas Munro, who had a Columbia PhD and was then teaching in that university's adult education program. His candidacy was approved for a two-year term and the arrangement led to an initial burst of unrestrained enthusiasm on Barnes' part — a characteristic reaction which (as in the case of Bertrand Russell) later proved to be premature. In a state of great excitement, he wrote to Penniman that "no human power can stop Philadelphia from becoming the only place in the world where plastic art can be adequately studied objectively and scientifically."[27]

From Barnes' point of view, the "takeover" of Penn's art department was close to being accomplished. He suggested to Penniman that Munro's course could be greatly strengthened if it were preceded by an offering in aesthetics, which Buermeyer (who had recovered from his illness) would teach. Edgar Singer, a professor of philosophy at Penn (and a former teacher of Buermeyer) responded favorably.[28] With two professors — Munro and Buermeyer — in place, Barnes seemed to be moving steadily toward his goal.

But predictably, questions about the Penn–Barnes alliance were soon raised by some in the Philadelphia art establishment, the university, and alumni, including the principal of the School of Industrial Design, the director of the art program in the Philadelphia public school system, and

[27]Barnes to Penniman, May 3, 1924. BF Archives.

[28]Meyers, p. 82.

the dean of the School of Design for Women. Barnes had by this time made so many enemies that there was every reason to expect attacks of this kind. But Penniman was undeterred, although he did instruct Singer to warn Barnes of the risks he ran in denigrating others rather than presenting the new alliance as an initiative that would demonstrate its clear value through intrinsic quality.

Singer's politic warning fell on deaf ears. The October 1925 editorial in the Barnes Foundation's *Journal* declared that the Foundation's "policy of branding as radically false and pernicious what seems to it such, offers the most helpful method of eliminating the irrational and antiquated practices so strongly entrenched in influential art and education circles. . . . [Such] a struggle cannot always be kept within the rules."[29] Barnes distributed 25,000 copies of the *Journal*, and made certain that it would reach "the militarist, the religious persecutor, the defender of unintelligent subservience to mere custom and authority — these, who are not considered criminals at all, [but who] are the real enemies of humanity."

The pattern of attacks and counterattacks was far from helpful to the new Barnes-Penn venture. Moreover, Munro's class attracted only five students and Buermeyer's only six. Barnes blamed the university for failing to encourage students to take the Foundation-sponsored courses. He also began to think that "his" professors were not as magnetic as he had hoped, and long before the end of the agreed upon trial period, he terminated his support of Buemeyer's course.

Despite these setbacks, neither Barnes nor Penniman was yet prepared to abandon the initiative. Barnes tried to be encouraging, indicating that after his and Laura's death, the gallery would be open to Penn "students and instructors in connection with university courses in Fine Arts and Aesthetics."[30] He wrote Penniman a conciliatory letter while also indicating that Penn's art program was due for reorganization and, in addition, requesting a personal meeting with the board of trustees. Penniman passed the letter to Laird, who sent it on to Thomas Munro, offering to arrange for a faculty meeting to discuss the possible reorganization of the university's art program, but the academic year was coming to an end, and the faculty meeting was postponed.

Barnes remained oblivious of any and all complications. For him, the achievement of his plan was the burning issue that occupied all of his energies. For Penn, it was potentially important, but could hardly be given the same unwavering attention. Penniman and Laird had a large and complex institution to run, quite apart from the doubts they may have had about Barnes himself. Characteristically, Barnes assumed that things would move

[29]"Construction and Controversy," *Journal*, pp. 1–3. BF Archives.

[30]Indenture of Trust, Barnes Foundation, Article IX, par. 30. BF Archives.

swiftly, on terms decided by himself alone. Indeed, in the fall of 1926, he wrote to Munro, saying that he expected to meet with Penn's board of trustees in September or October 1926,

> to present, in person, to them . . . a plan to reorganize the teaching of art and aesthetics at Penn. I expect them to accept the plan and ask me to propose a method and a personnel. You would figure large in that program; but you must first acquire the kind of goods we would offer.[31]

Totally naïve about the way in which major academic institutions function, Barnes assumed that he could dictate policy as well as the choice of methods — and even insist that Munro equip himself to teach according to Barnes' principles. There was no immediate response to Barnes' proposals. Laird was apparently (and understandably) cool to Barnes' ideas. Five months passed before a polite but noncommittal reply from Penn was received, and by that time, Barnes had unilaterally decided to cancel the idea of a collaboration with the university.

It is not clear why Penniman himself did not respond to Barnes. Some have blamed Penniman for missing a potentially golden opportunity, but he had been fully attentive to Barnes for a considerable period of time. He had already done a great deal in creating two "visiting" professorships, and it would have been entirely plausible if he and Laird had come to see Barnes as too intrusive, difficult, and demanding. Moreover, Barnes' latest offer (that the gallery would be open to Penn students for classes in art and aesthetics, and that the university could nominate at least two trustees to the Foundation at some point in the future), did not diverge very significantly from the status quo. Penniman knew that Barnes was highly unpredictable, could change his Indenture at will, and had so far guaranteed Penn absolutely nothing.

Whether Penniman's failure to reply to Barnes personally (and quickly) did play a major role in the termination of the alliance soon became moot. Louis Flaccus, a member of Penn's philosophy department, sent a copy of his recently published volume on art and aesthetics to Barnes, who was outraged by it. He accused Flaccus of plagiarizing his central concept of "pictorial form" from Barnes' "plastic form," and added that, according to Foundation records, Flaccus had visited the gallery far too infrequently to enable him to gain any truly "plastic experience."[32] These charges were entirely unfounded. Barnes asked Singer to intervene, threatening the university with

[31] *Dr. Albert Barnes' Search for "An Educational Enterprise that has no Counterpart Elsewhere,"* Schnader, Harrison, Segal & Lewis, LLP. p. 10. BF Archives.

[32] Barnes to Flaccus, November 23, 1926. BF Archives.

a "major scandal" if Singer did not comply; when Singer refused to become involved, Barnes' belligerence only intensified:

> Let me state the cold facts, . . . Your apparent indifference to the danger [to the University] . . . is certainly no funeral of mine. The only resource left is prayer; and I offer all I have that your students and the public never learn why Penn has been kicked out of the Foundation.[33]

It was important to Barnes to come out on top: the Barnes Foundation was "kicking out" the university, not vice versa. Barnes was, once again, acting both destructively and self-destructively. His deep insecurities and defensiveness served to generate aggressive assaults. He could rarely deal with complex situations, or tolerate viewpoints that he saw as threats to his goals or serious challenges to the theories and methods that he had laboriously constructed over so many years. Early in life, he had ventured — with some real courage — into the realms of psychology, philosophy, aesthetics, and formalist analysis, determined to conquer where (he believed) no one else had previously succeeded. He soon persuaded himself that he had outpaced Berenson, Fry, Bell, and all other contenders. Having invested so much, he could only — given his temperament — guard with vigilance every part of the edifice he had created.

Even Dewey — always paternal, and ready to defend Barnes — expressed serious concern about his intransigence in a 1925 letter that proved to be all too prophetic:

> I think the policy of negative criticism which is being adopted instead of attaining [your] ends is inconsistent with [your goals], and as I said yesterday, if persisted in will result in the end in rendering the Foundation isolated as an educational influence. A policy of even ten percent vituperation, to say nothing of fifty percent, will gradually and surely alienate, or render access difficult to, the persons whom you are concerned to reach. One group after another will fall away, and you will [be] left with simply a few courses at the Foundation attended by a comparatively small number of persons. . . .
>
> Supposing that aside from the University connection you have broken off by controversial methods relations with the state educational people, with the local people, and with Philadelphia. . . . [What] is the outcome to be? With whom and with what is the Foundation to cooperate? I don't know how many letters of

[33]Barnes to Singer, November 27, 1926. Meyers, p. 127.

individual approval you get . . . but I have great difficulty believing that they offset the isolation produced by these alienations.[34]

For those who wondered at the time (and in later decades) why the Foundation was unable, throughout its history, to gain financial and other forms of help in order to remain solvent (and located in Merion), Dewey's letter provides ample testimony: there were simply no substantial constituencies willing and able to contribute support to an institution that was so determined to alienate all but the few who were its single-minded devotees.

In spite of the break with Penniman, Barnes continued to explore the possibility of an arrangement with the university, after the appointment of Penniman's successor, president Thomas Gates, who initially seemed receptive (even though the terms Barnes offered kept changing). Difficult problems related to this possible new collaboration with Gates and Penn arose in 1933, when Barnes was sued by the Tax Collector of Philadelphia. Barnes of course fought back and rejected the suggestion that he could easily replace a downtown office building by constructing additional administrative offices somewhere on the Foundation's many acres of land. As part of his legal strategy, Barnes asked the University of Pennsylvania to participate in the suit by supplying academics from the relevant departments (as witnesses in the case), threatening the university with "disinheritance" if it did not follow through. He wrote (from Paris, on June 12, 1933) to his intermediary, Robert McCracken:

> ask President Gates of the U. of P. to see you. Then show him how and to what colossal extent the U. of P. benefits after the Donor's death. Tell him that if the Supreme Court decides against us, we'll change the By-Laws, remove the U. of P. as the legatee and substitute Columbia University — and, by Jesus, I mean it. . . .
>
> What I mean by the above is that Gates should furnish us with the witnesses [from the departments of arboriculture and horticulture] to prove the incontestable fact that another building on our grounds would kill the landscape — architecture — park effect. . . . Ask Gates himself to testify also. . . .[35]

The university did not follow through, and in his testimony, Barnes indicated that he had in fact done what he threatened. He told the court that the Foundation's trustees had made new decisions for the disposition of its assets after his (and Laura's) death: "The paintings and other works of art now in the gallery in Merion will be deeded to the Department of Fine Arts of

[34]Dewey to Barnes, April 16, 1925. Meyers, pp. 119–120.

[35]BF Archives.

Columbia University, New York City, to be used by that institution for instruction to the students in their courses in art." In other words, when the University of Pennsylvania failed to produce witnesses (including president Gates) for the court hearing, Barnes stated that he would change his Indenture to designate Columbia as the actual *owner* of his art collection (while naming the NAACP and the Urban League as legatees of the grounds and buildings, to create a "negro" center for education in Merion).

It is not clear from the language whether these arrangements were ever legally enacted, or whether the Merion paintings would be *moved* to Columbia, or stay in place. Any discussions were obviously undertaken in haste, during the four months that elapsed between Barnes' original letter to McCracken (in June 1933) and the court testimony (in October of that year).

When pressed on the point whether the arboretum and art gallery were absolutely integral to one another, Barnes replied,

> These two aspects of one and the same purpose cannot be separated: they are one and indivisible and both are educational in their essence. In fact, the more important of the two aspects, as far as the "uses and purposes" of the land is concerned, is the arboretum because large areas of the grounds are necessary. . . . The art gallery could be located in a city.

This was not the first time that Barnes declared that the art gallery might be located in a city — Philadelphia had been mentioned in one of his early wills, and now, because of Barnes' relationship with Dewey, he also considered Columbia in New York.

It is difficult to know how to interpret all of Barnes' actions in this case, but some points are clear. The idea that Barnes would try to commandeer faculty members and the president of the University of Pennsylvania to testify in a minor case concerning the tax exemption of a small Philadelphia building demonstrates his total lack of perspective and judgment. The fact that he would threaten to terminate a possible collaboration with the University of Pennsylvania if Gates and others did not comply is well beyond comprehension. That he would go as far as he did — considering a switch from Penn to Columbia — only serves to underscore how erratic and autocratic he could be.

Given all that passed in 1933, it is more than surprising that Barnes did not definitively abandon the idea of creating an eventual alliance with Penn. In fact, he embarked once more upon discussions during the years 1945 to 1950. It is difficult to understand why he persisted on an errand that seemed bound to fail, but it is clear that he wanted above all to promulgate his approach to art, and that may have been motive enough. He must by then have had some insight into the problems that any partnership would pose, either because of his own uncompromising attitude or because of the deep

disrespect he felt for essentially all "established" organizations. From Barnes' point of view, such institutions were by definition the captives of wealthy, class-conscious, superficial people who were not serious about the study of art and aesthetics. Every attempt to create an affiliation, therefore, was based on the premise that the institution must be reformed — purified of its many imperfections — and that Barnes' educational methods were the only adequate way of achieving a genuine transformation.

While he began to explore yet another relationship with Penn, he also undertook — in 1948 — to see whether an alliance could be formed with Haverford College, where it was agreed that one of Barnes' "professors" would offer a Foundation-linked course. But when the Haverford course catalogue was published, Barnes saw that students would receive no "credit" for the Foundation's courses, whereas they *would* receive credit for art courses taken at Bryn Mawr. This immediately brought the entire venture to an end: Barnes wrote to Dewey to say that he felt he had been "tricked in the present fiasco."[36]

For the last time, he turned his attention to Penn, where (following another lengthy series of incidents and exchanges) this effort also failed. Barnes wrote insultingly to Penn's new president, Harold Stassen, to say that he could hardly expect Penn to be changed by "you, a man not trained in educational science and not having around you anybody who has evidenced any such knowledge." To imagine that Penn could "bring about [the] desired results is practically a confession of a belief in miracles." "Your problem, I think, is the very old one of how to eat your cake and have it, too, and is, it seems to me, not unlike that of Hercules when he had to clean out the Augean stable."[37]

Perhaps the shrewdest, most decisive college administrator Barnes ever encountered was Harold Taylor, the newly appointed president of Sarah Lawrence, whom Barnes met (on the recommendation of Dewey) in 1950, just one year before his sudden death in a car accident. Barnes was nearly eighty, and had begun his unsuccessful search for a partner institution approximately twenty-five years earlier. Taylor and his wife were invited to meet Barnes in Merion, and a cordial conversation apparently took place. But Barnes made the improbable suggestion that Taylor travel to Merion once a week to take a class in order to learn more about art and the Foundation, which Taylor declined (his job was fulltime!). Barnes then suggested indirectly that Jon Longaker (a Barnes faculty member) and perhaps one or more future Sarah Lawrence graduates could be given "joint" teaching positions at the college and the Foundation. Taylor had no direct comment, but later made it clear to Longaker that the scheme could not possibly work, and

[36]*Dr. Albert Barnes' Search*, p. 27.

[37]Barnes to Stassen, November 3, 1949. BF Archives.

is said to have confided (in a much quoted line) that he thought Barnes was "off his rocker."

Taylor seems to have been the only president who sized up the situation immediately, and he was not about to hand over to the Barnes Foundation the teaching of art and aesthetics at his own institution. Outraged by Barnes' tactics, he responded with a letter worthy of the doctor himself:

> Every little while I get copies of letters you or somebody else have written with insulting remarks in them about me, my character, my ideas, and my plans. When I first read them they annoy me because they are so goddamn inaccurate and condescending, then I file them and forget about them because I'm far too busy doing the lord's work to have time to discuss my character with anybody. Let's get this straight right away though. There is nothing you have that I want. As far as I'm concerned you can stuff your money, your pictures, your iron work, your antiques, and the whole goddamn thing right up the Schuylkill River, Pennsylvania or the Barnes Foundation chimney. You are the one who to wrote me, invited me up, talked my head off, tried to make me take your course, tried to get me to do something about Longaker. All I've done is try to be polite to you because you are a friend of John Dewey's and he thinks a lot of you.[38]

✳ ✳ ✳

Denouement

Once his final attempt to collaborate with Penn had failed, and those with Haverford and Sarah Lawrence had also collapsed, Barnes seemed to have no options left. He had ruled out any arrangement with Bryn Mawr, Swarthmore, and the Pennsylvania Academy of the Fine Arts. He was in fact so discouraged that he wrote to Dewey (in April 1950) that he might dissolve the Foundation, sell the paintings, and give $10 million to a postgraduate program in medical research and treatment.[39] "[W]e are," he said, "as a voice crying in the wilderness. . . ."

He abandoned the medical plan, however, and began turning his attention to Lincoln University, a small black college with a few hundred students, about forty miles from Philadelphia. Lincoln had no art department, and few financial resources. But it had a distinguished history and an extraordinarily intelligent and charming president, Horace Mann Bond.

[38]*Dr. Albert Barnes' Search*, p. 35.

[39]Richard J. Wattenmaker, *American Paintings and Works on Paper in the Barnes Foundation*, p. 49. Wattenmaker's volume is the definitive work on Barnes' American holdings.

Bond and Barnes met accidentally in Philadelphia at the funeral of a civil rights advocate, and over the course of a few years — from 1946 until Barnes' death in 1951 — their relationship remained very cordial. Bond admired Barnes' strong commitment to equal rights for African-Americans, and Barnes respected Bond's willingness to stand up strongly and courageously for "integration." When Bond's own children were scheduled to be placed in all-black classes taught by a black school teacher, he protested the policy of segregation and brought suit against his local school board, running the risk of being ostracized by his white (and even some black) townspeople. Barnes applauded the action, and was quick to draw a personal analogy, dramatizing his own sense of kinship with those who were vilified or denigrated (as he had earlier in the case of Bertrand Russell):

> I faced a similar situation some twenty-odd years ago when I had the Bordentown [Negro] singers give a concert once or twice a year in our [Merion] gallery. I got anonymous communications branding me "nigger lover" and all kinds of abuse from the social and intellectual elite of this community. That lasted for about five years. . . .[40]

Bond clearly needed financial help for Lincoln, and well understood the art of cultivating even an unpredictable donor such as Barnes. In 1947, early in their friendship, he made a persuasive case to help Lincoln's African students from abroad, who needed the most basic kinds of assistance. Barnes responded with a gift of $1,000. The two men remained on friendly terms, and in the following year Barnes was invited to visit the Lincoln campus where he delivered a talk to the senior class.

Meanwhile, the very occasional and sparse correspondence between Barnes and Bond reveals a number of shared values and experiences. Bond took pleasure, for example, in Barnes' description of his battles with the Philadelphia Museum of Art, reinforcing their mutual sense of being victorious "outsiders" in a world where each had learned how to survive and even succeed. And Bond was blessed with an engaging wit — as well as great resilience — transforming potentially difficult moments with Barnes into occasions for good humor.

Bond invited Barnes to offer a course at Lincoln, which he turned down, but Bond's letter had been an ingenious exercise in flattery: he wrote that Barnes "could greatly benefit the human race" if he would devote even "the smallest portion of your time to this institution. . . . I believe that you could help increase that fund of love and affection [with which African people are generally blessed] and arm it with greater intelligence and appreciation. Certainly we should repay your gift of yourself . . . with loving affection and

[40]Meyers, p. 274.

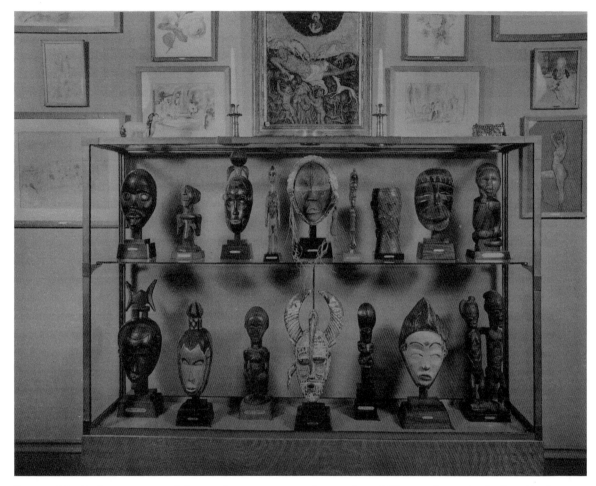

Room 20, display case containing sculpture representing various African cultures including Baule, Dan, Guro, Kongo, and other peoples
Photograph c. 1952 by Angelo Pinto, Barnes Foundation Archives

gratitude."[41] Barnes was touched, and in return, offered Bond a (rather minimal) trial plan similar to the one he had originally offered to Penn and other institutions: accept a Foundation professor on Lincoln's faculty, handpick a few outstanding Lincoln undergraduates to take classes at the Foundation, and thereby begin to train students who could be new leaders in the field of art.

Bond did not hesitate and saw no problem with appointing a faculty member (in this case Jon Longaker) chosen by Barnes himself. Bond also agreed to let his academic dean accompany the students to their weekly class (while the dean himself attended de Mazia's introductory course). These were surprising (and ultimately unwise) concessions; but Bond urgently needed financial resources, and Barnes appeared to be genuinely interested in helping, as long as his own agenda was followed.

[41]Bond to Barnes, August 18, 1950. BF Archives.

Inevitably, difficulties arose. Barnes viewed the initial year as an experiment, testing the performance of Lincoln students, but the course did not go well, and Barnes wrote to dean Newton Hill that "the experiment has failed in practically all requisites."[42] He was appreciative of the dean's efforts, however, and did not immediately give up. In fact, he soon developed ideas for a somewhat more ambitious collaboration. Bond had been planning (if he could find the money) to start an African Institute at Lincoln, with Africans teaching their own native languages. Barnes considered providing some resources if Lincoln were willing to unify its philosophy and nascent art courses (to be taught by a Barnes-trained instructor) linking them to the new African Institute. The director of the Institute would coordinate the entire venture in accordance with Barnes' ideas. His handpicked candidate for the directorship was a professor of philosophy at Howard University, Sing-Nan Fen, who had earned his PhD at Columbia and was recommended by Dewey.

But Bond hesitated, having learned to be wary of this potential benefactor. He wanted to hire Sing-Nan Fen to suit his own conception of the African Institute, which did not coincide with that of Barnes. He also had concerns about Barnes himself (especially his "wrath" and reputation for "irascibility") which he expressed in a letter to an attorney friend, Lewis Stevens, also referring to Barnes' treatment of Bertrand Russell and his tendency to make private correspondence public when it served his purposes. "It is therefore even dangerous to write him a letter."[43] The relationship between Barnes and Bond (and between Barnes and Lincoln) has often been romanticized, but Bond was clearly very shrewd, and very much on his guard. Once he had expressed hesitation, clarifying his own concept for the Institute, Barnes wrote that this divergence "makes me sad because it forecasts things to come that make impossible what I had hoped to do for Lincoln — namely, carry on there, and to your credit, what we have done alone for so many years."[44] In other words, Barnes clearly wanted (above all) to use Lincoln to realize his own ideas:

> I hold no brief for Dr. Fen, but unless a man of his background is in residence to coordinate philosophy and art, beginning next fall, I prefer to pass out of the picture. Our institution has thrived by scientific method. These two subjects [philosophy and art] were amalgamated and made an instrument of education.[45]

[42]Barnes to Hill, October 27, 1950. Greenfeld, p. 282.

[43]*Dr. Albert Barnes' Search*, p. 47.

[44]Ibid., p. 64.

[45]Ibid., p. 64.

In spite of his cordial relationship with Bond, Barnes had moved quickly to impose his own terms: Fen, or someone of his caliber, would have to be in place within about three months or Barnes would prefer to "pass out of the picture," dismantling any potential collaborative program with Lincoln. Several months earlier (October 1950), he had changed his Indenture of Trust to designate Lincoln (instead of Penn) as the institution that would be empowered, at some point in the future, to nominate (though not appoint) Barnes trustees. In view of the difficulties that were now emerging in the Barnes/Lincoln relationship, however, he might well have changed these provisions (as he had previously done in other situations).

Not long after Lincoln's commencement ceremonies in 1951, Barnes and Bond met for a pleasant lunch in Merion, and there was some discussion of having Lincoln students take courses at the Foundation during the following year. That was to be their last encounter. Within a week Barnes was killed in a late-night automobile crash while driving home.

According to the October 1950 alterations to the Indenture, Lincoln was now legally designated as the sole institution that could nominate trustees to the Foundation, although it would not be able to exercise that right for many years to come. Laura Barnes succeeded her husband as chair of the Barnes board until her death in 1966. Violette de Mazia then emerged as the Foundation's most influential figure till she died in 1988. Only then was Lincoln able, for the first time, to suggest the name of someone to lead the Barnes board of trustees.

It is impossible to know what would have become of the Lincoln–Barnes arrangement if Barnes had lived. He might have become even more deeply disappointed, canceling every aspect of the nascent relationship including the arrangement for Lincoln students to take courses at the Barnes. To date, Barnes wrote, "the experiment with Lincoln had failed in practically all the requisites for a such success."[46] Bond himself was pessimistic about even a minimal program. In August 1950 he wrote to his friend, Lewis Stevens, that he was inclined to try something "although everyone will tell you that no one has ever gotten along with Dr. Barnes, and that it is almost sure to lead to a violent fuss of some kind."[47]

On the other hand, Barnes might have attempted a modest arrangement with Lincoln. He was nearly eighty years old; he had exhausted all other options. He liked Bond and had become fond of Lincoln. He once said that when he visited the campus he felt as if he were "going home." Moreover, Lincoln provided an environment where Barnes could identify with the plight of embattled African-Americans, while also assuming the role of generous patron and heroic defender. There was no struggle with "elite"

[46]Ibid., p. 63.

[47]Ibid., p. 48.

individuals and elite institutions, and no more potential humiliations. Here was a place that welcomed him, praised him, and appreciated him in precisely the ways he most desired and needed.

In addition, Barnes' defense of equal rights, and his respect for the aesthetic and intellectual capacities of Negros had been a part of him from a very early age, and the subject was touched upon in Dewey's inaugural address at the opening of the Foundation in 1925:

> I know of no more significant, symbolic contribution than that which the work of members of this institution have made to the solution of what sometimes seems to be not merely a perplexing but a hopeless problem — that of race relations. The demonstration that two races may work together successfully and cooperatively, that the work has the capacity to draw out from our negro friends something of that artistic interest and taste in making the contribution which their own native temperament so well fits them to make, is something to be dwelt upon in a celebration like this.[48]

Barnes had believed from his boyhood that African-Americans were endowed by nature with extraordinary artistic talent, and he often expressed his conviction that they were fully equal to whites in intelligence. He was the first American to acquire African sculpture in a serious way, and his collection is of high quality. When he was invited (in 1936) to give the annual Barnwell Address at Central High School (his *alma mater*) in Philadelphia, he titled it "The Art of the American Negro." He also began with a revealing personal reminiscence:

> Let us turn our attention now to an account of what happened to me at my first Negro camp-meeting. . . . The thrill was so intense that it held me enthralled. It was produced by a number of events acting upon me simultaneously: the singing of a large number of people, the movements as they wandered to and fro, their shouting, waving of their arms, dancing, and the ejaculations of homely, picturesque speech which showed that deep emotion had stirred the imagination of each of the participants. . . . I know now that I was having my first religious experience, that I was switched suddenly from my everyday world to the realm of mysticism — a realm where nothing else counts except the ineffable joy of the immediate moment. I became an addict to Negro camp-meetings, baptizings, revivals, and to seeking the company of individual

[48]*Journal of the Barnes Foundation*, May 1925, pp. 4–5.

Negroes who, I soon discovered, carried out in their daily lives . . .
poetry, music, dance, and drama. . . .[49]

He traced the African-American history of bondage and "incessant
toil" in America — and described the "negro spirituals" that grew out of that
experience as "the greatest art America has produced." The capacities of
African-Americans, he added, went well beyond music:

> The Negro is a poet by nature. Uninterested in the abstract and
> mechanical, his attention is fixed upon the immediate moment. . . .
> His mind runs to rich luxuriant images which he organizes to
> meet the requirements of his emotion and temperament. This
> poetry, this rhythm is apparent in everything he does. . . .[50]

Barnes may have been unconsciously stereotyping African-Americans,
but his admiration for them and his commitment to their cause was deeply
felt and genuine. He was far ahead of his time in understanding and respond-
ing to the African-American struggle to achieve racial equality. In his desire to
include Lincoln students in the Foundation's art courses, he perhaps imagined
the power that could result from a marriage between their "natural" aesthetic
capacities and their potential to analyze individual works of art in a serious
"scientific" way. In that case, Lincoln might have proved a suitable partner to
fulfill some, if not all, of Barnes' hopes.

Siege

In the immediate aftermath of Barnes' death, few (if any) significant changes
were made at the Foundation. Laura Barnes remained chair of the board and
director of the arboretum program. Violette de Mazia retained oversight of
the art program. The Mullen sisters (unquestioning loyalists) continued as
trustees. Any desire to create a strong Barnes/Lincoln teaching program
quickly faded, and Lincoln's relationship with the Foundation soon became
completely peripheral. Meanwhile, Laura Barnes and Violette de Mazia
(who was now in charge of both the gallery and the art curriculum) found it
increasingly difficult to work together.

What proved even more problematic, however, was the series of court
battles, beginning in 1951, intended to compel the tax-exempt Foundation
to open to the public for at least two or more days per week.

[49] *The Barnwell Addresses*, 1937, p. 380. BF Archives.

[50] Ibid., p. 383.

The first of these legal suits, which took the Foundation's officers by complete surprise, was filed by Harold Wiegand on behalf of the *Philadelphia Inquirer* (whose publisher was Walter Annenberg). It charged that the "closed" Foundation was failing to advance the full "appreciation of art" described in its Indenture. The Foundation successfully brought counter-charges claiming — among other things — that Wiegand had no legal "standing" to pursue his case, which proved correct: he lost his suit. But Walter Annenberg and the *Inquirer* were far from willing to give up. By 1958, a new Pennsylvania state Attorney General (with clear legal standing) was in place, and he firmly believed that the Barnes did indeed have an unequivocal obligation to open the gallery to the public for some number of days per week. Another legal suit was filed, and although the Barnes won the first round (claiming it was an educational institution, not a museum or public gallery), the Superior Court of Pennsylvania disagreed. Additional legal skirmishes delayed the proceedings, but in March 1960, the Attorney General was finally given unambiguous power to conduct a "full discovery" of the Foundation's records in order to protect the "rights of the public."

The Barnes stalled, insisting that "by the terms of the trust indenture, the trustees of the Barnes Foundation are given express authority . . . to deny to the public access to the art gallery." Even though the Foundation emphasized the primacy of its educational mission, it was unwilling (or unable) to provide any information about its actual activities, and the presiding judge complained:

> Although the Foundation has been in court at least three times, it is not yet . . . too clear just what constitutes the curriculum of the educational courses of the Foundation. . . . At the oral argument, counsel for the Foundation did not know or would not say how many pupils were enrolled in the Foundation. He contented himself with saying merely that the school was "full."[51]

When representatives of the Barnes claimed once more that the gallery should be left "unhampered by interference from the public," the court responded that this "is an anomalous observation to make concerning a public institution exempt from public taxation."[52] The Attorney General prevailed, and adverse publicity, as well as the costs of litigation, eventually persuaded the Foundation to settle the case: the gallery would be open to the public two days a week, with a maximum of 200 visitors per day. Teachers of art (and students) could make special visiting appointments. The new arrangements were approved late in 1960 and were finally implemented in

[51]Judge Michael Musmanno, *Commonwealth Appellant v. The Barnes Foundation (1960)*, p. 3.
[52]Ibid., p. 4.

1961. The Foundation had capitulated. The battle for at least some measure of public access had been won, although this was far from the end of the Foundation's days in court. The significance of the 1960 case can hardly be overstated. For the first time, it had been made clear that the Foundation was to be open to the public. A major principle had been irrevocably established.

From the time of Albert Barnes' death, the Foundation was in serious litigation for eight of the following thirteen years — an ominous record, not at all auspicious for the future. The stubbornly antagonistic attitude of the Foundation to the outside world generated animosity among several constituencies, including the media; those individuals who had been explicitly denied entrance to the Barnes; many members of the larger general public who had a natural desire to see the gallery and its famed collection; and any potential supporters of the institution. Moreover, the decision to begin public visiting days — with potential crowds of people — alarmed the Foundation's wealthy suburban Main Line neighbors. They wondered how many cars and buses might invade the quiet residential enclave on Latch's Lane and what zoning restrictions might therefore be needed to protect the area. The local Civic Association was suddenly poised to take action if necessary. Meanwhile, the students who were enrolled in Foundation courses wanted to retain as many "closed" days as possible, in order to study the collection and take their classes without outside disturbance. "The Friends of the Barnes Foundation," whose members were current and former students, was established at this time, and the group swiftly began to protest what it called the destruction of "Our Educational Facilities."

In short, storm clouds began to gather in several regions, and it may have been increasingly clear to some observers that Lower Merion Township might not prove to be a congenial environment for an institution that was in the process of becoming more public. Indeed, the eight years of litigation between 1951 and 1963 were a mere prelude to the more than twenty years (from 1991 to 2012) of nearly continuous legal proceedings that followed.

A great deal of this controversial, often litigious history has been forgotten during the past decade. Indeed, some people have contended that there were no difficulties between the Barnes Foundation and Lower Merion before the 1990s. Although spearheaded by the Attorney General, battle lines were already being drawn and various groups were being created as early as 1961. The Civic Association and the "Friends of the Barnes" fought every successive move to extend access to the gallery whenever the issue arose — as it did several times over the course of the next half century.

8

Doomed by Indenture

The potential individual donors and philanthropic organizations were alike unwilling to support the Foundation because of the restrictions imposed by the Township and the Indenture.

— Judge Stanley Ott

There were several major problems with the original Indenture of the Foundation, nearly all of them stemming from the highly detailed nature of Barnes' specifications. The salary figures of several staff members, for example, were "fixed" at a certain level, requiring court approval for any effort to change them. Far more serious, however, were several fundamental terms — rigidly followed for forty years after Barnes' death — that led inexorably to the Foundation's eventual financial crisis. The most significant among these was

- a stipulation that the Foundation's endowment could be placed solely in "legal investments for savings banks." At the time, the annual yield from these were in the range of two and a half to three and a half percent.

Because the trustees — inexplicably — did not choose to invest for the greatest return, the 1952 endowment of $9.7 million yielded (after amortization expenses) $310,000 in interest.[1] Meanwhile, total expenses were $250,000, leaving a positive balance of just $60,000. By 1960, the endowment had barely grown — it was $10.1 million and yielded $258,000, while expenses stood at $235,000, leaving a "cushion" of only $23,000. This trend was already ominous. If inflation were to increase above the range of three to four percent, expenses could very quickly begin to outpace endowment

[1]Figures for the earliest years of the Foundation do not exist. 1952 data represent the financial situation in the year following Barnes' death. All data derive from the BF Archives.

earnings, leading to a steady decline in the value of the corpus. Finally (and most important) the Indenture restriction meant that the Foundation missed more than half a century of robust stock-market earnings, which could have dramatically increased the size of the endowment.

- The Indenture stated that "in any building or buildings of the Foundation," no "society functions commonly designated as receptions, teas, parties, dinners, banquets, dances, musicals, or similar affairs" could be held.

Sooner rather than later, most not-for-profit institutions are forced to seek sources of funds over and above endowment earnings. But in the case of the Barnes, all such avenues were intentionally blocked. The exclusion of all "social" events ruled out the cultivation of friends or members, much less donors, simply because there was no way to invite anyone to the Barnes. An absolutely vital stream of potential revenue in the form of annual gifts to support the operating budget, or add to the endowment, was consequently eliminated — with disastrous long-term implications.

- After the death of Barnes and of his wife, the gallery was to be open to the public only on Saturdays, from 10 A.M. to 4 P.M. Visitors and students could be admitted only after screening by trustees, all of whom were Barnes' closest associates. Even after the court case of 1960, the number of students and visitors was very small indeed, and another possible source of income was virtually eliminated.

Some financial problems emerged within a decade of the founder's death. In 1961, after the Barnes lost its legal case concerning increased public access to the gallery, the admission of a modest increase in the number of visitors each week represented only an inconsequential growth in revenue. But the costs associated with opening the galleries on a regular schedule of two days a week (later increased to two and a half) were considerable, since full-time security guards had to be hired to protect the collection, causing the operating budget to slide into deficit. The Foundation then introduced a $2 fee per visitor, although even such a modest sum would have been insufficient to cover the new expenses. With no cash reserves, no significant endowment growth, and no annual gifts, an entrance fee seemed to be the only way to begin to solve this serious financial problem. But the Foundation (which had already gained considerable visibility through its "public access" litigation), quickly attracted the attention of the Attorney General of Pennsylvania who brought suit, contending that admission to the tax-exempt gallery was intended to be free.

The case was important, for two main reasons. First, it highlighted the fact that even a relatively modest change in the Foundation's operations

could (as early as 1961) force the institution into deficit. Second, it revealed serious basic problems in the very management of the Barnes. The court asked why the Foundation had chosen to invest more than half of its endowment in bonds yielding only two and a half percent, when it could easily have placed most or all of its funds in instruments yielding three to three and a half percent. The trustees had no adequate answer to the question, except that they wanted to "diversify" their holdings. The court found this to be an odd form of diversification:

> No convincing reasons were put forth to justify such distribution ... and if the ratio were merely reversed ... the increase in income would be from $25,000–$50,000 annually. . . . The Trustees were not obtaining the highest possible income [even within the terms of the Indenture] prior to their imposing an admission charge. This is an abuse of authority.

"Abuse of authority" is a grave charge coming from a court. In the end, the court agreed to a compromise in view of the Foundation's financial difficulties: a $1 (instead of $2) fee would be allowed. It had been necessary, however, for the court to point out a serious yet elementary problem with respect to investment returns, demonstrating that the Foundation had no real capacity for financial planning or operations.

To grasp the reasons for the Foundation's continuing major financial difficulties, a relatively few statistics are sufficient. The fundamental problem was that the endowment effectively ceased to grow after 1961 — indeed it even fell for a while. By 1984, for example, the corpus was valued at $7.8 million, having dropped more than 20%, but expenses had risen from $235,000 (in 1960) to $747,459 (in 1984): an increase of about $500,000, or more than 200%. The result was a considerable deficit.

Normally, nonprofits draw five percent of the annual value of their endowment to help pay for operating-budget expenditures. But five percent of the Barnes' 1984 endowment of $7.8 million would have yielded only about $390,000, whereas the expense side of the budget required approximately $747,000. To balance the budget, nearly ten percent (instead of five percent) was taken from the endowment. Without that, there would have been a reported deficit of about $367,000.

Inescapably, this policy, if followed on an annual basis, would lead to eventual insolvency. By 1990 the endowment had recovered somewhat — to about $9.5 million, but expenses stood at $1,149,409. The endowment increase, in other words, was barely 5% compared to the 1952 baseline of $9.1 million, whereas expenses had increased more than 350% since then. Had

the Foundation only drawn the customary prudent nonprofit guideline of five percent from the endowment, the yield would have been $470,000 at a time when expenses were more than twice that figure. The resulting deficit would have been approximately $700,000. To close the gap, the additional funds were taken from the endowment corpus.

Expenses continued to rise steadily at a far greater rate than the endowment, resulting in larger and larger annual deficits, requiring more endowment funds to cover them. The cumulative effect of these steady "draws" eventually caused the corpus to shrink until it was virtually depleted. It has sometimes been stated that the Foundation's annual deficit was only about $1 million, and this could somehow have been covered without much difficulty. But, as we have seen, the short-falls were not only *repetitive* but constantly *increasing*. Regularly drawing large sums of capital from the endowment to cover recurring deficits had a devastating long term total effect on the finances of the Barnes.

This pattern reveals several significant points that bear strongly on the Foundation's steep economic decline. The Barnes was exceptionally badly managed. Any competent financial officer could have foretold, by at least 1980, that the Foundation was headed toward insolvency. Yet nothing was done to change course. All of the above figures derive from before the 1990s, which has frequently been cited as the irresponsible and financially ruinous decade of Richard Glanton's tenure as chair of the foundation's board. But these earlier problems were grave, with no apparent solution in sight, well before Glanton arrived, and they stemmed from the fundamental stipulations described earlier: Indenture restrictions on investments; negligible revenues from tuition and admissions; and no ability (as well as no desire) to invite people to the Foundation in order to build up a significant group of friends, members, and steady donors. Given this predicament, the Barnes — in the face of steadily rising costs — was essentially doomed. Dewey's 1925 prophecy had in effect come true: "One group after another will fall away, and you will [be] left with simply a few courses at the Foundation itself attended by a comparatively small number of persons."

Some of these points (as well as many others) were thoroughly addressed in the January, 2004 decision by Judge Stanley Ott (preliminary to his final decision in December of the same year). He stated that the

> Foundation is unable to cover its general operating expenses and to meet its needs in staffing, conservation treatment, fundraising, collection assessment, facilities care, and public relations....[2] [The] previous administration attempted to increase public admission to the gallery. This effort was stymied by the limits imposed by Lower

[2]Opinion, Judge Stanley Ott, January 29, 2004, p. 4.

Merion Township. . . .[3] [It] was met with hostility, bordering on hysteria, from some of the owners of the adjacent houses. . . .[4] [The] attempts to build up the Foundation's endowment were met with negative responses. The potential individual donors and philanthropic organizations were alike unwilling to support the Foundation because of the restrictions imposed by the Township and the Indenture.[5]

As Ott noted, problems created by the Indenture were seriously exacerbated by those presented by the township and the neighbors. In his January 2004 opinion, Ott did not finally rule on whether the Foundation could move to Philadelphia, but as he began to weigh the issues, it was increasingly clear that, not only the Indenture but the Foundation's actual location was emerging as a significant matter. "The township," said Judge Ott, has "put a stranglehold on the Foundation's admission policy."[6] The response of the neighbors to any increase of access bordered "on hysteria." And the Foundation, of course, had long since compounded all its other problems by its severe lack of responsible management.

[3]Ibid., p. 14.

[4]Ibid., p. 219.

[5]Ibid., p. 17.

[6]Ibid., p. 24.

9

❧

Mr. Glanton

In 1988, following the death of Violette de Mazia, Lincoln University was finally in a position to nominate someone with the capacity to chair the Barnes board of trustees and selected the Honorable Franklin L. Williams, former United States ambassador to Ghana.

Williams was an exceptional leader — highly intelligent, cultivated, energetic, and wholly committed to making the Barnes a genuinely open, vital, and financially stable center for art education. He was also determined to ensure that the staff and programs would be fully professional. He eliminated the requirement that visitors (as in previous times) would be "pre-screened" by staff or trustees, and he gradually allowed the number of weekly visitors to grow modestly.

Williams knew that the Barnes needed significantly more resources, and he began to make contact with individuals and foundations, seeking advice and making his case for financial assistance. But he was seriously ill by the time he assumed the leadership position. He died within a year — tragically cutting short his tenure before he was able to accomplish any of his important objectives.

Williams was succeeded in 1990 by Richard Glanton, who had served as general counsel for Lincoln since 1987. He was a very capable lawyer and, in many ways, an impressive person. He quickly grasped the perilous financial situation in which the Barnes found itself, and immediately set out to find solutions to the problem, which was becoming more acute with each passing year.

He found (not to his surprise) that the Barnes had no committed group of supporters or donors. He knew that the only way to avert a looming crisis was to significantly increase the size of the endowment, which at the time was less than $10 million, hopelessly inadequate to undergird an annual operating budget of close to $2 million. The Indenture's rigid restriction on investments, and the steady drain on the endowment to make up for continual deficits during the 1980s, had crippled the Barnes. Glanton estimated that the bare bones operating budget of 1990 would have required $30 million in

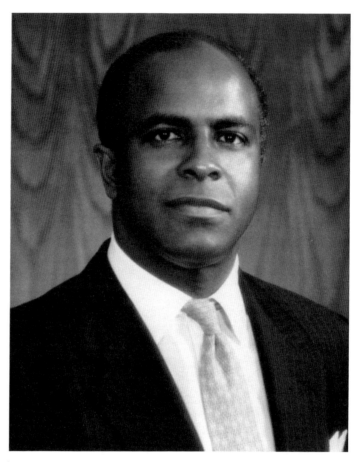

Richard Glanton, 1993
Photographer unknown, Barnes Foundation Archives

endowment (generating income of $1.5 million), although even that figure would quickly prove inadequate once the Foundation began to modernize its gallery, professionalize its staff, and expand its educational programs.

Seeing the need for immediate action, Glanton decided that the only recourse was to sell a number of paintings — some from the "permanent" gallery collection, and others hanging in the residence building. Walter Annenberg agreed to chair an advisory committee to guide this process and Glanton naively hoped for a speedy resolution in the courts. But a storm of protest arose. Major newspapers, art magazines, individuals, and institutions spoke out vehemently against the proposed sale, and even the Lincoln board of trustees opposed the idea. Glanton was forced to back down and withdrew his petition.

But his ambitions for the Barnes far exceeded this bold first step. In March 1991, he asked the Montgomery County Orphans' Court for a number of specific changes to the Foundation's Indenture: to allow a broad-

ening of the Barnes investment policy, to grant an increase in the admission fee, and to allow "social" and fundraising events to be held on the Latch's Lane premises. A more general clause requested that the trustees be given the right to make any other changes that were in the interest of realizing the ultimate "purposes and intent" of the Barnes. These were exceptional requests, and they signaled Glanton's determination to save the Barnes from what was otherwise inevitable insolvency. Those who criticized Glanton for concentrating on these issues rather than on educational programs simply failed to recognize the state of immediate jeopardy in which the institution found itself.

While these petitions were pending, Glanton was already considering other steps to bolster the Foundation's declining financial situation. The most ambitious by far was his decision to organize a traveling international exhibition of masterpieces from the permanent collection. Substantial fees would be charged for the privilege of exhibiting the works, and the income would cover the cost of critical renovations to the Foundation's gallery building, which had steadily deteriorated following Barnes' death. The building also lacked a modern security system, climate control, and suitable lighting.

Permission was granted by the presiding judge, Louis Stefan, although he stipulated that *all* revenues from the tour would have to be placed in a special account and be used *only* for renovations and similar projects, *not* for endowment or general operating funds. The gallery would be closed in order to carry out the renovations, and the paintings would then be allowed to go on tour. Glanton asked Walter Annenberg to approach J. Carter Brown, director of the National Gallery of Art, to organize the tour, to assemble the curatorial staff required to produce an informative and exceptionally handsome catalogue, and to guarantee the safety of the works of art. The exhibition traveled from Washington to Paris, Tokyo, Munich, Toronto, Fort Worth, and Philadelphia, raising more than $17 million, none of which could be used to support the Foundation's basic budget. All the fundamental financial problems of the Foundation remained unchanged.

The tour did, however, produce abundant evidence of the immense power and magnetism of Barnes' collection. It is difficult to know what expectations there may have been in advance, but the exhibition was an astonishing success. More than 500,000 visitors saw the National Gallery installation; a million visited the exhibition in Tokyo, and 1.5 million in Paris. Major "welcoming committees" turned out everywhere: in Paris, president Mitterrand was on hand; in Washington, the group included the Supreme Court's Chief Justice, the newly named Ambassador to France, and any number of trustees and socially prominent guests. If any proof were needed, the tour demonstrated not only the quality of the works of art, but also their capacity to draw large crowds of admirers.

Glanton's decision to produce a substantial catalogue with color illustrations was also groundbreaking. No such publication had ever before been produced by the Foundation because Barnes and de Mazia were unalterably opposed to color photography (which they considered to be an unacceptable attempt to replicate the originals) and they had no interest in traditional art-historical information or in publications that might seem to be "popular."

Glanton on the other hand realized that even a selection of the gallery's masterpieces in book form would appeal to a wide audience. The collection was fabled, but few people had ever seen it, and the publishing house of Alfred A. Knopf offered an advance of $750,000 for exclusive rights to the book which came on the market in 1993. Richard Glanton wrote the preface, and presented the volume "as part of our efforts to open up the Foundation to a wider public.... The book is also significant because it symbolizes the forward direction the Barnes Foundation is taking as it enters the next century."[1]

These achievements were all significant, but none were realized without substantial tension. Glanton's actions generated suspicion or outright hostility that often led to legal proceedings. The de Mazia Trust sued the Foundation over a financial matter arising out of the relationship between the Barnes and Lincoln. The Barnes struck back with a suit of its own, claiming that the funds in the de Mazia Trust derived from the sale of pictures that never legally belonged to de Mazia. The Foundation's students, meanwhile, had lodged their own complaint to stop the proposed sale of pictures from the collection, while also expressing concern about any expansion of the number of visiting days, because that would clearly result in fewer "closed" hours when they could have the gallery to themselves.

In 1995, when the exhibition tour was over, Glanton approached the court for permission to hold a celebratory dinner at the Foundation — a request that was initially denied, although a compromise was ultimately granted on appeal. The dinner — to which many people had already been invited — would not take place in any of the Barnes' buildings (as specified in the Indenture) but in a large tent on the Foundation grounds. This decision only served to heighten anxieties on virtually every front. Nearby residents ("The Barnes Watch") were concerned, not only about the potential enormous influx of people and cars into the neighborhood, but also about a recent court decision allowing the gallery to open one additional day each week.

[1]Wattenmaker, Distel and others, *Great French Paintings*, 1993, p. vii.

On the day of the celebratory dinner, private security guards were hired by the neighbors, and Barnes students lined the streets with signs accusing Lincoln of "betraying" the Foundation — largely because Glanton had paid very little attention to the education program. He was frustrated at nearly every turn, and he began to suspect that he was being harassed because of his race. Nonetheless, the celebratory dinner was a success; the tour had been an unprecedented triumph in the Barnes' history; and the renovations — by the team of Robert Venturi and Denise Scott Brown — were impeccable. Glanton may have been vexed, but he was also very pleased.

While Glanton continued his tenure as chair of the Barnes board, he sought alternative ways to generate the revenue required to meet the Foundation's operating budget. With all other avenues closed, he set his sights on dramatically increasing the flow of visitors to the gallery, while also raising the entrance fee to $10. Ideally, he wanted the gallery to be open six days a week, twelve months a year, with a monthly attendance of at least 9,600 people. The yield in that case would potentially have been $1.15 million per year — less than he wanted (and considerably less than he would need), but at least enough to cover a reasonable proportion of the annual expenditures (then close to $2 million). With a large increase in attendance and the need for more security guards, the expenses, of course, would also rise substantially.

The most recent court ruling had allowed for three and a half open days per week (except in July and August), for a total of about 56,000 visitors annually. The difference between this figure and Glanton's target was very large, and there was no obvious way to bridge the gap. The struggle over visitor "numbers," meanwhile, did not take place in a vacuum. Earlier experiences had shown that even a few more cars, buses and people would disturb the quietude of Latch's Lane. Those who lived nearby distrusted Glanton's intentions, and in 1995, they went so far as to petition the commissioners of Lower Merion to restore the previous access and attendance limits of two and a half days per week, with a maximum of about 4,000 visitors per month. The commissioners proved to be sympathetic and, in December 1995, agreed to the requested change, infuriating Glanton. Within a month, without consulting his board, he filed a suit in federal court, accusing the commissioners and seventeen neighbors of racial discrimination. Glanton noted that other nearby educational institutions operated with very little interference from the commission, the zoning board, or the neighbors, and he lodged his complaint quickly as well as rashly.

The commissioners — and especially the neighbors — were stunned and immediately hired lawyers of their own. Whatever small modicum of good will may have remained among the various protagonists of Lower Merion was completely swept away by this single move on Glanton's part. The atmosphere was poisoned, and there would now be no way that Glanton could expect to achieve his ambitious goals. Moreover, the discrimination case against the residents was thrown out of court within a few months, and while the charges against the commissioners were reviewed for a longer period of time, they too were finally dismissed in 1997. Meanwhile, the Foundation's legal fees were very substantial, and were paid by drawing even further from the Foundation's meager endowment.

The unfortunate developments of the late 1990s resembled a game of legal ping-pong, with many actors in the drama: Glanton, the neighbors, the students, the township commissioners, the zoning board, the federal courts, the Montgomery County Orphans' Court, and the Superior Court of Pennsylvania. Between 1995 and 1999, virtually all of these individuals or institutions either lodged complaints or handed down decisions — some that were at odds with one another. The Orphans' Court had ruled that the Foundation could be open three and a half days per week, but Lower Merion Township ruled for a maximum of two and a half days. Following yet another appeal from Glanton, the Superior Court reinstated three and a half days per week. Then at the very end of 1996, the Zoning Board of Lower Merion Township suddenly decided that the Barnes was exceeding its permissible number of annual visitors and could no longer be classified as an educational institution: it had become a "museum" and would therefore need to apply for a special "variance" if it wished to continue operating. This ruling was, of course, immediately appealed. Meanwhile, vigilant members of "The Barnes Watch" joined Lower Merion Township in declaring that the Foundation had continued to disregard the zoning board's stipulated numbers, and in May 1998, they lodged yet another complaint.

By 1998, Glanton's actions and statements (especially his racial discrimination suit) had been so provocative and ruinous that he completely lost the confidence of his board. He was replaced by Kenneth Sadler, chair of Lincoln's own board, who immediately took steps to clear the air, while moving to gain an understanding of the financial situation at the Barnes. He appointed a chief administrative officer to oversee daily operations, and hired a staff member (formerly of the U.S. attorney's criminal division) from Deloitte & Touche. Both Sadler and the Attorney General's office wanted a complete financial analysis and accounting of the Barnes, from 1992 to 1998. When the audit was completed, the financial predicament was shown to be extraordinarily grim. The discrepancy between the 1998 income

($755,000) and expenses ($5.24 million) resulted in a deficit of approximately $4.5 million:

1998

Revenue		Expenses	
Investments;	$198,936	Salaries and wages:	$769,000
Book contract:	6,657	Payroll taxes and medical:	116,687
Merchandising:	45,833	Guards and security:	339,765
Education:	72,910	Professional and consulting fees:	2,597,280
Admissions:	158,633	Repairs and utilities:	354,323
Gift shop:	213,592	Office expenses:	192,693
Contributions:	89,098	Depreciation:	414,239
		Insurance:	143,883
		Miscellaneous:	313,503
Total:	$755,659	Total:	$5,241,373

Deficit: $4,485,714

It is clear that even if the legal and other consulting fees were eliminated, *there would still have been a deficit of about $2 million.* Meanwhile, by 1998, the endowment had fallen to about $7 million (about 30% less than its 1952 value), while expenses had increased by nearly 2,000%. Absent the legal and consulting fees, the expenses would still have been 1,000% greater than 1952. The inescapable fact was that the Foundation had significant structural deficits that stretched over a great many years, and that had grown continuously with the passage of time. Removing even $2 million — not to mention the full $4.5 million — from a steadily diminishing endowment in order to cover the 1998 operating short-fall left the Barnes in a hopeless financial situation. And more deficits were projected for the years immediately ahead.

The longer term finances of the Foundation were irremediable. The combined cost of even a few essential services (security, repairs and utilities) for the single year 1998 were almost $700,000 (virtually equivalent to the total revenue) before a single staff member's salary — let alone anything else — was taken into account. In short, the reasonable expenses of running the most basic operations of the Barnes far exceeded the institution's capacity.

Sadler's 1998 audit documented the financial predicament inherited by Kimberly Camp, who had been appointed as the first director of the Barnes

in late 1998, and Dr. Bernard Watson, the newly elected chair of the board of trustees. To understand what they were facing, one has to bear in mind two essential points. First, all means of generating more revenue — from selling paintings, to increasing annual visitors, to seeking endowment and other gifts — had been explored during the recent past, and all had failed. Second, time was quickly running out. Payrolls had to be met, art had to be guarded, essential functions had to continue, and all of these required money, on schedule, in a way that met high professional standards. Under these conditions, it was not at all clear how long the Foundation could continue to operate. But Watson was determined to save the institution if at all possible. The alternative, to dissolve the Foundation and make provision for dispersing its art, seemed unthinkable. It was in this context that Watson began his effort to rehabilitate the Barnes in Merion and, when that failed, to explore the possibility of a move to Philadelphia.

In spite of the fact that many of Richard Glanton's actions proved ultimately disastrous, it is important to recognize his accomplishments, which have been largely overshadowed by the blizzard of controversy surrounding his years as chair of the board. He recognized on arrival the dire financial circumstances of the Foundation and brought energy and determination to bear on the problem, hoping to rescue the institution. He managed — with court approval (on several occasions) — to deviate from the allegedly sacrosanct Indenture of the Foundation:

- In 1995, he persuaded the court to allow for a complete change in investment policy.
- He won (again in court) the right to hold fundraising events at the Barnes, although the victory came much too late when there were no donors in sight. But it was Glanton who managed to circumvent the Indenture on this issue.
- He recognized the need for a major renovation of the gallery, and successfully carried it out.
- He conceived the international tour that took place while the gallery was closed. This major triumph, thanks to Judge Stefan, clearly deviated from the Indenture's stipulation that none of the Barnes paintings should ever be moved or lent.
- He imaginatively circumvented the Indenture's prohibition on social events of any kind when he hosted a highly successful dinner (and a visit to the galleries) to celebrate the return of the paintings after their tour.
- He initiated the publication of a highly credible and handsome catalogue of a large number of the Foundation's paintings.

- He won the right (thanks to the introduction of air conditioning) to introduce visitor days in July and August, even though the Indenture explicitly prohibited it.
- He won the battle to create an on-site parking lot — something that clearly became necessary, but that Barnes would almost certainly not have approved.
- He managed — at least for a period of time — to extend access to the Barnes from two and a half to three and a half days per week.

Nearly all of these initiatives were opposed by either the neighborhood, the students, or both. And the township and zoning board fought at least some of them. But forty years (and more) had passed since Barnes' death and — with the exception of Walter Annenberg and the Attorney General — no one had advocated broader access to the art collection. No one had thought of pressing ahead, as Glanton did, on even so basic a matter as a change in the investment policy. No one (except Franklin Williams) was willing to recognize the hopeless financial course on which the Foundation was embarked, and no one attempted to do anything about it. No one (except Williams) realized that the physical state of the gallery building had deteriorated sharply, and no one found a way to address the problem.

In short, although the Glanton years were marred by seriously misguided and self-defeating episodes, he understood the urgent need for changes in the Indenture, and he undertook to achieve them in circumstances that were at best difficult, and often fiercely hostile.

10

Dr. Watson

Dr. Bernard Watson and Merion

As soon as Dr. Bernard Watson began his tenure as chair of the Barnes trustees in the autumn of 1999, he developed a long-range plan designed to revive the Foundation in Merion and commissioned a study by Deloitte and Touche to analyze the financial viability of his ideas. Fortunately, the recently appointed very effective director, Kimberly Camp, had already pressed ahead. She hired a director of education — the first in the Foundation's history — and began to publicize the Foundation's course offerings. She also assembled a professional advisory committee of scholars and teachers to help chart a course for future curatorial and educational activities. And she launched a Collection Assessment Project, under excellent professional leadership, to begin the process of documenting the collections as well as cataloging and making accessible the Foundation's large and rich cache of archival materials.

Meanwhile, Watson hoped that there might be a program of modest-scale temporary art exhibitions, and that Ker-Feal — a fine early American farmhouse owned by the Foundation — could be renovated and opened to visitors, so that its exceptional collection of early American furniture and other objects could be shown. A touring exhibition of important works of art that were not in the permanent collection was also under consideration. Watson's ambitious initiatives were already in process before his first year was out, and he was simultaneously talking with many people whom he hoped might offer major financial help, even before several of the new projects could be started. Within a few months, the Foundation was operating with new energy (and with slightly more students, although the numbers continued to be small).

In spite of Watson's long experience as a distinguished educator (he had been academic vice president at Temple University) and his transparent seriousness and conviction, he found that persuading people to invest in the Barnes was essentially impossible. As an African-American and an honored

Dr. Bernard C. Watson, 2012
Photograph by Susan Beard

citizen of Philadelphia (he had also been president of the William Penn Foundation), he was ideally placed to bring about a renaissance of the Barnes, and he was able to assure people that he was focusing as much on long-range sustainability as on short-term improvements. But despite his energy, commitment, and vision, he was unable to raise the necessary "general funds" or endowment money for the crippled institution.

The reasons are not difficult to understand, and several of them have already been mentioned. The Barnes had spent much of its existence keeping people out of the grounds and the gallery. Why would individuals and institutions suddenly decide to give very substantial sums of money to a Foundation that had never made any gesture to welcome them? In addition, the neighborhood had proven, over the course of time, to be much less than hospitable (or predictable). Every effort to expand the number of visitors, to hold special events, or even to have tours for selected groups of people had been attacked and habitually blocked. The township and the zoning board stood vigilantly by, ready to hear every complaint against the Foundation. This was hardly an environment in which a reinvigorated and aspiring institution could be confident about its capacity to function energetically with-

out constant friction and frequent prohibitions. Finally, the sums of money required to save the Barnes were enormous and had to be raised very rapidly if they were to prevent complete financial collapse. To professionalize the staff and its operations properly would have required a budget of at least $4 million a year; and to do the job at a more realistic level, while also providing adequate contingency funds, would have demanded even more — that is to say, an endowment (at a five percent spend rate) of $80 to $90 million. Kimberly Camp's estimate was approximately $70 million. Yet the Foundation had never received an unrestricted gift of even $1 million. As an interim measure, the Foundation began a $15 million emergency campaign simply to keep the institution afloat for a limited period of time, while Watson continued to seek the required additional funds.

Not everything was negative, however. Although individuals and foundations were understandably not willing to give significant operating or endowment funds to the Barnes as an *institution*, some of them were concerned to ensure that the art collections were protected, documented, and maintained in excellent condition — and that long-range strategic planning could be supported. In 2001, a series of restricted foundation grants were made by a diverse group of major philanthropic institutions. This was a highly encouraging "first" for the Barnes.

The J. Paul Getty Trust, the Pew Charitable Trusts, the Andrew W. Mellon Foundation, and the Luce Foundation all gave "targeted" grants (in the range of $500,000 each) to support special efforts — one of which was the "Collections Assessment Project" designed to inventory, evaluate, and record in a scholarly manner all of the Foundation's works of art and to organize the archives. Support for the Foundation's American art collection and the costs of a subsequent scholarly catalogue was forthcoming from Luce. Resources from Getty and Pew covered the costs of experienced advisers and consultants to undertake a planning process to create a viable framework for the Barnes' future in Merion.

All of these generous contributions were invaluable, and they were clearly the fruit of Watson's and Camp's continuous efforts. But the new grants, significant as they were, had essentially no material effect on the basic financial predicament of the Foundation. The "Collections Assessment Project," which included scholarly and curatorial initiatives never before attempted at the Barnes, required adding staff positions. The Mellon Foundation continued for a decade to underwrite the salaries and associated expenses for these scholarly and conservation activities, but the net impact on the Barnes' financial stability was zero. Meanwhile, the Barnes faced another major deficit in 2000, and a projected one of over $1 million for 2001. The new initiatives started by Watson and Camp were energizing; the support from the four foundations was a great boon for special projects; yet there was no help at all from any quarter for the Barnes as an enterprise with continuous and inescapable monthly and annual expenses.

Watson had arrived and moved forward with the expectation that substantial support for operations and endowment would be forthcoming if the Barnes could show that it was now established on a promising steady course, with clear goals and thoughtful, capable leadership. After two years of continuous effort, however, this optimistic prospect remained no more than a hope. Although the grants from the four foundations helped morale and contributed in extraordinary measure to enabling scholarly activity, their fundamental message was discouraging, signaling that a wide range of internationally distinguished philanthropic institutions with very different agendas — based in different parts of the country, from California to New York and Philadelphia — had a similar view of the Barnes Foundation: they would not help the Merion-based institution to address its immediate fundamental financial needs, although they would assist with specific circumscribed projects.

These were not unusual or eccentric decisions on the part of the foundations, particularly because all of them took the same approach in the case of the Barnes. Major foundations invariably follow strict and well-established criteria in making substantial philanthropic decisions of any kind, considering factors such as the causes that have led to any operating deficits. Were effective corrective actions taken over a period of years to solve any financial problems? No less important, could the institution count on receiving continuing annual funds and endowment gifts in the future, ensuring that the years ahead would be significantly different from the past? The goal of any substantial endowment or operating support is to enable an institution to quickly gain and maintain its financial stability and vitality, allowing it to move ahead with renewed energy and capacity. Without assurance that this goal can be met — and sustained indefinitely — there is no clear argument for giving major endowment or operating assistance.

Another important consideration for a grant-making foundation would be the extent to which an institution could depend upon the good will and support of its surrounding community, especially if it wanted to introduce new (and potentially more ambitious) programs consistent with its mission. We already know a good deal about the contentious nature of the relationship between the Barnes and Merion, but one should also remember that the major problems were not only a matter of past history. When Bernard Watson first arrived at the Barnes in 1999, he was immediately asked by the neighbors to apologize for Glanton's racial discrimination lawsuit and to pay the legal fees of the offended parties. The Barnes had no money, and Watson refused. Tensions reemerged. This scarcely augured a promising future.

In short, it was hardly surprising that no foundations or other major donors were willing to contribute consequential sums of money to the Barnes in Merion — an institution that was, in effect, an isolated island unto itself. The Foundation's location in a residentially zoned area posed complex challenges, and Merion itself had never shown any serious interest in raising

funds for the Foundation even though the financial crisis was well-known during Watson's years (and earlier).

Three full years after Watson's arrival, virtually no local individuals or groups had stepped forward to offer more than symbolic support, let alone substantial funding. It was in this climate that — in September 2002 — the Barnes petitioned the court for permission to move to Philadelphia, where the prospects for substantial funding and strong support for the Barnes were evidently strong. After the petition was filed, there were vigorous protests. Those individuals and groups who had previously opposed greater "access" and every other plan of the Barnes, quickly shifted ground and moved into forceful and steady opposition to the proposed migration to Philadelphia. And the battle was prolonged, reaching even beyond the time when the new building in Philadelphia was rising quickly on Philadelphia's main Parkway, located near a number of other cultural institutions.

<p style="text-align:center">✫　　✫　　✫</p>

Whose Education?

From a legal point of view, it was clear that permission to move the Barnes to Philadelphia could only be justified if the Foundation were no longer capable of fulfilling its mission in its original location. Barnes had actually anticipated in the Indenture that something of this kind might eventually occur, and indicated that if the Foundation could no longer achieve its goals, it should be dissolved:

> Should the said collection become impossible to administer the trust hereby created concerning such collection of pictures, then the property and funds . . . shall be applied to an object as nearly within the scope to be in connection with an existing and organized institution then in being and functioning in Philadelphia, Pennsylvania, or its suburbs.[1]

By 2002, Watson and others felt that such a moment had come: one could either relocate to a supportive location and a sympathetic constituency — where there was a prospect of revitalizing the Barnes and raising necessary funds on a continuing basis — or one could dissolve the institution by disbursing its property and art. Watson and his board decided, very wisely, not to dissolve.

In addition to the "financial test" that resulted in the court petition, however, Barnes had also provided for a more fundamental criterion that should

[1] Barnes Foundation Indenture of Trust, p. 11. Also cited by Judge Ott in his Opinion, January 29, 2004, p. 13.

determine whether the Foundation ought to continue: was the institution's educational "experiment" a success, and had it met its stated ambitious goals? If it had not, the Foundation should be closed. The central purpose was to advance "education and the appreciation in the fine arts." Barnes specified that more precise methods of achieving that goal would "have to be developed by experience after the Foundation has been in operation for a term of years." Additional relevant considerations — most of which have been highlighted previously — were described in other parts of the Indenture:

- The "facilities are to be made available, under proper rules and regulations of the board of trustees, to all properly qualified institutions;"
- "students of art are to be admitted by special arrangement under regulations prescribed by the board of trustees;"
- the desire is for the educational plan to "be operative for the spread of the principles of democracy and education;"
- it will be incumbent upon the board of trustees to make such rules and regulations as will ensure that "the plain people, that is, men and women who gain their livelihood by daily toil in shops, factories, schools, stores, and similar places, shall have free access to the art gallery and the arboretum upon those days when the gallery and the arboretum are to be open to the public;"
- the establishment of the art gallery is "an experiment to determine how much practical good to the public of all classes and stations of life may be accomplished;"
- "the purpose of this gift is democratic and educational in the true meaning of these words, and special privileges are forbidden."

Apart from references to teaching art according to the principles of modern psychology, all the other purposes of the Foundation concerned the "spreading" of the principles of "democracy and education." The emphasis on democracy was certainly influenced, at least in part, by Dewey, although Barnes' own earlier educational experiments with ordinary workers in his factory — and the larger context (in England and America) of art education for "the people" — certainly played a role. For the rest, the Indenture not only stressed that "plain people" should be admitted free of charge, and that people from "all classes and stations of life" should benefit, but also that the crucial test of the program's success or failure should depend upon *"how much practical good to the public . . . may be accomplished."*

Deciding whether or not an educational experiment has succeeded is clearly not a scientific exercise. One way to make an approximate judgment, however, is to trace the steps that an institution takes and the measurements it uses to achieve its stated goals. Once the Barnes opened to the public in 1961 for at least two days a week, what efforts were made to determine whether any "plain" working-class people were visiting the collection, and

what provisions were established between 1961 and 1988 to make it convenient (and free) for them to do so? How were "plain people" identified in a fair and systematic way, and what procedures existed to determine whether people from "all classes and stations of life" were benefiting from gallery visits or the educational program? How many African-Americans, people from working-class backgrounds, or other "classes" of people were enrolled in Foundation courses? Were any specific means introduced to help "spread" the principles of "democracy" through the educational program? If so, how were these principles defined and promulgated?

Above all, did the Foundation try to measure *"how much practical good to the public of all classes and stations of life"* was being "accomplished"? Unless one could give some reasonably specific and persuasive positive response to these questions, it would obviously be difficult to claim that the Foundation's program was successful.

There is scant evidence that such questions were raised, let alone addressed during Barnes' lifetime or afterward. We know that many people were prevented from visiting the gallery or attending courses, and there was no consistent policy or rationale in place. For years after Barnes' death, the gallery was rarely if ever open to visitors of any kind, and student applicants were arbitrarily screened by staff. Nor is there any evidence at all of special and consistent efforts made to admit plain people free of charge or to determine the extent to which the Foundation was actively trying to spread democratic principles or doing "practical good" for the "public" in general. These terms and criteria were not empty phrases: they were central elements of the rationale for the Foundation's tax-exempt status as an educational institution.

If we look even more closely at the Barnes' educational program, we can see the extent to which it has — or has not — served a broad range of people drawn from all classes. Some of the earlier Barnes teachers remained at the Foundation throughout the 1990s into the first years of the twenty-first century, so there has been a good deal of continuity. Data exist to document the number and "types" of students enrolled. Over a recent seven-year period, we find that there were a total of 756 enrollments in all art courses, for an average of about 100 each year, distributed among three or more courses per term. Courses normally met once a week for a four-hour period (counting preclass study), so the entire two-story gallery was closed three and a half days per week in order to serve about 100 students (or, at a maximum, about 200) in a relatively small number of weekly class sessions.

How diversified was this audience during the same period? The average age was fifty-six: 76.5 percent were women, and 23.5 percent men. The highest concentrations of students came from well-off suburban towns: Bryn Mawr, seventy-three; Haverford, eighteen; Villanova, eighteen; Merion, thirty-two; and Bala Cynwyd, thirty-three. Only about fourteen per year came from Philadelphia. More than forty students took the very same course two or more

times, and in a few cases, four to five times, often with the same instructor. Thus, more than 100 of the 756 enrollments represented "repeats."[2]

In short, the Barnes Foundation has typically served an extremely small adult education audience coming largely from nearby suburban communities. In terms of location, age, gender, socioeconomic class, race, and ethnicity, there has been very little diversity indeed. In addition to other factors inhibiting a broader range of enrollments, tuition by the 1990s had risen to $650 per course, and travel to Merion on a weekday would hardly be easy for working-class people, a constituency that might also find it difficult to take advantage of a free public visiting day.

There is no doubt that the small number of students who attend courses at the Barnes have generally responded very favorably. And the circumstances — in terms of private gallery time in a beautiful and wooded setting — could hardly be more alluring or educationally luxurious. But the situation seems inordinately far from the strongly stated democratic purposes in the Foundation's Indenture. Has the "experiment" succeeded? Has it failed in such a way as to suggest that the works of art should in fact be distributed among one or more institutions? Most of all, how much time and focused effort did the Foundation expend during two-thirds of a century to achieve its articulated goals?

A great deal of — indeed, by far the strongest — opposition to the planned move of the Barnes has come from those who are focused on the art collection and the Foundation's setting. Significant as these are, they do not relate directly to Barnes' own stated purpose in creating his Foundation, or to the goals that he himself said he wanted to fulfill — or to the Foundation's tax-exempt status. How would those who have opposed the move evaluate the educational results of the institution's experiment? Is the Foundation well-positioned — in terms of its location and community — to carry out a vital educational mission of the broad kind that Dewey envisioned and that Albert Barnes described in his Indenture? The weight of evidence to date would suggest that the experiment has fallen far short of its original goals. The diverse city of Philadelphia would clearly offer the promise of greater openness and accessibility in a "democratic" milieu.

Whose Barnes?

One of the major questions concerning the Barnes Foundation that has generated a vast amount of misinformation over the past quarter century is this: who has actually owned, controlled, and run the institution since the death of the founder?

[2]All statistics derive from the archive of the Barnes Foundation.

In December 1940, Albert Barnes first introduced his clear instructions regarding leadership responsibility and governance. A special provision in the Indenture clarified any potential relationship between *trustee-nominations* by an outside institution (originally the University of Pennsylvania) and actual control of the Foundation. Barnes was willing to offer "nomination-power" to an institution, *provided* that the Foundation's art (and aesthetic) teaching conformed to his own methodological and pedagogical approach, and provided that the Barnes continued to exist as a completely independent organization with its own identity and decision-making capacity. He insisted that the Foundation and its board — rather than any outside institution — should remain in firm control of its art, programs, and policies. This provision was initially introduced when the (belated) possibility of collaborating with the University of Pennsylvania — after several earlier attempts — was once again seen by Barnes to be conceivable:

> [U]nder no circumstances shall either the [Foundation] or the conduct of its plans and purposes ever be subject to the control of the University of Pennsylvania or its Board of Trustees. The object of the aforesaid stipulation is to preserve for all time the identity of the [Foundation] as an educational institution, and to make available to various other . . . institutions . . . the resources of the [Foundation].[3]

When the latest (and final) partnership plan with the University of Pennsylvania failed, it became simple to insert (into the Indenture clause) the name of another institution.

From its establishment in 1922 until the late 1980s, Albert Barnes and his successors — Laura Barnes and then Violette de Mazia — made all policy for the Foundation and had complete oversight of its art, educational programs, budget, and other operations. During this entire period of approximately sixty-five years, very little changed. The number of students enrolled in courses remained modest. Access to the gallery was severely restricted until the courts mandated a limited number of "open days." The question of ownership — or power over the affairs of the Barnes — only arose in the very late 1980s when, following the severe illness of Violette de Mazia, Lincoln University nominated Franklin Williams to head the extremely small five-member board of trustees. It was then that the issue of control of the Barnes was first raised, but Franklin Williams had no doubts about the matter. While Lincoln did, under the law, have the right to nominate (not appoint) four trustees, Williams adhered firmly to Barnes' Indenture. Once a new trustee was elected, he or she was clearly responsible to

[3]*Dr. Albert Barnes' Search*, p. 13.

the Barnes board and its programs, rather than to Lincoln. The board (not Lincoln) would have full authority over the Foundation, exercising the fiduciary responsibilities expected of any group of trustees.

It should also be stressed that, under the stipulation of Barnes' Indenture, Lincoln owned neither the buildings nor the art collection, and it had no role at all in policy making, operations, or in the management of the educational programs. Williams' model was not only in accord with Barnes' specifications, but it was also the conventional one: the trustees of an institution are ultimately responsible for its fate. When Richard Glanton was nominated to the board following Williams' untimely death, he immediately assumed the chairmanship and followed the example that Williams had set. Indeed, he went further, and was widely characterized as managing the Barnes autocratically, as he saw fit.

What do these facts indicate about Lincoln's actual statutory powers in relationship to the Barnes? Fundamentally, it demonstrates that once individuals (such as Williams and Glanton) became leaders of the Barnes, they and the board acted absolutely independently of Lincoln, running all the affairs of the Foundation. If Lincoln *had* been granted "ownership" or any policy-related power, it would have been held fully responsible for the Foundation's actions, including the financial, legal and other turmoil of the years from 1988 to 1998. It would also have been ultimately responsible for addressing the budget problems, seeking to raise money to save the institution. Yet, no one has ever suggested that this was — or should have been — the case. Anyone who knew Barnes' stipulations realized that Lincoln was meant to have only the most "token" of roles. Nevertheless, the university was forced to bear a good deal of the criticism of Glanton's serious errors of judgment, finding itself in the unenviable position of being publicly viewed as controlling, owning, or carrying responsibility for the Foundation, while having had no legal authority to do so. In essence, it had the worst of both worlds. Barnes' Indenture had left an idiosyncratic — potentially self-defeating — form of power to the university: the limited authority to nominate four trustees. The structure was woefully ill-conceived — but then, Albert Barnes was not in the habit of giving away anything unambiguously.

This entire issue took on considerable significance when the Montgomery County Orphans' Court granted the Barnes' request to move the Foundation to Philadelphia and to expand its board from five members to fifteen (of which Lincoln would have the right, in perpetuity, to nominate five). Lincoln objected to the stipulation concerning the board's expansion, and the proposal has been portrayed by some as a move by wealthy and political elite interests in Philadelphia to strip Lincoln of its "ownership" or its power to control and run the Barnes. A relatively poor African-American institu-

tion was said to be the victim of a "steal" or "power grab," which — with the political and financial support of the governor — would enable "white" Philadelphia to capture a prize possession which it could then exploit for its own purposes.

But the facts of the situation were otherwise. The Barnes board that proposed both the move to Philadelphia and the expansion of the governing board was composed of trustees *who had all been nominated by Lincoln itself*, not by "outsider" Philadelphians. This board had exhaustively explored a large number of alternatives before eventually concluding that a move represented the best — indeed the only — means of ensuring the survival of the institution. Moreover, it was not until December 2001 that board chair, Bernard Watson, convened a meeting with three major Philadelphia foundations, in order to discuss the idea of a possible move. This occurred only after continual unsuccessful efforts to raise operating and endowment funds to support his plans for the Foundation's future.

As part of the arrangement to help the Barnes financially, the Pew and Lenfest foundations requested — and were ultimately granted — a one-time opportunity to approve four members of the Foundation board, if the expansion to fifteen members were sanctioned by the court. This request has often been wrongly characterized as an effort to compel Lincoln University to "cede its power" to the Philadelphia foundations. But, as we have seen, Lincoln had no real power — and Lincoln nominees (and a "trust" lawyer) already occupied all the original board seats. Moreover, under the potential new agreement Lincoln would have the right to nominate an additional three trustees immediately. In other words, by retaining seven of the proposed fifteen nominations, Lincoln would continue to be — by far — the majority "nominating" institution for an indefinite time to come, while the four nominees to be approved by the two Foundations would serve only once.

The Philadelphia foundations did not request any continuing role on the board because they had no desire to control the institution. They wanted a limited role in the creation of an expanded board whose members would have had considerable previous trustee experience and who would be responsive not only to the Foundation's primary educational mission but also to matters of finance, the law, management, planning, and fundraising. Without such a balanced and experienced board, the Barnes would clearly have run the risk of repeating much of its unhappy history.

The issue of the size and composition of the board was considered in detail during the course of the 2004 court case concerning the potential move to Philadelphia. The presiding judge examined the arguments for and against this with care, relying in large part on testimony from Maureen Robinson, an expert consultant on nonprofit organizations. She stated that the average size of comparable nonprofit boards was nineteen (in 2002). In her view, the current size of the Barnes board (five members) was too small to be effective: raising necessary funds was not "a task for a one-man band.

It's not even a task for a quintet. You need a pretty full orchestra."[4] She recommended a board of no fewer than fifteen.

Robinson also argued that a larger board would ensure participation and accountability. Under the original Barnes arrangements, Robinson said, "[A] quorum is reached with only three trustees, and decisions can be made by a simple majority vote of only two,"[5] a recipe for potential divisiveness, political maneuvering, and room for serious error.

Robinson made two additional points. A larger board would increase the pool of members from whom future leadership could be drawn. Moreover, control of all nominees by a single, completely independent institution (e.g., Lincoln) could quickly lead to conflicts-of-interest. For instance, both the Barnes and Lincoln needed major sums of money for operations and endowment. When considering potential board members who might possess substantial wealth, would Lincoln nominate them for the board of the Barnes — or keep them for itself?[6] Having taken all of these matters into account, the presiding judge summarized:

> We find ample support for the proposal that the Board of Trustees of the Foundation should be expanded. It is clear that the stewardship of a modern-day nonprofit must rest on many shoulders. It is imperative that the Trustees have wide-ranging experience, expertise, and contacts, and the ability to attract donors of substance. A board of only five trustees, no matter how talented and dedicated the individuals may be, cannot meet the enormous responsibility of carrying the Foundation into the twenty-first century.[7]

☆　　☆　　☆

[4] Memorandum Opinion and Order, Judge Stanley Ott, January 29, 2004, p. 7.

[5] Ibid., p. 7.

[6] Ibid., pp. 7–8.

[7] Ibid., p. 9.

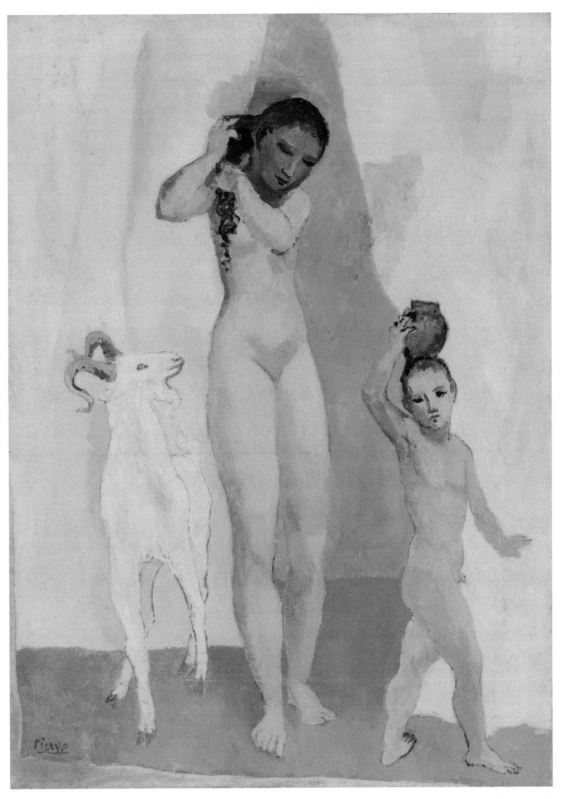

Plate 9. Pablo Picasso, *Girl with a Goat*; *La Jeune fille à la chèvre*, 1906. Oil on canvas, 54⅞ × 40¼ in. (139.4 × 102.2 cm). BF250
Acquired by 1926

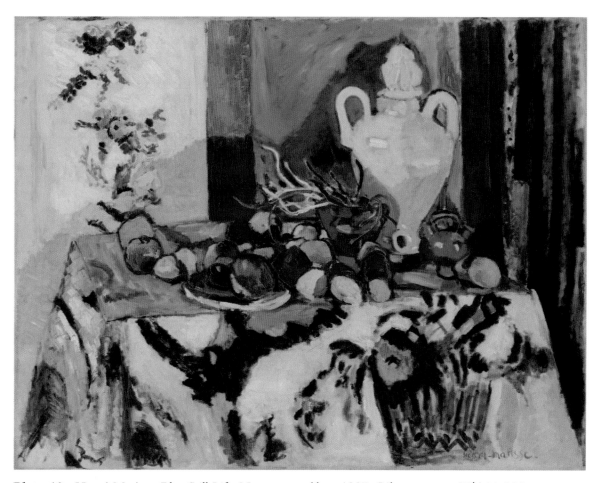

Plate 10. Henri Matisse, *Blue Still Life*; *Nature morte bleue*, 1907. Oil on canvas, 35½ × 46 in. (90.2 × 116.8 cm). BF185
Acquired January 1925 through Paul Guillaume

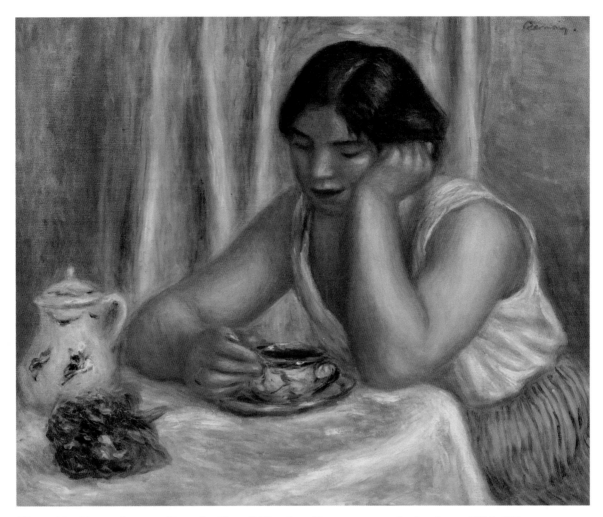

Plate 11. Pierre-Auguste Renoir, *Cup of Chocolate*; *Femme prenant du chocolat*, c. 1912. Oil on canvas, 21⁵⁄₁₆ × 25 ⅝ in. (54.1 × 65.1 cm). BF14
Acquired April 1921 from Leo Stein

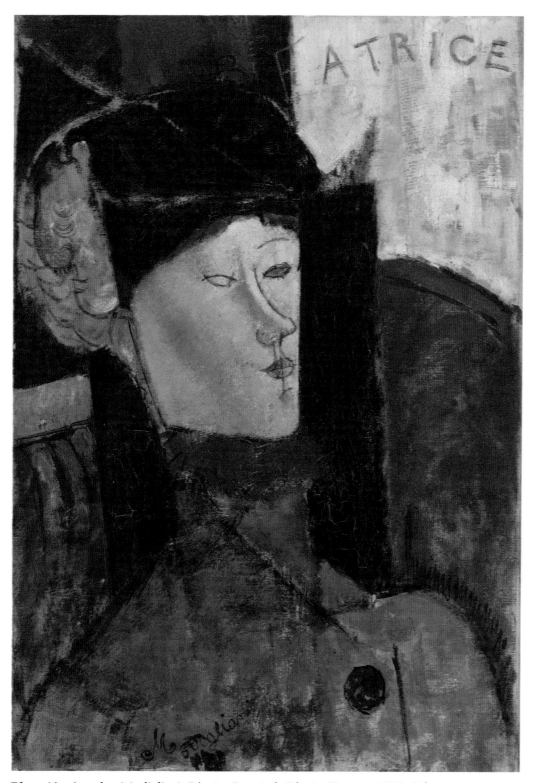

Plate 12. Amedeo Modigliani, *Béatrice*; *Portrait de Béatrice Hastings*, 1916. Oil on canvas, 21⅝ × 15³⁄₁₆ in. (55 × 38.5 cm). BF361
Acquired June 1923 from Paul Guillaume, Paris

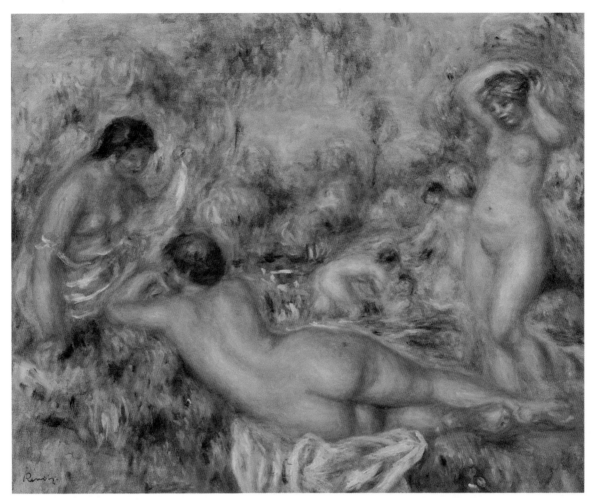

Plate 13. Pierre-Auguste Renoir, *Composition, Five Bathers; Composition, cinq baigneuses*, c. 1918. Oil on canvas, 26⅜ × 31⅞ in. (67.5 × 81 cm). BF902
Acquired January 1932 from Maurice Renou, Paris, through Galerie Georges Petit / La Peinture Contemporaine, Paris

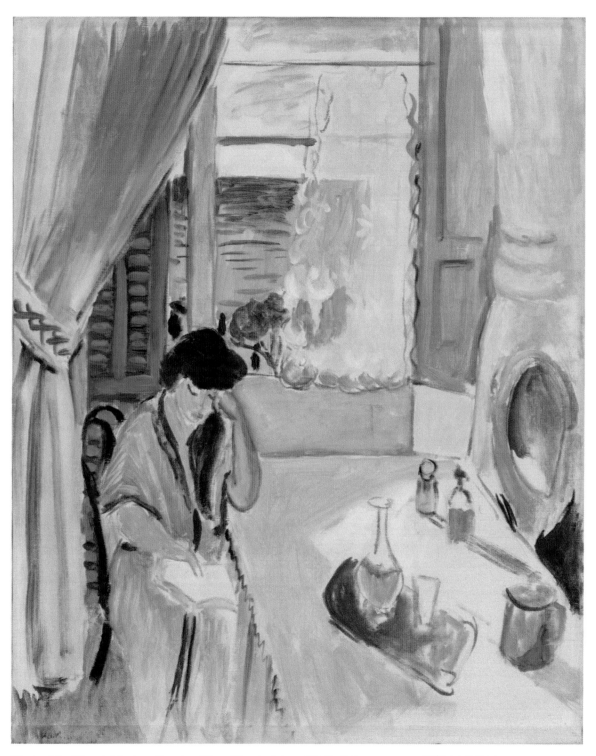

Plate 14. Henri Matisse, *Interior, Nice; Nice, intérieur*, 1919. Oil on canvas, 29¾ × 24⅛ in. (75.6 × 61.3 cm). BF394
Acquired by September 1930, but probably by 1925

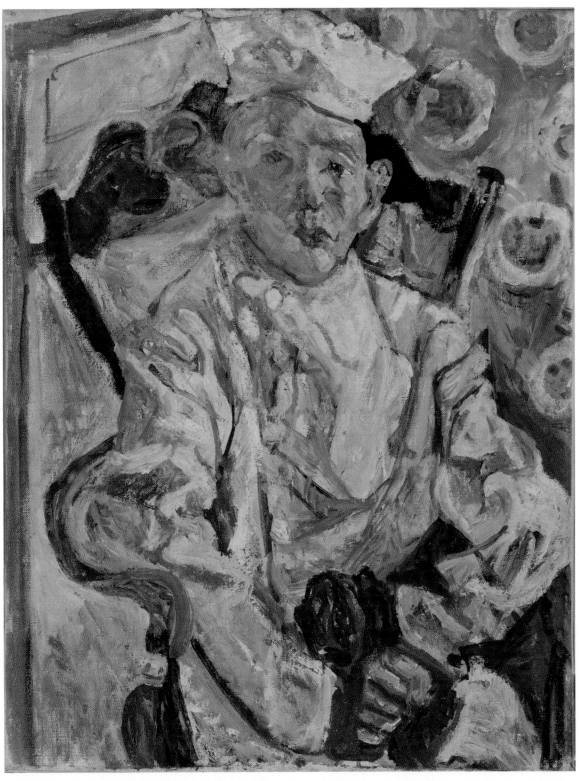

Plate 15. Chaim Soutine, *The Pastry Chef (Baker Boy)*; *Le Pâtissier*, c. 1919. Oil on canvas, 26 × 20 in. (66 × 50.8 cm). BF442
Acquired January 1923 from Paul Guillaume, Paris

Plate 16. Henri Matisse, *The Dance*; *La Danse*, Summer 1932–April 1933. Oil on canvas, three panels, left: 11ft. 1¾ in. × 14 ft. 5¾ in. (339.7 × 441.3 cm); center: 11ft. 8⅛ in. × 16 ft. 6⅛ in. (355.9 × 503.2 cm); right: 11 ft. 1⅜ in. × 14 ft. 5 in. (338.8 × 439.4 cm). 2001.25.50a,b,c Commissioned 1930, installed May 1933

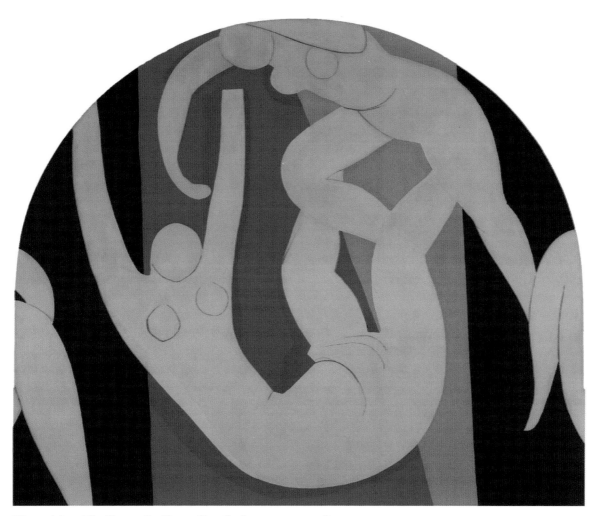

Plate 16a. *The Dance*; *La Danse* (detail, the center panel)

11

The Court and the Case

Judge Ott

The Orphans' Court of Montgomery County (which has jurisdiction over the Barnes Foundation) was led by Judge Stanley Ott (who had succeeded Louis Stefan). Once the Barnes board of trustees decided to try to move the Foundation to Philadelphia, the case went directly to him. Those who question the Foundation's motives for the move rarely (if ever) focus on the central role of Judge Ott and the significance of his two detailed, carefully reasoned opinions in the case. Yet everything involving the Foundation's Indenture and the rationale for a possible move depended on his analysis and conclusions. There has been no claim that he was at all biased or that he could be viewed as part of a conspiracy to allow the Barnes to change its location. He ruled on the merits of the case and would not have approved the petition had he not been fully persuaded by the extensive evidence that he demanded, received, and analyzed.

Moreover, it would be impossible to demonstrate that Judge Ott had ever been in any way indulgent toward the Foundation in the many Barnes-related cases that were previously brought before him. He ruled on at least seven such petitions prior to 2002, and in most cases he decided partly or fully against the Foundation, whenever he saw a possible violation of the terms of the Indenture. No one, least of all Richard Glanton, would have characterized the judge as a friend of the Barnes. But his rulings demonstrate the cautious minimalism and judicious objectivity that guided him.

To summarize some important points already made on this subject in earlier chapters:

> In the autumn of 1995, Glanton had asked the court for a number of changes to the Indenture. He requested permission to modernize the investment policy, to eliminate the prohibition on holding "social functions," and to open the gallery to the public six days a week, instead of two and a half, with the admission fee raised from

$1 to $10. The Judge denied permission for social events while granting permission to increase the number of open days to three and a half. Recognizing the dire financial straits of the Foundation, he compromised on the entrance fee, allowing an increase to $5. Far more consequentially, he concluded that a change in the original rigid investment policy (stipulated in the Indenture) was fully warranted.

Glanton was disturbed by most of these rulings because he was counting on much larger attendance figures and a much higher entrance fee to help balance the budget. Nor was it long before he was back in court. The Barnes' paintings were returning from their international tour, and Glanton wanted to celebrate with a gala dinner following which guests would be invited to visit the gallery to see the reinstalled paintings. The Judge initially denied both requests: there could be neither social events in any Foundation building nor any extra "open" hours for visiting the gallery. This led to a crisis. Glanton had already organized the dinner and invited an all-star cast of guests. An appeal to the Superior Court of Pennsylvania and more conversations with Ott led to a partial accommodation reached between the two courts. Although the dinner was approved if held *outside*, in a tent, the Superior Court overruled Ott on the related issue: the guests would be allowed to tour the gallery after dinner for a limited period of time.

Another case involved the fact that the Barnes Foundation and the de Mazia Trust had always been linked in their joint support of the Foundation's educational program. In the midst of all the turmoil of the 1990s, however, they too became embroiled in a legal battle and petitioned the Orphans' Court to allow them to separate. Ott denied the request on the grounds that a divorce of this kind would fail to honor the donors' original intent. Once again, Ott was overruled by the Superior Court; the de Mazia Trust and the Foundation have been separate entities ever since.

Several months later in July 1996 Glanton was back in Ott's court. He wanted to change the Indenture's stipulation against any "open" public days in the gallery during July and August. Ott followed the Indenture and turned down the request. But he was again overruled by the Superior Court. Now that the galleries were air-conditioned, the Superior Court concluded that opening them three and a half days per week during the summer was reasonable.

In short, Ott consistently upheld the stipulations of the Foundation's original documents in every case in which it was at all reasonable to do so,

even to the point of being overruled on appeal — several times — whenever his conclusions appeared to be unduly restrictive. He was always reluctant to contravene the Foundation's Indenture and did so only on rare occasions. Any judge who would refuse to allow one single celebratory dinner at the Foundation, followed by a viewing of the paintings after their return from an international tour, was obviously not likely — except under the most compelling circumstances — to conclude that a move of the Barnes Foundation to Philadelphia was justified in law.

Banks, stores, restaurants, and occasionally even schools change locations for any number of reasons without controversy or legal challenge. But the location of other institutions can be viewed as sacrosanct because their very setting seems intrinsic to their character. This was true of the Barnes Foundation, rooted as it was in acres of land and trees; tranquil and isolated in a way that heightened its sense of identity; and beautifully designed, combining intimate domesticity with unobtrusive institutional order.

It was not surprising, therefore, that the petition allowing the Foundation to move to Philadelphia generated — in many quarters — reactions of shock, anger and disbelief. For many people, it was as if one of one's own treasures were being torn away, with no visible sensitivity to the magnitude of what was being proposed. Suddenly, a vital part of one's landscape was threatened — and for what appeared to be no explicable reason. Indeed, when Judge Ott first wrote about the case, he began with a highly unusual statement:

> At the outset, we must comment on the unprecedented public interest in this case. Since the filing of the original petition, rarely a day has gone by without a letter or phone call arriving at the undersigned's chambers from someone wanting to weigh in on this matter. Politicians, art scholars, financial experts, and former students have sent suggestions for saving the Foundation. Major newspapers have published endless dialogues of letters to the editors, as well as editorials endorsing one outcome or another, as if this were a political race. Even legal scholars, attorneys, and law professors, who know that cases are determined by applying the law to the evidence produced in court and *not* by public opinion, have sent unsolicited opinion letters for our edification. The court has studiously avoided being influenced by these outside forces; however, the experience has been unique.[1]

[1]Memorandum Opinion and Order, Judge Stanley Ott, January 29, 2004, p. 2.

The opposition to the move to Philadelphia (as well as support for it) continued for a decade, from the moment when a proposed change of location was announced. Inevitably, there were proposals or views suggesting how and why the Barnes should remain in Merion, and there was continued speculation about the rationale for the move. Many people thought that a solution to the problems of the Foundation was not a difficult matter — and they also believed that the motives of the proponents of the move were more than suspect. Neither assumption was valid, but it is understandable why each might have seemed plausible at different times to different observers.

When the petition to expand the board of trustees and move the Barnes first came before Judge Ott, he initially proceeded in such a way as to suggest that he would decide all of the issues at once. But, by January 2004, when he made his first set of determinations, he had concluded that there was only sufficient evidence to rule on the question of expanding the board.

The Foundation's financial situation was dire. It was only able to operate by combining its meager remaining cash with temporary "bridge funding" provided by the Pew and Lenfest foundations. Judge Ott nevertheless put off indefinitely a ruling on the main motion because he believed that there were still insufficient facts and evidence on which to base a decision: "[T]he fact-finding in this case has been seriously hamstrung by the total absence of hard numbers in evaluating these proposals:"

> We have only a preliminary "guestimate" about the real cost of constructing the new venue. We have no concept of the Foundation's operating expenses at the new space. There have been no feasibility studies or *pro formas* projecting the success of the proposed venture. We don't know how much it would cost to maintain the Merion facility. . . .
>
> On the opposite side of the coin, we have no hard numbers to evaluate options. . . . Other than the offers for the land surrounding Ker-Feal, we have not heard even a wild estimate of the value of the items owned by the Foundation but not on display in the gallery in Merion.[2]

Ott suggested that the views of the three Philadelphia foundations could not be taken into account, because they represented something resembling "zealous advocacy." Finally — and even more extraordinary — he was scathing about the role played by the office of the state's Attorney General: it provided no relevant information via discovery proceedings "and even indicated its full support for the petition before the hearings took place." In this

[2]Ibid., pp. 19–20.

sense, it did no more than "cheer" the witnesses of the Foundation and "prevented the court from seeing a balanced, objective presentation of the situation" in a way that constituted "an abdication of that office's responsibility."[3]

Citing other cases decided by the Superior Court of the state, Ott realized that it was possible to conclude "that the present location of the gallery is not sacrosanct, and relocation may be permitted *if necessary* to achieve the settlor's ultimate purposes."[4] But, he insisted, the "element of necessity has not so far been established clearly and convincingly." As a result, the Judge would request detailed information concerning all the financial and other issues raised. Only after a full, exhaustive inquiry, would he render a final decision.

It was virtually another full year before Judge Ott concluded the case in December 2004. He had set out a series of questions concerning the total realizable assets of the Foundation (if everything that could be lawfully deaccessioned were sold), of the potential financial feasibility of the Foundation's proposal to move, and of the possible alternative plans that might allow the Foundation to remain in Merion. All of these issues were addressed "and generated more than 1,200 pages of testimony" which Ott summarized in his opinion.

In order to evaluate the persuasiveness of Ott's conclusion, there is no substitute for reading at least the major parts of his final decision, with its citation of various financial projections for the possible sale of some Foundation assets (such as the Foundation's nongallery paintings; the farmhouse, Ker-Feal, and its land as well as the large amount of "raw land" owned by the Foundation). Further data include projections about the likely costs of building and operating a new Foundation in Philadelphia, while maintaining the arboretum and a study center in Merion. Other issues were also dealt with: would the potential new Philadelphia gallery "replicate" the existing gallery? Was it consistent with Albert Barnes' intent to allow a much larger number of visitors to have access to the gallery? Would a new "mega museum-like" building be the result, and would that be consistent with Barnes' vision?

Few of these questions could be answered definitively, but the financial factors could now be "bracketed" with plausible high-low estimates, while newly discovered documents (as well as testimony) could help to clarify the nonfinancial matters. In the end, Ott estimated that $20 million of endowment could be raised by selling as many Foundation assets as possible. At a five percent spend rate, this would yield only $1 million per year, far less than the

[3]Ibid., p. 21.

[4]Ibid., p. 24.

Foundation needed to operate. Even if the figure had been doubled, the money would have clearly been far from sufficient: as noted earlier, Kimberly Camp had estimated that approximately $70 million was necessary.

With respect to Barnes' intentions for the use of the gallery after his death, the evidence was ambiguous. He clearly wanted his own method of education to be sustained, and this desire tipped the scales in the direction of a largely "closed" institution. In addition, however, he had said more than once (in letters to Dewey, for instance) that he intended the gallery to be eventually — if not sooner — open to the public (as well as to students from local colleges and universities). Moreover, a 1923 letter from Barnes to his attorney, Owen J. Roberts, was introduced as evidence to help clarify his intentions. Essentially, Barnes had insisted that during his lifetime, he wanted his privacy and control over his education program, but that he expected to have the gallery open after his death:

> In view of the general belief that I am about to give my life and privacy away to the public — which I never intended — I am afraid of the statement in the affidavit for the Internal Revenue Collector, which reads, "An art gallery for the education of . . . the masses in art, etc." That, of course, is the purpose of the Foundation after I am gone, . . . In short, I am building for the future, I want to guarantee my privacy, and I want to prepare the way for the gallery to be a public one after my death.[5]

In spite of this 1923 statement (written shortly before the establishment of the Foundation), no single view on the matter can be taken as definitive since Barnes so often changed his mind. His democratic side tilted in the direction of openness, while his experience with casual "museum-goers" led him to be more and more exclusive. The challenge, therefore, was to try to envision an institution that could fulfill both impulses: a high degree of public access and an equally strong program for a limited number of students who would have the gallery to themselves.

At least one witness for the students simplified (and thereby distorted) this issue. It was claimed that Barnes' mission was always "quite narrow" — solely to advance his own method of teaching art in his gallery. And, the witness added, a public institution in "a very large traditional museum" in Philadelphia would be directly contrary to Barnes' purposes: the trustees will "have the gallery in one corner because it will be lost, and also it will put such a burden on the trustees to maintain that building. They won't have much time for Dr. Barnes' core purpose."[6]

[5]Opinion, Judge Stanley Ott, December 13, 2004, p. 20.
[6]Ibid., p. 22.

Quite apart from the witness' oversimplification of Barnes' goals, there was no evidence at all that the new building would be a large conventional museum with the gallery "in one corner." There were of course no architectural plans at the time — but those that were created — and the new building itself — have entirely belied the images that so disturbed the witness' imagination.

Judge Ott concluded on this and related points that a Philadelphia facility could be consistent with both the educational aims and the "public access" goals of the Foundation because a center-city location would be free of the zoning prohibitions and other restrictive (often unpredictable) policies and conflicts of Merion. It could be open more hours each day and more days per week. In effect, the art program could have a sufficient number of "closed" hours, while the new environment could also provide for considerably more (and more convenient) public access.

With respect to the Foundation's financial prospects in Philadelphia, it was possible to make sensible projections, but not to be definitive. The trustees of the Barnes committed themselves to raise $50 million in endowment by the time a new building was constructed (and paid for). The income from that initial endowment, in addition to other revenues (such as increased numbers of visitors, education-related fees, and store sales) would perhaps leave an annual operating-budget gap of approximately $4 million — not very different from what was needed to operate in Merion. The difference, of course, was that Philadelphia had a large, broad-based "constituency" of donors, potential members, and friends who would prove themselves willing to be generous with substantial annual giving and endowment funds. The three main Philadelphia foundations had been more than generous in helping the Barnes in its initial efforts to raise money for a move to Philadelphia. And by 2011, approximately $100 million had been donated by individuals and institutions *excluding* the three foundations. In Merion, essentially no significant funding had ever been forthcoming either from the local community or any other quarter. In Philadelphia, funds were contributed from many sources once the move was approved. In other words, there were very good reasons to think that the Barnes in Philadelphia could function effectively from a financial point of view, and it could move ahead in expanding its educational programs (and visitor numbers) without having to try to operate in a residential environment with the complication of vigilant — sometimes litigious — neighbors, township officials, zoning boards (and the courts).

Quite apart from the larger considerations related to access and finances, the court specified that the gallery would (in its new setting) maintain the original scale and sequence of rooms, and that the collection would be installed precisely as it had been in Lower Merion. The galleries would be no more crowded than they had been: a comparable limited number of people would be admitted to the collection at any one time, though far larger

numbers would gain access because the gallery — in strong contrast to Merion — could be open many more hours per day and per week.

Having explored all possible alternatives to enabling the Barnes to remain in Merion, Judge Ott concluded that

> maintaining the *status quo* will neither generate excitement among potential benefactors nor attract the all-crucial [major] . . . donors to the cause. . . . Pew, Lenfest and Annenberg . . . have deemed the current situation to be unsalvageable; and Dr. Watson has testified that the Foundation's Board has approached all other potential saviors and been rebuffed.
>
> Regarding options for increasing the income produced by the day-to-day operations at Merion, no solid solutions surfaced. The dream of augmented admissions (with the attendant increases in shop sales and parking fees) was shown, during these hearings, to be as elusive as ever. We noted in the January 2004 opinion [that] this Orphans' Court "has no jurisdiction to broker or impose any changes in the unfortunate situation" between the Foundation and the Lower Merion Township.[7]

Judge Ott's review of the case had been exhaustive. He had taken a full additional year to examine all the evidence. He had allowed the students — who had no legal "standing" — to participate in the case, with their own counsel and witnesses. He had a record of the strictest possible scrutiny in all previous cases involving the Barnes, and the record showed more rulings against the Barnes than in its favor. He analyzed every aspect of the case, weighing the pros and cons of each step before he delivered his judgment authorizing the move.

<p style="text-align:center">✶ ✶ ✶</p>

Takeover?

The first reactions to Judge Ott's decision were mixed, but very quickly, strong opposition from several quarters gathered momentum, including academics, museum professionals, Merion neighbors, present and past students of the Barnes Foundation, and the media. Soon a popular conspiracy theory emerged: wealthy Philadelphia had joined together to capture the Barnes from Lincoln, as a "trophy" to increase tourism and heighten the city's identity as an international cultural "destination." Headlines proliferated: "Philly Deals: elite want a new Barnes, masses are paying for it;" "No Museum Left Behind: the relocation of the Barnes Foundation is fueled by ignorance and

[7]Ibid., p. 31.

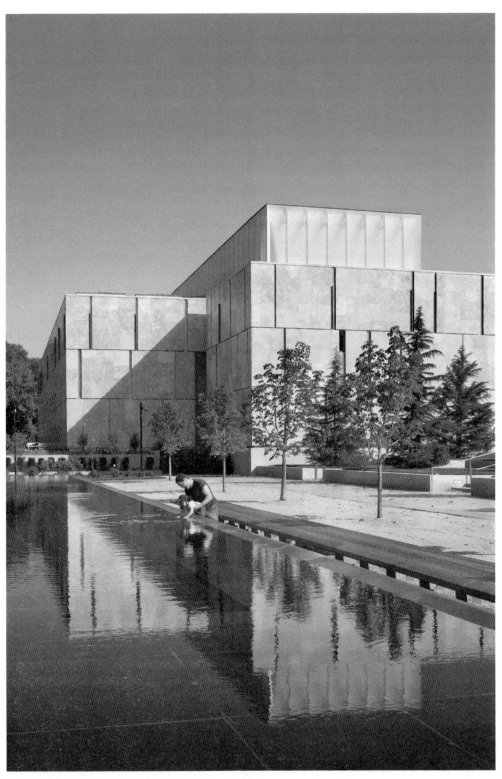

The Barnes Foundation, Philadelphia, public plaza
Tod Williams Billie Tsien Architects, 2012
Photograph © Michael Moran / OTTO

avarice, not altruism;" "The Art of the Steal" (a film widely distributed) tried to make a case for the move as one of the greatest art thefts since World War II. The conspiracy theory was appealingly simple: the three Philadelphia-based foundations, joined by some prominent public figures, had collaborated to take advantage of the Barnes' financial crisis in order to force a move of the institution to center city.

These (and similar views) soon acquired a life of their own. This should not be surprising: conspiracy theories are always much easier to invent than to disprove. Alternative ways to preserve the *status quo* — however unrealistic — always seem conceivable, just as the stated facts or findings in a case remain inevitably open to continuing challenge and debate. With respect to the Barnes, there was enough material to support different views of what actually happened — and why. For instance, there is no doubt that the governor, the mayor, and other city officials saw the move of the Barnes as a way of increasing Philadelphia's prestige — as well as expanding its tourism and revenue. Others felt strongly about bringing the educational programs within reach of many more individuals and groups. Still others emphasized that the Barnes in Merion had always held itself entirely aloof — indeed unwelcoming — and there was little if any sympathy for an institution that had (in addition) managed all of its affairs so badly. A number of those who had read the relevant documents believed that there was no way to overcome the obstacles (both financial and "environmental") in Merion, and many believed that the remote location of the Barnes in Merion made it essentially inaccessible.

In short, a large cluster of reasons or motives on the part of many different people converged in favor of moving the Foundation to center city. But a convergence is of course something completely different from a conspiracy. One implies a coincidence of attitudes and views; the other is motivated by collusion. Although there is overwhelming evidence of the "convergence" view, the conspiracy theory persists in some quarters. Reviewing some of the major issues at stake can at least help to clarify the facts.

On the "conspiracy" side are those who believe that the annual deficit of the Barnes in Merion was about $1 million, that the Foundation could operate with about $2 million, and that the gap could easily be filled through higher admission fees, shop sales, tuition, and a flow of new gifts. In fact, by 2000, the Barnes' annual budget was already above $3 million (excluding legal fees) largely because it was for the first time in its history beginning to be professionally staffed. Neither a $3 million Merion budget, nor the more likely adequate one of $4 to $4.5 million could possibly be met through increased admission, tuition, and shop revenues. If one adds "gifts" to the equation, one must ask "what gifts"? A decade of efforts to raise operating funds for the Barnes in Merion failed, and the next two years of intense fundraising efforts by Dr. Watson and Kimberly Camp yielded little. The record is indisputable.

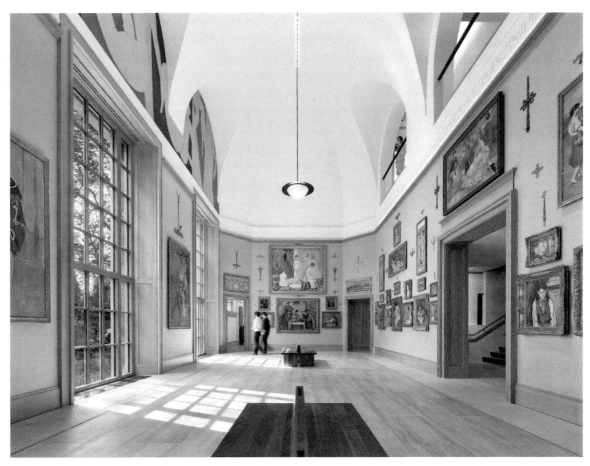

The Barnes Foundation, Philadelphia, northern view of the Main Gallery
Tod Williams Billie Tsien Architects, 2012
Photograph © Michael Moran / OTTO

There were also some who believed that the Pew, Lenfest, and Annenberg Foundations deliberately withheld support for the Barnes in Merion in order to capture and somehow "own" and run the Barnes in Philadelphia. But one should remember that Walter Annenberg chaired Glanton's "deaccession" committee in the early 1990s in order to try to raise endowment funds by auctioning paintings to help the Barnes remain in Lower Merion. Then, in 2001, the Pew grant (in collaboration with the Getty Trust) was intended in large part for long range planning to help the Barnes regain its financial stability in Merion. In the words of Rebecca Rimel, president and CEO of the Pew Charitable Trusts, "[W]e hope ... to assist the Barnes reach its full potential." She then added, "We are eager to help the Barnes set its splendid house in order." Barry Munitz, head of the Getty Trust, said that the two foundations were working to help the Barnes to shore up its finances and added that the Getty wanted to "assist the Barnes Foundation to achieve a sound and stable artistic and economic base."

Had the Pew Charitable Trusts been hoping to move the Barnes to Philadelphia, it seems unlikely that they would have joined forces with the Getty in 2001 to help the institution with its forward planning, in order to reach its "full potential" in Merion.

Most significant, however, is the fact that all three Philadelphia foundations (together with the Mellon Foundation, the Getty, and the Luce Foundation) actually made completely sound decisions in choosing to provide special "project" support rather than annual operating (or endowment) funds for the Barnes in Merion — a fact that opponents of the move have found difficult to accept. Far from conspiring to achieve a move, these foundations all understood that after years of contentious disagreements with the neighbors, with the zoning board and with the township; after conflicting court decisions, student protests, the absence of any significant local financial help or of a "committed constituency;" and given the sheer unpredictable dynamics of the Lower Merion "environment," the Barnes was simply not viable in its original location. Neither Judge Ott nor any other individual or donor institution could discover a way to save the Foundation in Merion. As Judge Ott himself said,

> Attempts to build up the Foundation's endowment were met with negative responses. The potential individual donors and philanthropic organizations alike were unwilling to support The Foundation because of the restrictions imposed by the township and the indenture.[8]

Other suspicions arose, especially concerning Judge Ott's decision to allow the expansion of the Barnes board. There was a perception that Lincoln University was "bribed," and withdrew its opposition only when promised additional state funding by Governor Rendell. The governor's action was one important factor, but far from decisive. Dr. Bernard Watson played a major role in helping to persuade Lincoln to accept the new composition of an expanded board: Lincoln was ultimately compelled to confront the fact that the previous arrangements in Merion were no longer sustainable. The real choice was between a bankrupt or "dissolved" Barnes or one based in Philadelphia, with an expanded and more heterogeneous group of trustees as well as a large base of potential donors.

Equally significant, Lincoln's continuing opposition would have led to its direct involvement in the court case, and that would have proved to be embarrassing, as well as very expensive. The dual role that Glanton played at both Lincoln and the Barnes; an investigation into possible misuse of Lincoln's funds by its president; and the inquiry into Glanton's financial dealings

[8]Opinion, January 29, 2004, p. 17.

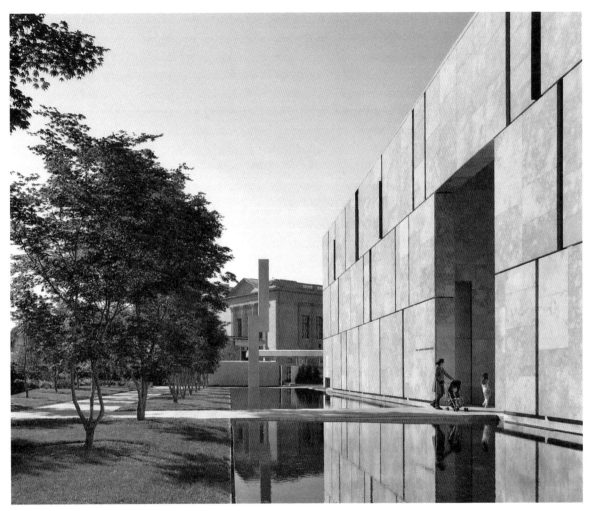

The Barnes Foundation, Philadelphia, southern view of the north façade
(with *Barnes Totem*, Ellsworth Kelly, 2012)
Tod Williams Billie Tsien Architects, 2012
Photograph © Michael Moran / OTTO

would all have been aired in open court, affecting Lincoln's reputation. All of the questions concerning potential conflicts of interest would also have arisen, and there would have been a careful scrutiny of the method by which Lincoln searched for and nominated possible members for the Barnes board. Was there a standing nominating committee, and what were the stipulated criteria for choosing nominees? What was the exact process that led to the nomination of Glanton? How many other candidates were considered, and what were the reasons for the final choice?

Finally, if Lincoln had continued to express opposition to the enlargement of the board, its arguments would not have affected the outcome. Judge Ott's decision to expand the board was justified on the basis of strong

evidence, including professional testimony from a witness who was thoroughly knowledgeable about the prevailing size, composition and roles of nonprofit boards.

In addition to all of the issues already considered, there was a conviction shared by a limited number of people that after the resignation of Glanton, the Barnes could simply have continued as before: a quiet, largely closed (and self-enclosed) institution with about 500 visitors a week and an inconspicuous number of 100 to 200 enrolled students. The Barnes might then function without tensions or discord with either the neighbors, the township, the students or the courts — as it had for several decades since its founding.

But a number of obstacles would have made this impossible: problems with the neighbors had surfaced as early as 1961, and the nature of the residential area, as we have seen, made clear that these difficulties were intractable. In addition, Dr. Watson was determined to fulfill the Foundation's broad educational goals as defined by Barnes, and this would have required greater access to the art collection, more open days for visitors, and some significant diversification of the academic program, including students from a variety of backgrounds. A bus service would almost certainly have become necessary as would more on-site parking. More activities and more traffic would inevitably have stimulated opposition from at least some Merion constituencies. Even if "variances" were granted by one set of township commissioners or zoning board members, their successors might well have refused to agree. Moreover, in view of the nature of the neighborhood, anyone with "standing" could initiate a complaint or suit against the Barnes at any time, and there would be no way to predict how the courts (or township) would rule.

Finally, there would have to be a major (and successful) fundraising campaign followed by annual solicitations on a continuing basis. This would have required invitations to potential members, friends, and donors to visit the Foundation on a regular basis, for social events, lectures, symposia, and other gatherings. All such activities, bringing even more people and traffic to Lower Merion, would have to be sanctioned by the courts, and then embraced by the total Lower Merion community — with very little hope for favorable outcomes.

In short, there was no way that a return to the "old" Barnes was possible, and there was also no takeover of the Foundation. On the contrary, the original idea to move to Philadelphia was conceived by the Lincoln-nominated board and its chair, Dr. Bernard Watson. It was arrived at only after an exhaustive exploration of all other alternatives, and the board's analysis was confirmed by the ruling of Judge Ott. Throughout, the board's central focus was on the goal of fulfilling the Foundation's fundamental purposes: to expand and diversify or "democratize" access to the Barnes collection and its educational programs, while also finding a location where the Barnes could expect to be strongly and predictably supported from a financial as well as a "community" point of view. In this quest, the board continued to make its

own independent determinations about its programs, its new building, and its effort to create a group of committed friends and donors.

<p style="text-align:center">✶ ✶ ✶</p>

One Upon Whom Nothing Is Lost

Henry James visited America in 1904 after a twenty-year absence. His volume, *The American Scene*, is a work of brilliant observation and meditation: nothing is lost upon James as he chronicles, with unremitting irony, the tale of a natural and urban landscape largely transformed in the name of progress — a rush toward some unknown future destination. In New York, north of Washington Square, James found neighborhoods where modest amiable dwellings had simply disappeared, replaced by domineering skyscrapers. Speed, usefulness, efficiency — yes. But the sense of place or of character — not at all.

Moreover, upper Fifth Avenue was studded with the mansions of the very rich, and the Waldorf-Astoria epitomized all that was most repugnant to James: a kind of social machine in which everything was superbly organized, with nothing awry — nothing individualistic, perturbing, or idiosyncratic that might bestow character on the place. Who were these congregated people in the hotel, and what were they seeking? "The question of who they might be — interesting in other societies and times" was simply irrelevant at the Waldorf. This was a purely "public" place, never "in disaccord with itself."

When James reached Philadelphia, there was an immediate sense of relief and a palpable feeling of relaxation. Here at last was a society that was settled and congenial. And even though it seemed to be populated by everyone's cousins, aunts, parents, brothers, and second cousins — a city marked by its consanguinity — it had the great value of knowing what it was, thanks to having been so "for a couple of centuries." The streets seemed everywhere awry, and the buildings were often characterized as much by their architectural flaws as by their virtues. But, happily, no one had felt the relentless urge to "correct" or replace everything. Philadelphia was, consequently, an "illimitable town" — "a little masterpiece of the creative imagination," which would have been destroyed if touched by the hand of modernity. Nowhere else, said James — except perhaps at Mount Vernon — "does our historic past shine through" so brightly.

James would have viewed the move of the Barnes Foundation as another symptom of all that was misguided about the nation's race to the future. Private places, sociable places, unostentatious but ample places, and rooted places — these were what James valued and what he found a century ago in Philadelphia. The idea of developing a Philadelphian urban cultural center, a "museum mile," or a new "democratic" institution in which people

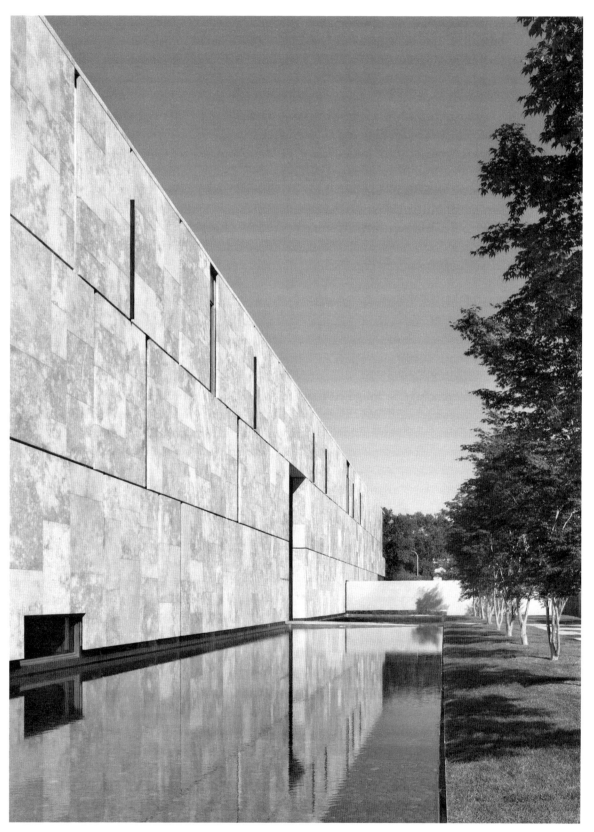

The Barnes Foundation, Philadelphia, western view of the north façade
Tod Williams Billie Tsien Architects, 2012
Photograph © Michael Moran / OTTO

of "all stations of life" could meet and intermingle and where various kinds of formal art education could be carried on for "the masses" as well as for the select: all of this would have jarred James, and perhaps moved him well beyond his customary irony to something much more acerbic.

The new Barnes Foundation will undoubtedly be a part of Philadelphia's increasing urbanization, and will leave behind a part of living history, although the original buildings will remain as a study center with the rich Barnes archives available for research. Meanwhile, the arboretum education program will continue at full strength. In Philadelphia, much has been done with fine trees and landscaping to buffer the new Barnes art gallery from the immediate boisterousness of the parkway and the city, although nothing can replace the serenity of Latch's Lane.

The outstanding new building — by Tod Williams and Billie Tsien — does not (and should not) attempt to offer precisely the experience of Cret's original structure. So a move that was made with the greatest reluctance, in the face of institutional dissolution, may — inevitably — entail some permanent sense of loss.

But the architectural success of the new Barnes will enable it to improve and broaden the nature of its educational programs. People from every walk of life will be able to participate in one or another form of art education. A good number of ordinary "museum-goers" will be served, even though Barnes disliked such people. Nevertheless, it was he who considered (more than once) opening the gallery to the public, or even leaving the collection to an institution in Philadelphia, following his and his wife's death. And it was Barnes who wrote in his Indenture that the purpose of the education program was to see how much "practical good to the public of all classes and stations of life, may be accomplished."

There is very little that is "Jamesian" about the Barnes on the parkway. But the art is there, installed as it was in Merion. The education programs — improved and expanded — are there. Special exhibitions will — for the first time — be possible. Ambitious, scholarly works will be published. The primary purposes for which the Barnes was created will, reanimated, be at the center of the institution.

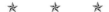

Selected Sources Consulted
by the Author

John Anderson, *Art Held Hostage* (W.W. Norton & Company, Inc., New York, 2003).

Albert C. Barnes, "How to Judge a Painting," *Arts and Decoration*, April 1915.

Albert C. Barnes, "Renoir: An Appreciation," *Arts and Decoration*, November 1920.

Albert C. Barnes, "The Temple," *Opportunity*, May 1924.

Albert C. Barnes, *The Art in Painting*, first published 1925 (third edition, revised and enlarged 1937, reprinted 1965, Harcourt, Brace & World, New York).

Albert C. Barnes, "Construction and Controversy," *Journal of the Barnes Foundation*, October 1925.

Albert C. Barnes and Violette de Mazia, *The French Primitives and Their Forms* (Barnes Foundation Press, Merion, Pa., 1931).

Albert C. Barnes and Violette de Mazia, *The Art of Henri Matisse* (Charles Scribner's Sons, New York and London, 1933).

Albert C. Barnes, "The Art of the American Negro," *The Barnwell Annual Addresses, 1931–1936* (The Central High School, Philadelphia, 1937, pp. 375–386).

Albert C. Barnes and Violette de Mazia, *The Art of Cézanne* (Barnes Foundation Press, Merion, Pa., 1939).

Albert C. Barnes, *The Case of Bertrand Russell vs. Democracy and Education* (pamphlet), The Barnes Foundation, Merion, Pa., 1944.

Albert C. Barnes, Indentures of Trust, The Barnes Foundation.

Albert C. Barnes and Violette de Mazia, *The Art of Renoir* (William J. Dornan, Philadelphia, 1944).

The Barnes Foundation, a corporation, vs. Harry W. Keely, Receiver of Taxes, Court of Common Pleas, Philadelphia, April 22, 1931.

Alfred H. Barr, Jr., "Plastic Values," *Saturday Review of Literature*, July 24, 1926.

Alfred H. Barr, Jr., *Matisse, His Art and His Public* (Museum of Modern Art, New York, 1951).

Alfred H. Barr, Jr., *Painting and Sculpture in the Museum of Modern Art* (Museum of Modern Art, New York, 1977).

Clive Bell, *Art* (Chatto & Windus, London, 1987; first published 1914).

Clive Bell, *Old Friends* (Chatto & Windus, London, 1956).

Bernard Berenson, *The Florentine Painters of the Renaissance* (G.P. Putnum's Sons, New York and London, 1896).

Janet Bishop, Cécile Debray, and Rebecca A. Rabinow eds., *The Steins Collect* (San Francisco Museum of Modern Art in association with Yale University Press, New Haven and London, 2011).

Asa Briggs, *William Morris, News from Nowhere and Selected Writings and Designs* (Penguin Books, Harmondsworth, Middlesex, 1980).

Milton W. Brown, *The Story of the Armory Show* (Abbeville, New York, 1988).

Nathaniel Burt, *Palaces for the People* (Little, Brown, Boston, 1977).

Leon Chai, *Aestheticism* (Columbia University Press, New York, 1990).

Kenneth Clark, *The Gothic Revival* (John Murray, London, 1970).

Kenneth Clark, *Another Part of the Wood: A Self Portrait* (John Murray, London, 1974).

T.J. Clark, *The Painting of Modern Life: Paris in the Art of Manet and his Followers* (Alfred A. Knopf, New York, 1985).

Michael Conforti, James A. Ganz, Neil Harris, Sarah Lees, Gilbert T. Vincent, and others, *The Clark Brothers Collect: Impressionist and Early Modern Painting* (Sterling and Francine Clark Art Institute, Williamstown, MA., 2006).

Douglas Cooper, *The Courtauld Collection* (Athlone Press, London, 1954).

Bernard Denvir, *The Early Nineteenth Century: Art, Design and Society, 1789–1852* (Longman, London and New York, 1984).

Bernard Denvir, *The Late Victorians: Art, Design and Society, 1852–1910* (Longman, London and New York, 1986).

John Dewey, *Intelligence in the Modern World: John Dewey's Philosophy*, ed. Joseph Ratner (Modern Library, New York, 1939).

Linda C. Dowling, *Language and Decadence in the Victorian Fin de Siècle* (Princeton University Press, Princeton, N.J., 1986).

Dr. Albert Barnes' Search for "An Educational Enterprise that has no Counterpart Elsewhere," February 10, 2005, prepared by Schnader, Harrison, Segal & Lewis LLP.

Terry Eagleton, *The Ideology of the Aesthetic* (Basil Blackwell, Oxford, 1990).

Claudia Einecke and Sylvie Patry eds., *Renoir in the 20th Century*, Los Angeles County Museum of Art / Philadelphia Museum of Art (Hartje Cantz Verlag, Osfildern, 2010).

Richard Ellman, *Oscar Wilde* (Hamish Hamilton, London, 1987).

Penelope Fitzgerald, *Edward Burne-Jones* (Hamish Hamilton, London, 1989).

Jack Flam, *Matisse on Art* (E.P. Dutton, New York, 1978).

Ford Madox Ford, *Memories and Impressions* (Harper & Brothers, New York, 1911).

Roger Fry, "Cézanne," *The Burlington Magazine*, January–February 1910.

Roger Fry, *Cézanne* (Noonday Press, New York, 1958; first published 1927).

Roger Fry, *Vision and Design* (Chatto & Windus, London, 1929).

Roger Fry, *Matisse* (London and Paris, 1930).

A Roger Fry Reader, ed. Christopher Reed (University of Chicago Press, Chicago and London, 1996).

Théophile Gautier, *Mademoiselle de Maupin and One of Cleopatra's Nights* (Modern Library, New York, n.d.; translation unattributed).

Vincent Giroud, "Picasso and Gertrude Stein," *Metropolitan Museum of Art Bulletin*, Winter 2007.

Christopher Green, *Art Made Modern: Roger Fry's Vision of Art* (Merrell Holberton, London, 1999).

Howard Greenfeld, *The Devil and Dr. Barnes: Portrait of an American Collector* (Penguin, New York, 1987).

Jennifer Gross, *The Société Anonyme* (Yale University Press, New Haven, 2006).

Paul Guillaume, " Le Docteur Barnes," *Les Arts à Paris*, January 1923.

Paul Guillaume, "Ma Visite à la Fondation Barnes," *Les Arts à Paris*, May 1926.

Henry Hart, *Dr. Barnes of Merion: An Appreciation* (Farrar, Straus, New York, 1963).

Philip Henderson, *William Morris: His Life, Work, and Friends* (Penguin Books, Harmondsworth, Middlesex, 1973).

Robert L. Herbert, *Barbizon Revisited* (Museum of Fine Arts, Boston, 1962).

Timothy Hilton, *The Pre-Raphaelites* (Thames and Hudson, London, 1985).

Eric Hobsbawm and Joan Scott, "Political Shoemakers," *Past and Present*, 89, no. 1, 1980.

John House, *Impressionism for England: Samuel Courtauld as Patron and Collector* (Courtauld Institute, London, 1994).

Journal of the Barnes Foundation (Barnes Foundation, April and May, 1925).

J.-K. Huysmans, *Against Nature*, translated by Robert Baldick (Penguin, Harmondsworth, Middlesex, 1976).

Charles Johnson, "Dr. Barnes," *Opportunity*, May 1924.

George Landow, *The Aesthetic and Critical Theories of John Ruskin* (Princeton University Press, Princeton, N.J., 1971).

Susanne K. Langer, *Problems of Art* (Scribner's, New York, 1957).

Russell Lynes, *The Tastemakers* (Harper, New York, 1972).

Russell Lynes, *Good Old Modern: An Intimate Portrait of the Museum of Modern Art* (Atheneum, New York, 1973).

Joseph Margolis, *Philosophy Looks at the Arts* (Temple University Press, Philadelphia, 1987).

Francis O. Mattson, "The John Quinn Memorial Collection," *Bulletin of the New York Public Library*, vol. 78, no. 2, Winter 1975.

Violette de Mazia, "The Barnes Foundation," *House and Garden*, December 1942.

Karl E. Meyer, *The Art Museum* (William Morrow, New York, 1979).

Mary Ann Meyers, *Art, Education, & African-American Culture: Albert Barnes and the Science of Philanthropy* (Transaction Publishers, New Brunswick, N.J. and London, 2004).

William Morris, *Hopes and Fears for Art* (Roberts Brothers, Boston, 1882).

Mary Mullen, *An Approach to Art* (Barnes Foundation Press, Merion, Pa., 1923).

Nelle Mullen, "Learning to See," *Journal of the Barnes Foundation*, April 1925.

Judge Michael Musmanno, *Commonwealth Appellant v. The Barnes Foundation* (1960).

Judge Stanley Ott, Memorandum Opinion and Order, January 29, 2004.

Judge Stanley Ott, Opinion, December 13, 2004.

Walter Pater, *The Renaissance* (MacMillan, London, 1910; reprinted 1982).

E. R. Pennell and J. Pennell, *The Life of James McNeill Whistler*, vol. 1 (William Heinemann, London, 1908).

Marjorie Phillips, *Duncan Phillips and His Collection* (W. W. Norton & Company, Inc. in association with the Phillips Collection, New York and London, 1982, revised edition, first published 1970).

Margaret Potter ed., *Four Americans in Paris: The Collections of Gertrude Stein and Her Family* (Museum of Modern Art, New York, 1970).

Edith Powell, "Peale Portraits — Ultra-Modern French Art," *Public Ledger*, Philadelphia, April 15, 1923.

Rebecca A. Rabinow ed., with Douglas W. Druick, Ann Dumas, Gloria Groom, Anne Roquebert, Gary Tinterow, *Cézanne to Picasso: Ambroise Vollard, Patron of the Avant-Garde* (The Metropolitan Museum of Art, New York, 2006).

B.L. Reid, *The Man from New York: John Quinn and His Friends* (Oxford University Press, New York, 1968).

John Rewald, *Cézanne and America* (Princeton University Press, Princeton, N.J., 1989).

John D. Rosenberg, *The Darkening Glass: A Portrait of Ruskin's Genius* (Columbia University Press, New York, 1986).

Isabel Ross, *Silhouette in Diamonds: The Life of Mrs. Potter Palmer* (Harper, New York, 1960).

John Ruskin, *On the Old Road: A Collection of Miscellaneous Essays and Articles on Art and Literature*, vol. 2, 1834–1885, Project Gutenberg, 2007. http://www.gutenberg.org/ebooks/21263.

Bertrand Russell, *Why I am Not a Christian* (Simon and Schuster, New York, 1957).

Bertrand Russell, *The Autobiography of Bertrand Russell*, vol. 2, 1914–1944 (Allen and Unwin, London, 1968).

Aline B. Saarinen, *The Proud Possessors* (Random House, New York, 1958).

Irving Sandler and Amy Newman eds., *Defining Modern Art: Selected Writings of Alfred H. Barr, Jr.* (Abrams, New York, 1986).

William Schack, *Art and Argyrol: The Life and Career of Dr. Albert C. Barnes* (Thomas Yoseloff, New York and London, 1960).

Frances Spalding, *Vanessa Bell* (Ticknor & Fields, New York and London, 1983).

Peter Stansky, *Redesigning the World: William Morris, the 1880s, and the Arts and Crafts* (Princeton University Press, Princeton, N.J., 1985).

John Steegman, *Victorian Taste* (MIT Press, Cambridge, MA., 1971).

Leo Stein, "The Art in Painting," *The New Republic*, December 2, 1925.

Leo Stein, *The A-B-C of Aesthetics* (Boni & Liveright, London, 1927).

Leo Stein, *Appreciation: Painting, Poetry & Prose* (Crown Publishers, New York, 1947).

Leo Stein, *Journey into the Self* (Crown Publishers, New York, 1950).

P.E. Tennant, *Théophile Gautier* (Athlone Press, London, 1975).

Calvin Tomkins, *Merchants and Masterpieces* (Dutton, New York, 1973).

Ambroise Vollard, *Recollections of a Picture Dealer* (Dover Publications, Mineola, New York, 1978).

Richard J. Wattenmaker, Anne Distel, and others, *Great French Paintings from the Barnes Foundation* (Alfred A. Knopf, New York in association with Lincoln University Press, 1993).

Richard J. Wattenmaker, *American Paintings and Works on Paper in the Barnes Foundation* (The Barnes Foundation, Merion, Pa. in association with Yale University Press, New Haven and London, 2010).

Eugene Weber, *France: Fin de Siècle* (Harvard University Press, Cambridge, MA., 1986).

Stanley Weintraub, *Whistler: A Biography* (Weybright and Talley, New York, 1974).

Frances Weitzenhoffer, *The Havemeyers* (Harry Abrams, New York, 1986).

James A. McNeill Whistler, *The Gentle Art of Making Enemies* (Dover, New York, 1967).

Walter M. Whitehill, *Museum of Fine Arts, Boston*, two vols. (Harvard University Press, Cambridge, MA., 1970).

Oscar Wilde, *The Picture of Dorian Gray* (Oxford University Press, 1989; first published July 1890 in *Lippincott's Monthly Magazine*).

Richard Wollheim, *Art and Its Objects* (Penguin, Harmondsworth, Middlesex, 1978).

Willard Huntington Wright, *Modern Painting* (John Lane, London and New York, 1915).

Judith Zilczer, *The Noble Buyer: John Quinn, Patron of the Avant-Garde* (Smithsonian Institution Press, Washington D.C., 1978).

Index

Notes: Illustrations are indicated by page references in italics; footnotes are indicated by the annotation *n* following the page reference. To distinguish them from titles of paintings, the titles of publications are annotated with the date of first publication. Works presently in the Barnes Foundation are annotated with accession numbers. Color plates 1–8 follow page 66, plates 9–16 follow page 178.

Photograph Credits

All reproductions of works in the Barnes Foundation collection, unless otherwise indicated, are "Copyright 2012 The Barnes Foundation. All rights reserved."

All photographs of ensembles and works of art in the Barnes Foundation by Tim Nighswander / IMAGING4ART

Pages 12, 13, 19, 21, 45, 56, 57, 118, 119, 123, 124, 143, 148, 158, 168, Photograph Collection, Barnes Foundation Archives

Page 13 and back cover, photograph by Walter H. Evans, Photograph Collection, Barnes Foundation Archives

Plates 7, 9 and pages 39, 48, 49. Pablo Picasso: © 2012 Estate of Pablo Picasso / Artists Rights Society (ARS), New York

Plates 8, 10, 14, 16 and pages 37, 55, 59, 60. Henri Matisse: © 2012 Succession H. Matisse / Artists Rights Society (ARS), New York

Plate 15. Chaim Soutine: © 2012 Artists Rights Society (ARS), New York / ADAGP, Paris

Page 16. Giorgio de Chirico: © 2012 Artists Rights Society (ARS), New York / SIAE, Rome

Page 21, photograph by Pierre Matisse. Pierre Matisse: © 2012 Estate of Pierre Matisse / Artists Rights Society (ARS), New York

Pages 34, 35. Beinecke Rare Book and Manuscript Library, Yale University

Page 112. © RMN-Grand Palais / Art Resource, NY, photograph by Hervé Landowski

Page 131. Temple University Libraries, SCRC, Philadelphia, PA

Pages 187, 189, 191, 194 and front cover. Photograph © Michael Moran / OTTO

Photograph of author: Kamal Badhey